Harald Mante **The Photograph**
Composition and Color Design
2nd Edition

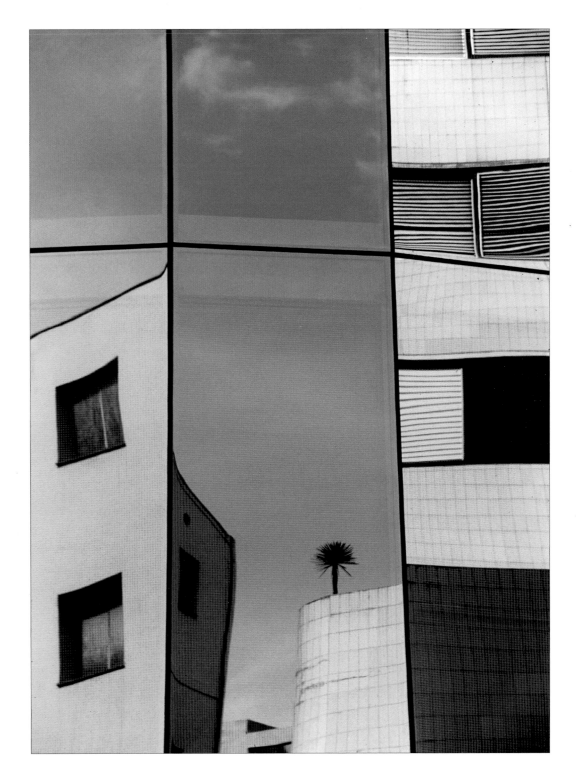

rockynook

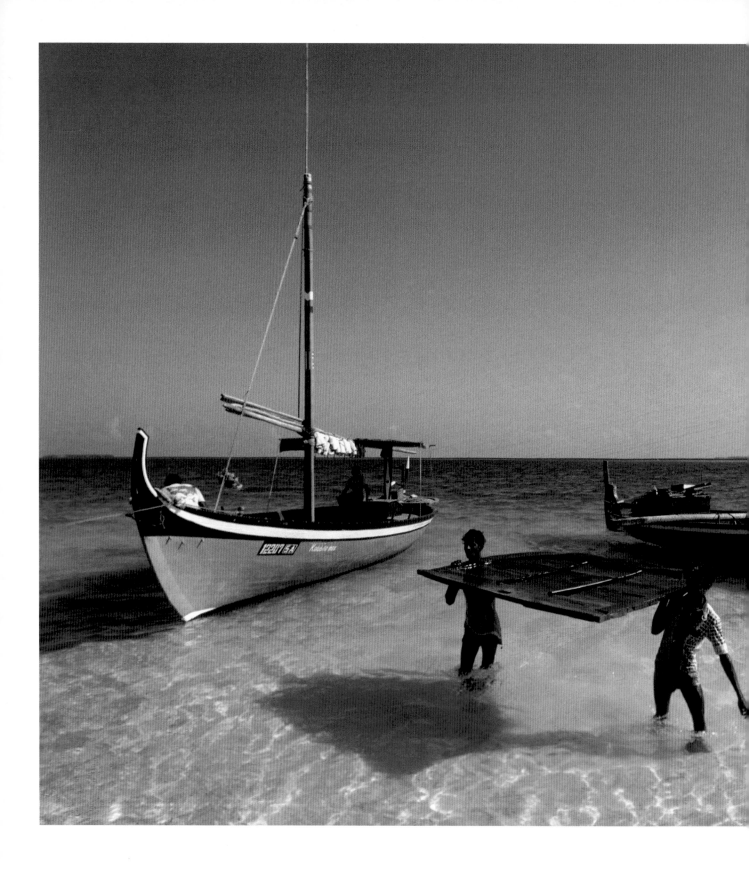

Harald Mante

The Photograph

Composition and Color Design

2nd Edition

Translated by Thomas C. Campbell III

rockynook

Editor: Gerhard Rossbach
Copy-Editor: Jeremy Cloot
Layout and Type: Verlag Photographie
Cover Design: Verlag Photographie
Translator: Thomas C. Campbell III
Printer: GorenjskiTisk
Printed in Slovenia

ISBN 978-1-937538-06-4

First published under the title:
"Das Foto – Bildaufbau & Farbdesign"
Copyright © 2010 by Verlag Photographie
Gilching, Germany
www.verlag-photographie.de

Translation Copyright © 2012
by Rocky Nook.
802 East Cota St., 3. Floor
Santa Barbara, CA 93103
www.rockynook.com
All rights reserved.

Library of Congress
Cataloging-in-Publication Data
Mante, Harald
[Foto – Bildaufbau und Farbdesign.
English]
The photograph: composition and color
design / by Harald Mante. — 2nd ed.
 p. cm
ISBN 978-1-937538-06-4 (hardcover:
alk. paper)
1. Composition (Photography) 2. Color
photography. 3. Photography, Artistic.
I. Title.

TR179.M35413 2012
778.6—dc23
 2012006740

Distributed by O'Reilly Media
1005 Gravenstein Highway North
Sebastopol, CA 95472

Contents

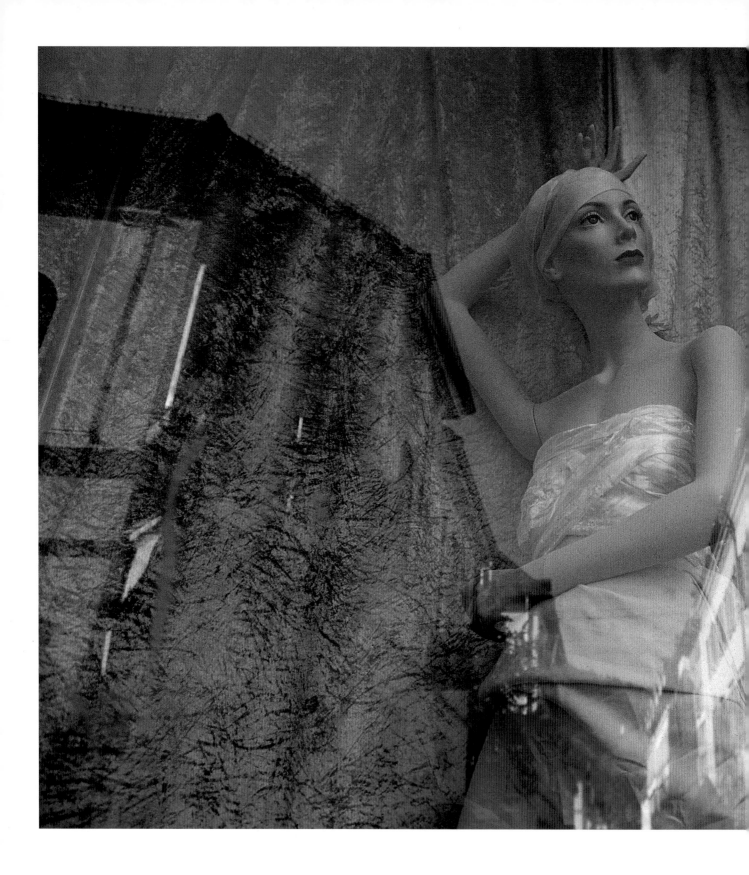

No Picture Content without Design

Independently of contents and of their importance, any picture achieves its visual effect through the use of design elements and color. A good composition underlies the picture's content without being intrusive.

The teachers at the Bauhaus – and later their pupils – struggled very intensively with all the problems of point, line, shape, and color. After studying applied painting, I transferred these teachings in my earlier books *Photo Design: Picture Composition for Black and White Photography* (1969) and *Color Design in Photography* (1970) to the medium of photography.

Alan Porter (editor of Camera magazine) wrote in the preface to Photo Design, "One searches to learn photography as in the other arts, but no art can stand on technique alone. The design and concept of the placement, the arrangement and order of line, space, depth, and other factors are the elements with which we strive for a creative picture." He continues with, "I have often found it necessary in my teaching to have such a book, so that students can realize their personal work using deliberate design concepts and not merely the concept of 'copying the master'." In the preface to Color Design, Karl Pawek says, "Color photography, as distinct from black-and-white, represents a completely new activity, with new creative potential. Those who take color photographs aim to achieve something with color…. Color thus opens up a completely new dimension in photography; it has introduced something which hitherto had represented at most a cause of

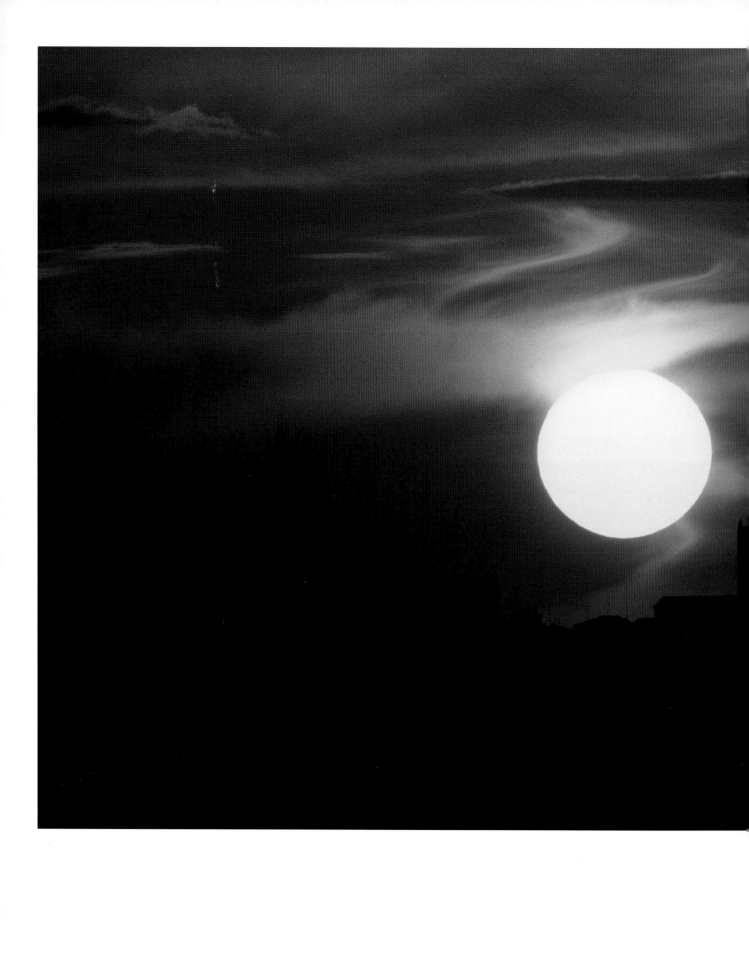

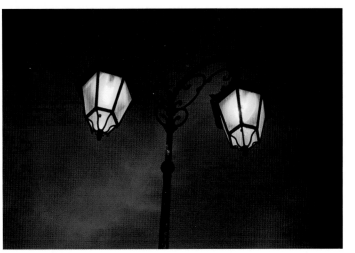

dissension among photographic artists – design." And "If color photography is not to be quite purposeless, restricted to an imitation of current trends, if there is to be any positive creativity among photographers, then they must study the principles of color design." Many years of teaching and constant independent photographing have extended my knowledge and made me conscious of design and color in photographic images.

Is there an operating instruction for good pictures? Such a question cannot be answered simply with yes or no, because the answer lies somewhere in between. It is between them, because each picture always has two levels of evaluation – the level of "contents and statement" with the fields of rational recognition and emotional reaction and the level of "quality of organization" with the structure of the image and color design. The viewer considers the content of a picture not with respect to its aesthetic quality, but on the information content and the viewer's interest in that information. Picture content can be roughly divided into the categories of very interesting, interesting, less interesting, and uninteresting – always from the perspective of each viewer. Picture contents may also be characterized as informative, instructional, dramatic, amusing,

shocking, sad, etc.. Interesting picture contents require the coincidence in the artist's mind of inspiration, creative ideas, and intelligent concepts – and there are neither operating instructions nor prescriptions to find these and develop them. It is remarkable that picture contents themselves can be still recognized with bad technique and bad organization. The primary task of good technique and good organization is thus to facilitate and support the recognition process. Two general theses apply to each photographic image. First of all: there is no content without organization, whereby there are, however, criteria for the quality of the visual design. Secondly: there is no design without content – and that includes uninteresting content. Some compositions may have content discernable only to a viewer possessing specialized knowledge of the meaning of that content. To see a large red circle on a white rectangle or a black square on white background is for the appropriately educated viewer the Japanese national flag and the famous picture by the Russian painter Kasimir Malewitsch, for example. Having learned the elements and principles of constructing a picture and its color design, one has the background also to make qualitative judgments about and criticisms of images. A picture's design elements and color

contrasts can be identified and explained analytically and used to evaluate the quality of the composition. There is, then, for the field of two-dimensional composition something approximating an "operating instruction". Knowing the grammar of art equips one to evaluate the qualities of an image, or to produce an image of high quality. Beyond that, it is a deeply enriching experience for educated viewers to see and feel more than before and to see with more skill than other viewers who lack the same knowledge. Applying these artistic methods may not be an end in itself. Knowledge of the rules – actually guidelines – of pictorial design should be totally internalized and influence practical work subconsciously, "from the belly", so to speak. With photographic work the practitioner can concentrate completely on the viewfinder image, the exposure, the subject, and its content.

Harald Mante

The Point

Within a composition the designation "point" refers to a means of organization, which in relation to the image plane is very small or relatively small. Points can be bright, dark, or colored. The point is static and maintains its location, without showing any tendency toward visual (imaginary) movement in the image space.

1 Brightness contrast, Half circles, Rectangles

The Point and Disturbing Points

The first experience any person has in viewing a picture is recognizing and reacting to its content. The quality of the composition can positively support and even benefit this process. Usually a picture's effect is determined by the interaction of several design elements and/or color contrasts. But sometimes certain elements and contrasts dominate to the extent of disturbing the viewer's experience. One of these design elements with the capability to dominate or disturb is the point.

The point, the most basic element of visual design

The most basic design element in a picture is the point. According to Wassely Kandinsky, "The point is the result of the first meeting of the artist's tools with the material, with the basic surface." In photography light takes over the role of the tools. A small source of light in a dark area or the reflection of light from a small bright object on an otherwise dark surface results in a mark on photosensitive material, which is comparable to the contact of a pencil or a brush on paper or canvas. Beyond that the emergence of the photographic picture is not comparable with the working processes in other artistic disciplines. While the surface of a painting generally "develops" slowly, brush stroke by brush stroke, with the act of

2 Quantity contrast, Sharp–unsharp contrast

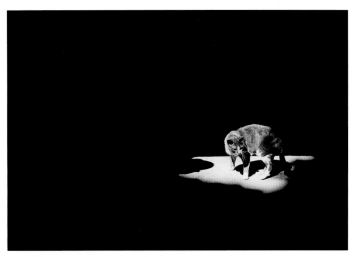

3 Brightness contrast, Quantity contrast

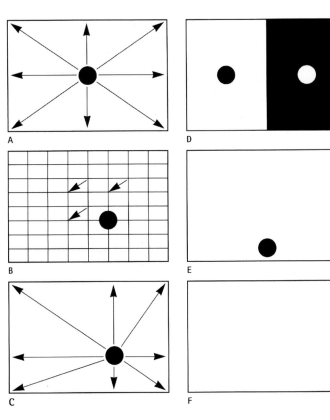

4 Brightness contrast, Texture

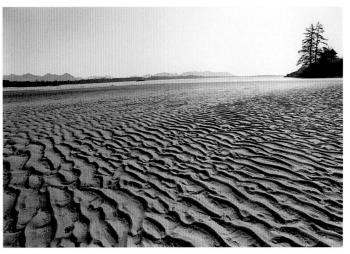

5 Horizontal lines, Textural detail

Diagrams A-F
Depending on its position within the image space, a point has any number of possible tension ratios to the edges and corners of the image. The size of the point and of the field surrounding it also influence the effect of the surface-dominating point.

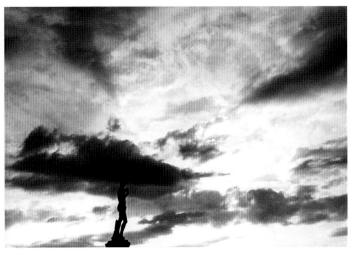

A

B

C

D

E

F

exposing a frame of film, classical photographic pictures start out as chemical reactions that register immediately on the film's entire surface. This act of exact documenting used to give the photographic picture a long recognized "conclusive force". With the advent of modern techniques allowing the manipuation of almost any aspect of the photographic image using photoediting software programs on computers, photography lost this conclusive force. The size, shape, and other aspects of a point can easily be corrected or changed within, removed from, or another point added to the image.

6 Horizontal lines, Quantity contrast, Cold–warm contrast

The position of the point on the image surface

Usually one can specify the situation of one point in the image frame as dominant and determine its direct visual effect as well as its effect within a composition. The place with the most obvious and absolute dominance for a single point is the center of the frame, the intersection of the rising and the falling diagonals. For a perfectly centered point on a square surface only two distances result in visual tensions. The distance to the four edges (the left, right, upper and lower) is shorter than the distance to the four corners. Placed with metric accuracy, a perfectly centered point carries a significant visual weight. To achieve an impression of visual balance with a centered point, the point must be shifted slightly upward. A centered spot may become an axis around which the rest of

Diagrams G–I
Not its shape, but its relative importance in the image plane determines that a spot functions visually as a point. Imaginary points result at the ends of line segments, line crossings, and at the vertices of angles.

G

H

J

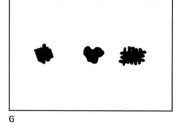

7 Monochrome color balance

8 Color accent

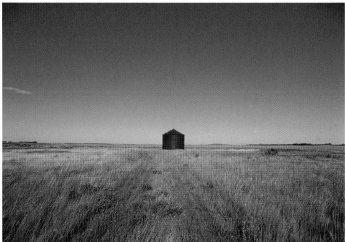

9 Horizontal lines, Textural detail

10 Contrast of shapes

11 Horizontal lines, Vertical lines

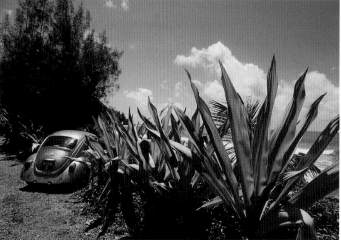

12 Quantity contrast, Cold-warm contrast, Oblique lines

the image appears to rotate. This optical effect is more pronounced with square frames, but it is also significant with vertical rectangles, which want to flip upside down. This effect is less with horizontal rectangular frames, unless there are unbalanced masses on either side of the center that appear to make one side drop and the other rise. The same applies conditionally to a point in the center of a rectangle, although here already three tension distances result. The shortest distance is from the two close picture edges (with the landscape format those are the upper and lower; with the portrait format, the left and right edges), the middle distance from the two other picture edges, and the furthest distance from the four corners (diagram A). As soon as a point is clearly shifted from this central situation, the number of tension distances from

the point to the four picture edges and the four corners increases. One point thereby loses some of its absolute dominance in favor of the distance tensions to the picture edges and the play of the visual balance of the areas surrounding the point. The harmonious quantities and divisions of the "golden section" result in ideal places on a surface for positioning design elements. Points and small visual masses at these places are in harmonious tension with the vertical and horizontal distances to the edges (diagrams B and C). Photo 9 shows a surface-dominating point in a central location. The centered horizon adds emphasis to the situation of the point. Compositions with less extreme dominance from the center are shown in photos 7, 8, 16, 17, 18, and 20.
The surface-controlling objects are usually already perceivable

as small shapes. Photos 7 and 8 show that changing the color and tonal contrast of one point can change the visual tensions in an image. Examples where the respective "points" are in, for instance, one of the four harmonious positions based on the golden section are shown in photos 2, 3, 6, 10, 11, 12, and 13.

Size and Shape of Points

Visible objects on a surface are felt as points, if they are relatively small in relation to the surrounding surface. The transition from this effect of being perceived as a point to being perceived as a "miniature surface", or "shape", is a continuum. During the process of rational recognition, if a viewer can recognize and define a somewhat larger spot as a particular type of object, one will very readily exchange the abstract design term "point" for the name of the recognized object. Because of its visual weight within a composition, this object will function in the design, however, as a point. The shape of a point can be abstract, geometrical, or of a material object. Nevertheless the surface areas of points in relation to the image space must always be "somewhat" small, in order to

19

13 Horizontal lines, Quantity contrast

14 Vertical lines, Oblique lines, Hued–hueless contrast

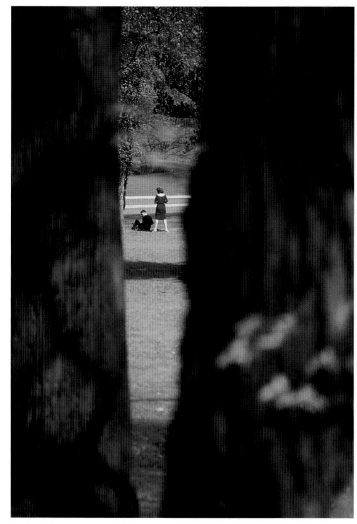

15 Quantity contrast, Vertical lines

work unambiguously as points (diagrams G, H). A viewer's interest in the primary effects of the "bright point" in photo 3, the "dark point" in photo 2, or the "red point" in photo 9 turns quickly toward recognizing the content of the points. In these cases it is easy to recognize a cat, a bird, and – not so clearly – a barn. Even if the objects in relation to the image plane have the character of a point by virtue of their small size, they are usually recognizable immediately as particular articles or symbols. So it is with the statue (photo 4), the trees (photo 5), the advertising balloon (photo 10), the doll (photo 11), the Volkswagen automobile (photo 12), or the boat (photo 13).

Distinct points, disturbing points

A point certainly has its most intensive compositional effect in black-and-white photography as a bright object on a dark background, as a dark object on a bright ground, or, in a color photograph, as a controlling or contrasting color against a colored background (diagram D). Apart from a central or harmonious position on the image plane, a point can naturally be placed anywhere within a design. Diagram E shows a schematic example of how one might experiment with pushing the boundaries of problems of visual balance or attempting to stress picture contents using compositions full of tension. However, often there are point-like objects that were overlooked during a photographic exposure and turn out to be annoying. Any trained viewer's

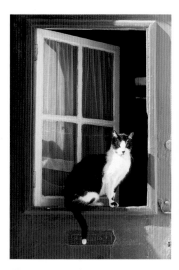

16 Vertical lines, Oblique lines, Brightness contrast

17 Quantity contrast, Visual lines

18 Horizontal lines, Oblique lines, Quantity contrast

19 Horizontal lines, Irregular lines, Brightness contrast

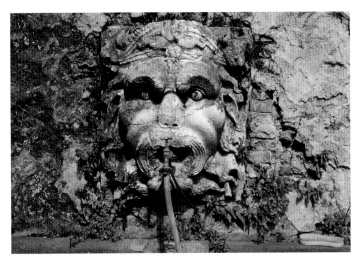

20 Quantity contrast, Irregular shapes, Textural detail

eye will invariably get stuck on these points (diagram F). Particularly bright, dark, or remarkably "loud" colored spots show up noticeably in photos 1 – 4, 6, 8, 9, 11, 12, 13, 16, 17, and 19. Even if the design of an image gives greater play to lines and shapes, an individual point can attract and hold the eye. In photo 1 the small figure stands out as a dark point on a bright surrounding area, as does the dominating violet colored Volkswagen in photo 12 against the varied green vegetation. The point at which a dominating spot changes from supporting a composition to being a disturbing element is not always unequivocal. Without doubt unretouched dust and lint are disturbing in black-and-white pictures, as is litter lying about that was not considered in the viewfinder during a black-and-white or a color exposure (photos 6, 13, 14). The pairs of

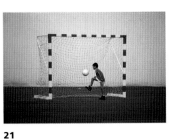

21

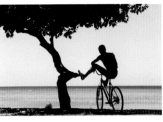

22

photos 17/21 and 19/22 show that by patience and sometimes luck, a "second shot" often can succeed in leaving out the disturbing points. There are exceptions to the rule that a point felt as too small in relation to the surface area always disturbs the viewer's eye. Here each individual's subjective feelings are decisive. Photos 9, 10, and 16 show this, but especially photo 15 with the very small red spot of the woman in a red dress standing on the grass. Similarly, it applies with visually accepting an experimental placement of points in a composition (photos 18, 20).

Imaginary points

Whenever a line meets or crosses another line, invisible, imaginary points result. An empty "normal" surface (square or rectangle) exhibits four imaginary points at its four corners. The "lines" meeting at right angles are in this case the edges delimiting the image surface. Straight lines on an image plane can form shapes, but can also form imaginary points at their visible beginnings and ends and where they touch or cross each other.
Thus numerous "invisible" points can quickly develop into a composition. Naturally the imaginary points do not have the same visual weight as material points. Nevertheless they should be treated as one of the numerous subtle design elements available to anyone consciously making images in any medium (diagram I).

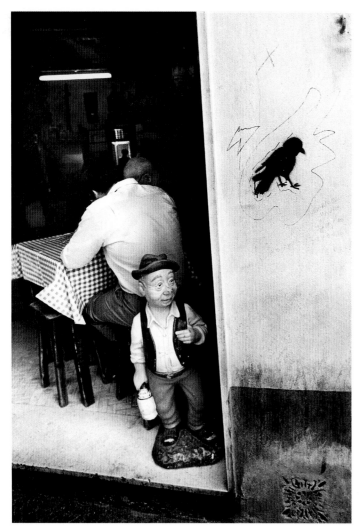

1 Brightness contrast, Vertical lines

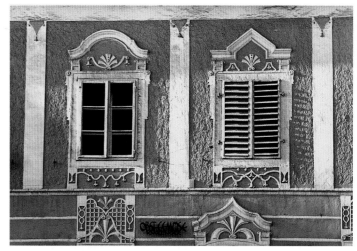

2 Vertical lines, Horizontal lines

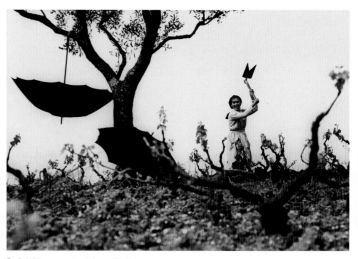

3 Brightness contrast, Irregular lines

Two and Three Points

An individual point has an absolute visual weight in a picture. It dominates the composition and thus the image plane. As soon as a second point is added, this absolute visual weight transforms into a relative weighting – each successive point on the surface is in optical competition with all the other points. At the same time the presence of a second or, to an even greater extent, a third point, especially if equal in size and shape, creates a repetition and thus the beginning of a simple visual rhythm.

Design Qualities

Usually there are several artistic contrasts and design elements which determine the formal and color qualities of a picture. To analyze an image, a viewer must possess a strong artistic knowledge to recognize these individual elements and be able to estimate their effects both within a composition and on the picture content. The artist or photographer naturally can be economical or sparing in designing an image, choosing to use only a few elements. Compositions based on a few points are not easier or simpler, but present rather a challenge. Too much variety throughout the image diverts or confuses the viewer. With an economical composition, however, the situation of each individual point, each tension distance from other points, from the edges, and to the corners can be seen

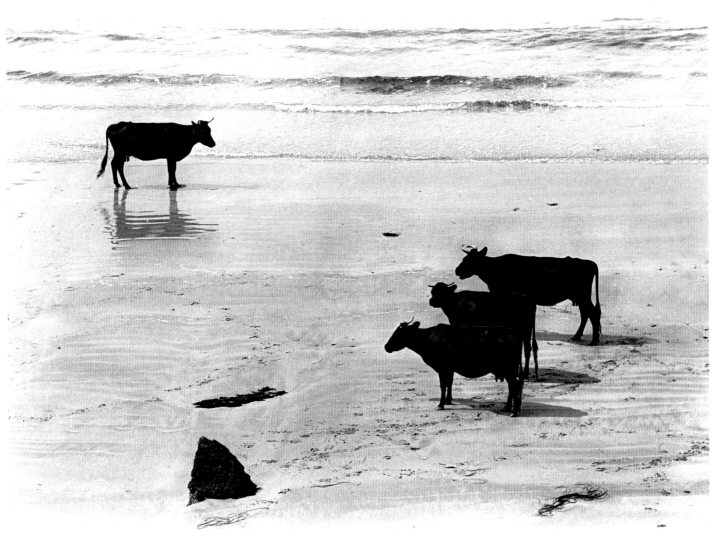

4 Brightness contrast, Quantity contrast

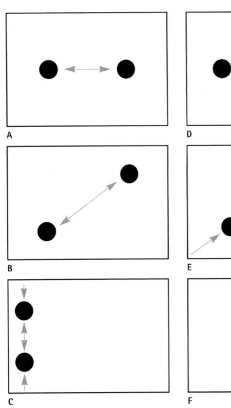

A

B

C

D

E

F

Diagrams A-F
Two equivalent points on a surface
often result in a visual competition.
Three points in a row form the begin-
ning of a visual line. Different situa-
tions of the points on the image plane
result in each case in different visual
effects.

and estimated in every detail. A design too sparing of visual offerings is a compositional technique that can rapidly lose its pictorial charm. On the other hand such a design strategy has a high recognition value in, for instance, the advertising industry for generating brand recognition, and can well be used as the fundamental concept for a series. Thus can arise a series of advertisments, whose conceptional grabber is the same economical design arising in each picture. Compositions with a single point, two competitive points, or three points forming a visual line or a visual triangle belong to the possibilities derived from the concept of economy of design.

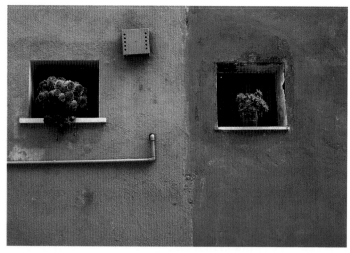

5 Vertical lines, Horizontal lines

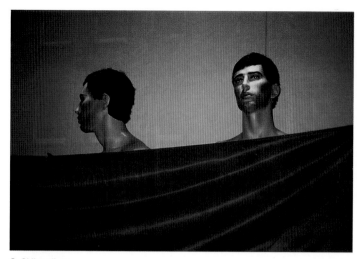

6 Oblique lines

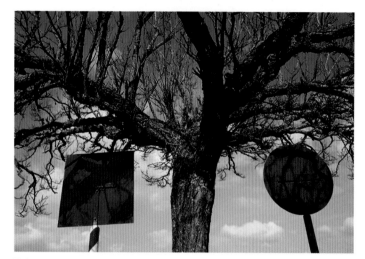

7 Contrast of shapes, Irregular lines, Cold–warm contrast

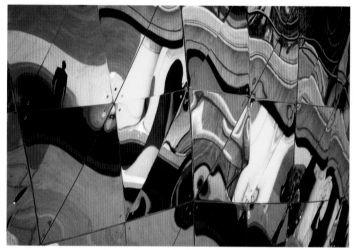

8 Oblique lines, Hued–hueless contrast

Two Points in the Frame

A viewer's eye immediately fixes the distances from a single point on an otherwise empty image surface to the edges and corners in order to estimate the tension ratios acting on the point. The presence of a second point induces a visual rivalry, and the tensions between these two points step into the forefront of the viewer's perception. Of course the positions of the points on the surface are also noticed, as are the possible tensions to the edges and corners. Usually these tensions remain secondary, because a clear visual competition develops between the two points. One's eye wanders restlessly back and forth from one to the other with an almost unexpressed "instruction" to look for differences and decide in favor of one of the points. If one wants to stress this competition as part of the

design, one should place the two points on a horizontal center line and not too close to each other (diagram A). The eye quickly perceives points placed quite high or low in the frame as developing a tension with the nearby edge. If two points are placed very close to a horizontal or vertical edge so as to form an implied line, the points can have a visual effect of "sticking" to the edge and can become irritating, disturbing objects (diagram C).
Two points positioned on one of the imaginary diagonals develop clear visual tensions with the respective corners (diagram B). With the rising diagonal this is the lower left and the upper right corners, and with the falling diagonal the upper right and lower left corners. Photos 1, 2, and 5-10 show examples where the compositional emphasis is on two more or less competitive points. The two

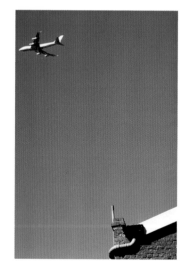

9 Cool color balance

small windows with plants (photo 5) and the two heads of the dolls in the shop window (photo 6) are nearly identical points (objects). The few additional compositional elements hardly divert from the primary visual impact of the points placed horizontally next to each other. The degree of this effect will be smaller, if the two points are different in structure, shape, or color. An attentive viewer can find subjects to be more charming because of these often small differences. In photo 2 the windows are equal in size but have several differences. With photo 7 the shapes and colors of the two points are different. The "tractor" and "man" in photo 10 are two different objects that act as visual points in competition with each other. The points in photos 1, 8, 9, and 11 have a dynamic visual effect (diagonal or oblique implicit visual lines). The competition for

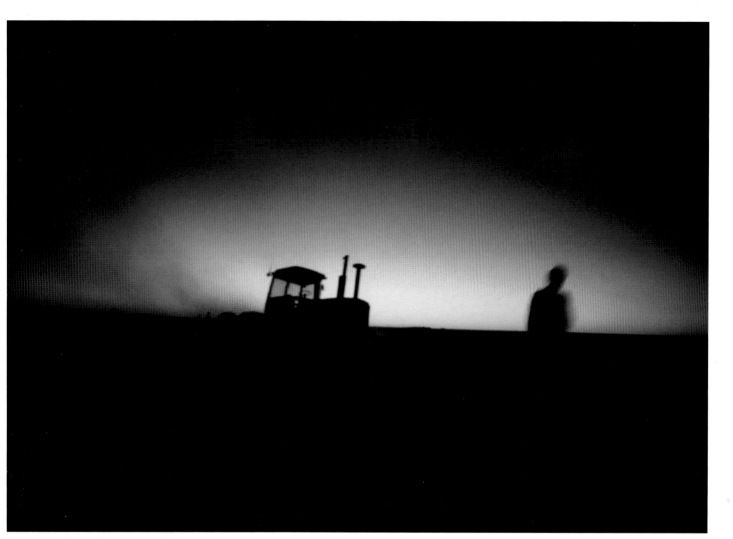

10 Horizontal lines, Brightness contrast, Quantity contrast

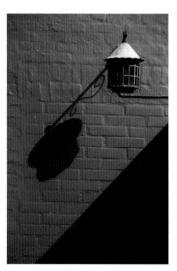

11 Oblique lines, Texture

visual supremacy is between the advertising mannequin and graffiti bird in photo 1, the two abstract yellow surfaces in photo 8, the airplane and the roof in photo 9, and a lamp and its own shadow in photo 11.

The situation of three points on a surface

Two points in an image plane can be sufficient to imply a visual subdivision of this surface into two smaller surfaces. So, for example, two points placed as in diagram A divide the frame into an upper and a lower half, or, placed along a diagonal as in diagram B, divide it into two triangles. This effect of dividing surfaces becomes even more clear when three points determine a visual line. Three points on an imaginary straight line are the beginning of a so-called "optical, visual, or implied line",

the three terms being used interchangeably. A third point placed between two points has its most natural, neutral situation at the midpoint (diagram D). Slight shifts do not change a viewer's tendency to perceive a visual line. If the middle point is shifted, however, close to either end point, the effect of a visual line disappears, and the problem of a visual equilibrium develops. A visual line can run horizontally, perpendicularly, diagonally, or obliquely depending upon how the points are placed in the frame (diagrams D and E). If one of the end points is positioned close to a picture edge or corner, then the line will establish a visual connection with and appear to extend to the edge or corner. Placing all three points too close to a picture edge also causes the eye to connect the individual points with the edge (diagram F). Besides the visual line, the eye's tendency to connect the points

to the edge causes a visual vibration that can be disconcerting. Points too close to an edge also are more likely to bother the eye as disturbing spots.). Three points not on a line can form the most basic visual shape – a "visual triangle". Visual shapes develop as the viewer's eye progressively makes connections between each successive pair of at least three spots. The "triangle" shape can point in a certain direction, and even suggest movement in this direction. A visual triangle has this characteristic in weakened form, compared to one clearly defined by material lines. This direction reference, this implied movement, is clearest if one of the three sides of the triangle runs parallel to one of the picture edges (diagrams G, H). This tendency to induce one's eye to move in a direction is reduced, if none of the sides of the triangle run parallel to the

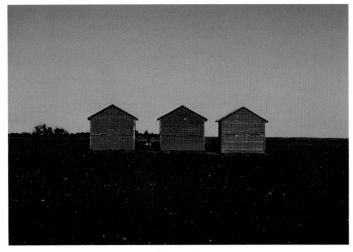

12 Horizontal lines, Cold–warm contrast

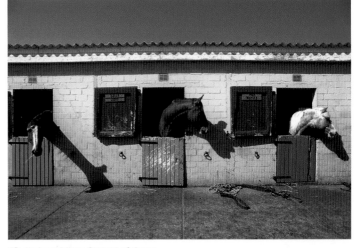

13 Horizontal lines, Contrast of shapes

14 Vertical lines, Brightness contrast

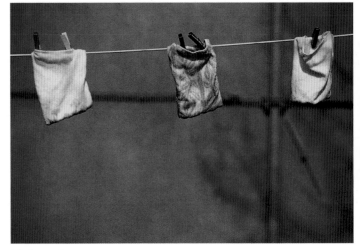

15 Oblique lines

16 Vertical lines, Circles

picture edges: such a triangle often appears to "float" in the image plane (diagram I). Triangles with one vertex forming a very sharp angle compared to the other two can cause the eye to move in the direction indicated by the sharp angle even if no side is parallel to a picture edge.

The three points in the photos 12-15 and 20 form visual lines. The three red huts are close to each other and form a short broad line in the center of the image plane. The short visual line does not have an optical connection to the edge, although one could argue that the horizon line functions to extend the visual line to both edges. On the other hand, with the horses and stables in photo 13, and the three face-cloths in photo 15, the end "points" are so close to the edges that the implied line runs from the left edge through to the right edge. Also the rising

Diagrams G-I
Whether a visual triangle suggests a movement on the image surface depends primarily on whether one of the sides is parallel to one of the picture edges. When no side is parallel to an edge, none of the vertices is likely to induce a strong sense of visual movement. This may result in a satisfying and balanced effect. The exception to this guideline is the case of an isosceles triangle with a very acute (sharp) vertex, which the eye may see as an arrow.

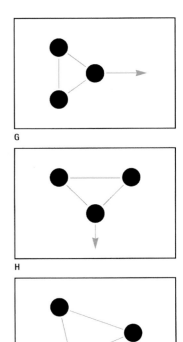

G

H

I

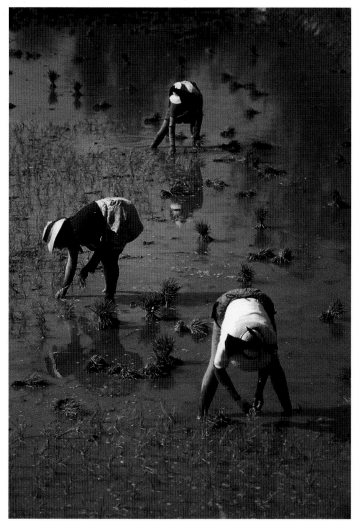

17 Textural detail

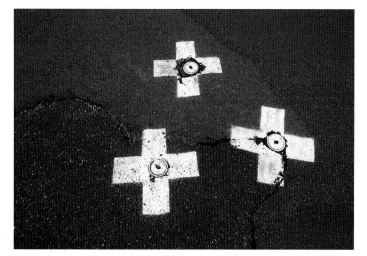

18 Brightness contrast, Irregular line

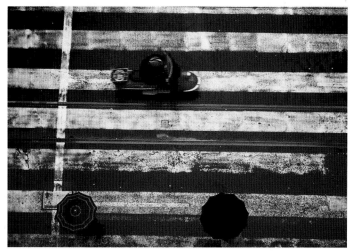

19 Horizontal lines, Vertical lines

20 Textural detail

diagonal in photo 20 runs visually from the lower left corner through the three women to the right upper corner. The yellow middle point in photo 14 has somewhat more visual weight than the points on the left and right. Thus a viewer will perceive a slightly bent visual line or, perhaps, the suggestion of a visual triangle. Completely obvious implied triangles are present in photos 3, 4, and 16-19. Besides, the three women bent at the waist in photo 17 and the white crosses on the street in photo 18 are points with almost identical visual properties. Different objects such as the two umbrellas and the woman chopping or the two umbrellas and a motor scooter form visual triangles in photos 3 and 19. The strong tonal contrast in photo 4 causes the visual triangle to stand out particularly clearly from the neutral image surface. The dark points on bright background

clearly mark the vertices of the visual triangle despite the differences in the shapes and sizes of the single cow, the three cows, and the rock.

Spot Size and Shapes

On a surface, competing points of the same size and same shape have the least tension among them. The simple artistic technique of using points that deviate somewhat from each other in size or shape makes the image more interesting and injects a variety of visual tensions. A sensitive viewer will react to these small deviations and differences of the points. The visual line or triangle formed by three points is naturally clearest in the case of three identical points equidistant from each other. But even if the points deviate significantly from each other in size, shape, or distance apart, or from edges and corners, the primary formative effect of an implied line or implied triangle nearly always remains.

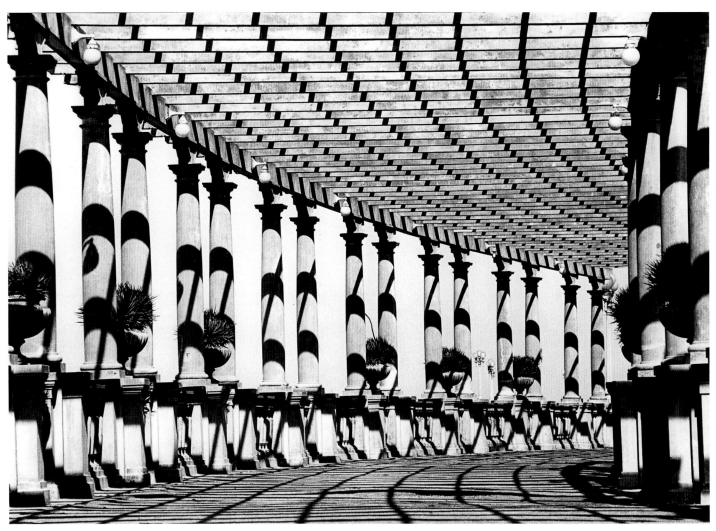

1 Vertical lines, Horizontal lines

Visual Lines and Visual Shapes

Three, four, or more points on an image surface contain the means of creating a repetition of elements and intervals. This repetition of points in a row forming a visual line is the beginning of a rhythm. Simple rhythmic repetition is again the beginning of a simple harmony in all artistic disciplines.

Using the eye's strong tendency to follow a succession of points forming a line or visual shapes, one can use the principle of simplicity to build a design structure.

Shapes Implied by Points

The point is the simplest design element and has no tendency for visual expansion. One point alone on a surface has no tendency toward any visual movement. Points which are too close to a picture edge or a picture corner are exceptions. Here an apparent movement of a point forming a visual connection to a picture edge or corner can develop. A second point disrupts the static character of the single point with a visual competition. While adding more points increases the effect of visual movement, the distances between points and their similarities or differences modulate the overall effect.

A viewer's eye flows easily along a row of equally spaced points. Unequal spacing between points or arrays of points can cause the eye to "get stuck" – tripping, so to speak, over the unequal

2 Vertical lines, Horizontal lines

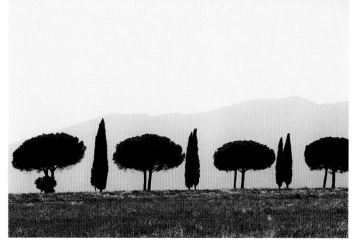

3 Brightness contrast, Contrast of shapes

4 Brightness contrast, Detail

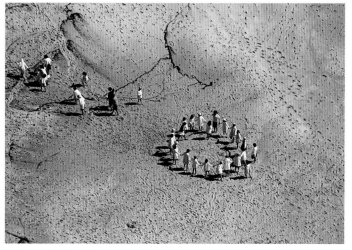

5 Central point, Detail

A

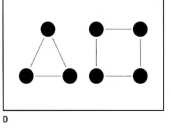

D

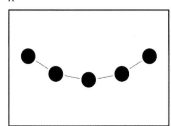

B

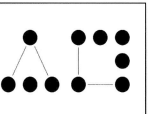

E

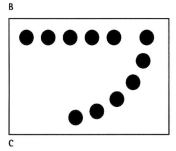

C

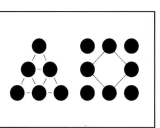

F

Diagrams A-F
The more closely a number of points in a straight or curved sequence lie next to each other, the more clear becomes the effect of an implied line. Salient forms such as a triangle and a square can form, visually, starting from three or four points.

rhythmic intervals. Points differing from each other in shape and size can likewise disturb the harmonious flow of the eye along an implied line. This quality of visual rhythms allows the artist to accelerate or to slow down the rate at which the eye moves along a series of points.

Visual Lines

For the eye to perceive a visual line, three points are sufficient (two points are necessary). The most direct connection between the first and third points is a straight line. A second point should be as exactly as possible on this apparent line at the midpoint. A small deviation from this straight line the eye can still "see" easily as a bent line, while a larger deviation (already described) leads to the first basic visual shape, a triangle.

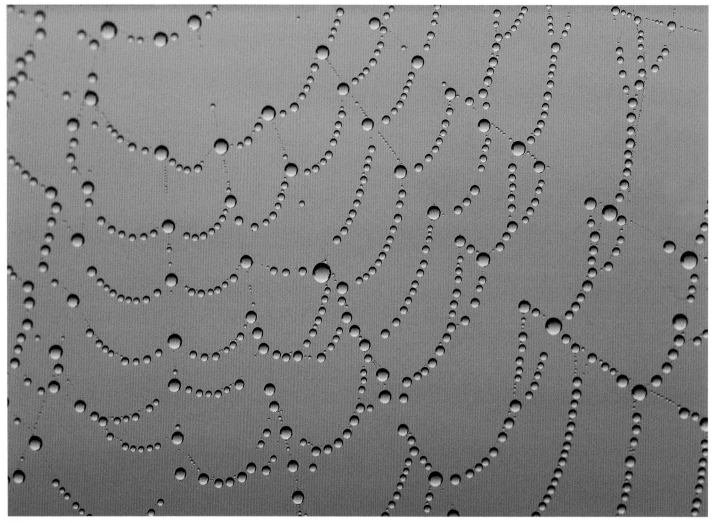

6 Hueless color balance

Larger quantities of points can intensify the visual impression of straight or curved lines depending upon their arrangement or situation on the image plane. So long as the points are arranged in a manner that a visual connection can develop in each case to the previous point and the following point, a viewer's eye will experience the effect of "line". This effect of line naturally increases with a higher number of points and a reduced distance between the points (diagrams A, B, C). Uniform shape and/or color of and distance between the subject's components possessing a point character along with a neutral background promote the viewer's perception of a "visual line" (photos 4, 6, 8, 10, 12, 16). In addition, linking the points to the ground with lines such as the light posts in photo 2 and the tree trunks in photo 3, or the colors of the cabanas being

7 Diagonal lines

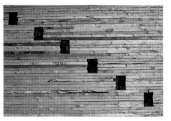

8 Diagonal lines, Detail

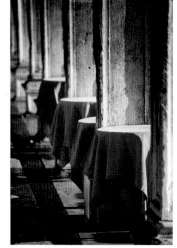

9 Vertical lines, Warm color balance

different from each other in photo 10, or the blooms differently colored from the tiles in photo 13, does not negate the effect of visual lines. Lining up letters to form words is such an automatic process that we do not think consciously about it. Different forms, dimensions, and distances of letters form rows which are seen not as lines, but as symbols with meaning. Only a free standing row of letters viewed from a distance is strongly felt as a line (photo 7). Curved visual lines are particularly well developed in photos 1, 6, and 12. While the dewdrops in the spider web in photo 6 and the blossoms on the tiles in photo 13 have little or no visual competition, the visual effect of the colonnade in photo 1 originates in the numerous lines formed by adjacent and alternating points and shapes of light and shadow.

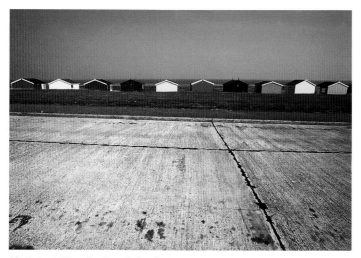

10 Horizontal lines, Dominant (colored) point

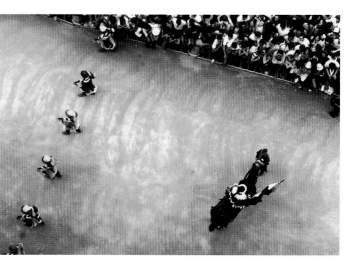

11 Cold–warm contrast

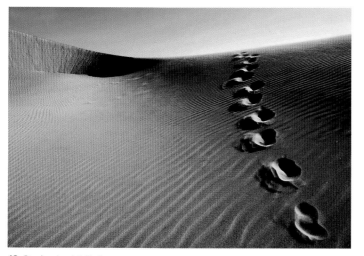

12 Dominant point, Texture

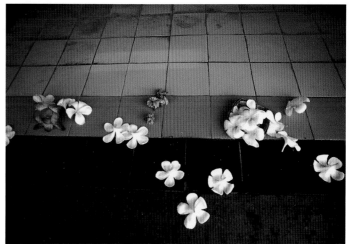

13 Brightness contrast, Quantity contrast

The Principle of Simplicity

The eye links points according to the principle of simplicity; that is, from point to point the eye always looks for the shortest connection – and the shortest connection between two points is a straight line. Therefore, the eye "fills in" the implied lines or, when several points are not on a straight line, perceives the simplest possible visual shape.

One's eye also tends to bind points in the vicinity of an edge to that edge by the shortest implied path. Three points become, by way of two simple straight lines, a visual line, while three freely distributed points connected to each other by three implied lines form a visual triangle. Adding further points creates favorable situations for other visual shapes to develop on the image surface. Four

points can determine a square or a rectangle (diagram D); five or six points correctly arranged can become a pentagon or a hexagon. With a still larger number of points, the eye may perceive irregular shapes or, if the situation of the points is favorable, a circle or an oval (diagram J). Two, three, or more points forming implied lines and shapes can naturally occupy any position in the image plane. The eye will not easily connect two points with something other than a straight line without the direct visual guidance of a real line or more points (diagrams K, L, M).

Situation and Effect on the Surface

Visual shapes develop most clearly from the minimum number of points of the same size and same distance apart. If other points are positioned between these minimum points on one or several of the implied straight lines, creating thusly shorter distances between points, it can be more difficult to perceive the shapes. A visual line acquires greater visual weight with more points lying close together, but the eye does not easily perceive a complete shape if too many in-between points are removed (diagram E). The fact that adding more points also violates the principle of simplicity in perceiving shapes and effects is shown in diagram F. Inside the large visual triangle, smaller triangles develop at the three vertices of the large shape. Within the

31

14 Brightness contrast

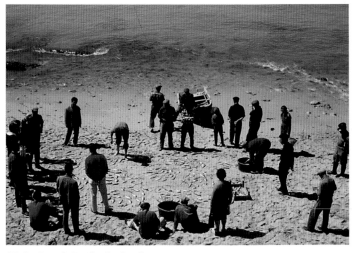

15 Dominant (colored) point, Detail

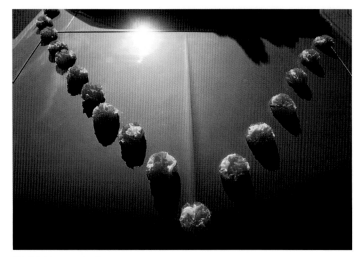

16 Brightness contrast

17 Brightness contrast

large square, one's eye will quite readily perceive an additional square standing on a corner. The examples shown in these diagrams, with the "implied lines" drawn in, can only suggest these optical effects. One can invent one's own visual exercises with points in image spaces using a pair of L-shaped boards to create a frame and a handful of points (small coins, buttons, or the like).

Diagrams G-L
Also visual lines have the property of dividing surfaces or shapes thereby, creating new, visual surfaces or shapes. Although there is no theoretical reason that implied (visual) lines running between two points have to be imagined as straight, a viewer's eye will always select the most simple, the straight path between the points.

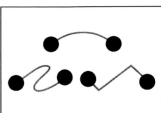

G

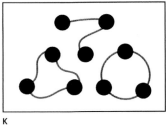

J

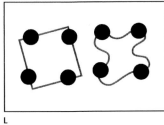

H

K

I

L

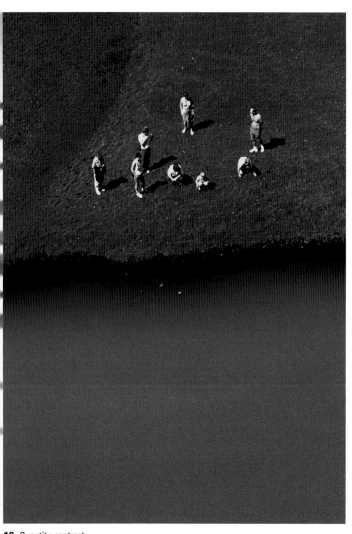

19 Dominant point, Texture

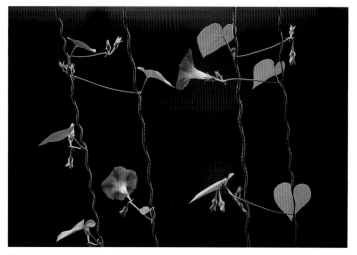

18 Quantity contrast

20 Two points, Brightness contrast, Vertical lines

Surface Division and Surface Formation

Visual lines, as do material lines, have the characteristic of dividing surfaces or shapes and forming new, smaller shapes. It is to a certain extent a double strength, because the act of dividing a shape automatically includes the act of forming new shapes. For example, if a surface is halved by a line, two new surfaces develop, each with half the area of the original. Straight visual lines running perpendicularly, horizontally, diagonally, or obliquely from one picture edge to another break the overall image surface into smaller areas or shapes (diagrams G, H). A visual line which begins in an image plane such that in its progress it affects only one picture edge and returns to the starting point, forms a shape within the image surface (diagram J). While oblique lines

have the assertive effect of optically cutting off parts or corners from an image plane (photos 2, 11, 12, 16), a horizontal line in the landscape format usually only suggests a surface division (photos 3, 10, 19). Photos 7, 8, and 9 show a clear division of the images by visual lines into two large triangles. Examples in which a larger number of points form relatively clear shapes (circle, oval, triangle, rectangle) as a "shape within a shape" are shown in photos 5 and 15-19. Numerous regular and irregular shapes can be seen in photo 13 in the flower blossoms and in the grid of the straight lines formed by the edges of the tiles, including to an extent the edges of the image frame. In photo 16 the two lines of pom-poms form visual triangles with the edges of the picture. Differently colored points can divert one's eye from the prevailing effect.

With the picture of the fishermen on the beach (photo 15), a rising visual diagonal cutting across and dominating the oval is formed by the three colored shirts – blue, red, and orange – functioning as visual points. One barely succeeds in seeing the visual back-and-forth between the two violet morning glory blossoms in photo 20 with the competing plethora of irregular shapes in the surrounding green leaves and the four plant stems running up the trellis wires.

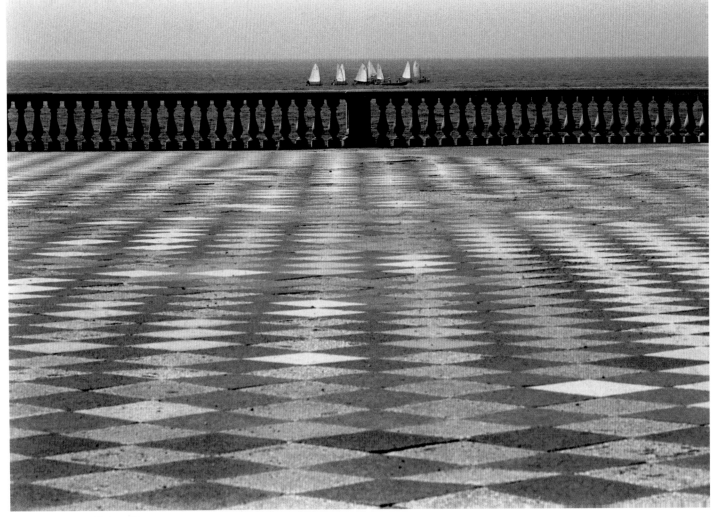

1 Brightness contrast, Horizontal lines

Clusters of Points, Detail and Pattern

Each person's process of perceiving begins with the fact that certain special and outstanding structures and shapes are learned at an early age. Thus, once the structure and shape characteristics of geometrical forms – triangle, circle, square, for instance – are learned and stored in memory, one will always recognize those shapes until quite late in life. This is also the case if these deviate in their size, tone, color, or their position in the image field from the first such shape one learned.

2 Brightness contrast, Oblique lines

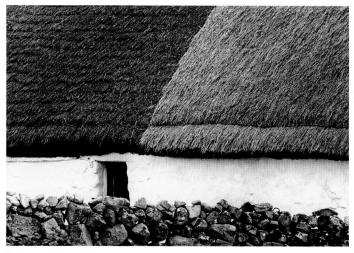

3 Horizontal lines, Oblique lines

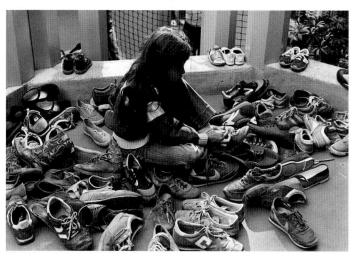

4 Dominant point, Oblique lines

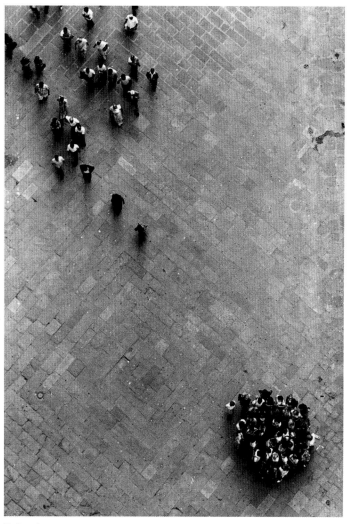

5 Quantity contrast

Similarity and Difference

In perceiving an image, we are programmed mentally to manufacture connections and organizations between similar things and simultaneously to recognize differences. Diagram A shows shapes, all of which are easily identifiable as squares, and thus in their fundamental form are similar. Also the tonality is identical for all the squares: each square is black and sits on a bright background. There are differences in the size and space orientation of the squares. The size difference results in a visual organization into two groups: three large squares and nine small squares, which stand out clearly from each other. With one exception all squares are aligned perpendicularly – horizontally. The eye immediately perceives that one small square with the completely

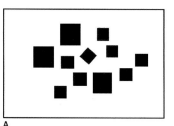

A

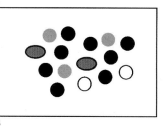

B

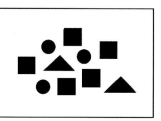

C

Diagrams A-C
In viewing a picture, one looks comparatively as much for similarities as for differences between shapes, tonal values, and sizes.

different orientation. Diagram B shows differences and groupings based on other visual characteristics. Circles compare to ovals, the latter having unequal long and short axes, as squares are to rectangles. Although circles and ovals do not have corners and only consist of curved lines, squares and rectangles have four right-angled corners. In both cases, however, the difference in shapes is large enough to be separable in mixed groups into two subgroups. In diagram B there is the tonal difference between black, grey, and white surfaces in addition to the grouping of circles and ovals. In diagram C there are groups comprised of different shapes: two triangles, three circles, and five squares. The connection among all the different shapes is their compact grouping and having the same tonal value (black).

6 Brightness contrast, Contrast of shapes, Contrast of hue

Loose and Tight Groups of Points

A large number of points (very small shapes, which have a point character in relation to the surface area) amassed near each other or together can form larger visual points, often with the effect of being textured surfaces. In a loose accumulation of points, each point stands individually in a surrounding field, and visual relations with nearby points develop. Short visual lines and/or small visual shapes form. Bunching the points, however, so closely that they touch each other visually or materially, changes a loose accumulation of points into a larger point – often with the character of a small textured surface. Photo 5 of tourists in Florence shows in an exemplary fashion the development of a tightly compressed structure from a loose cluster of points.

While in the upper part of the picture, the irregularly scattered people function as separate visual points, in the lower right corner the tight grouping functions both as a large point and as a rather small, textured shape. Diagram D shows the transition from a loose dispersion of points to an unordered compressed bunch of individual points, to a tight clump where the points lose some of their individuality by overlapping or touching adjacent points. Further examples of clumps of points are to be seen in photos 1, 4, 6, and 14. Points can also be arranged, of course, in strictly ordered groups. Diagram I shows the transition from points aligned in regular horizontal and vertical ranks to a mass of points in militarily precise rows and columns. The austere, symmetrical order of such arrangements generates feelings of rest and uniformity. A loose,

7 Monochrome color balance

asymmetrical arrangement of points is alive and rich in visual tensions in comparison.
Where both loose and ordered arrangements of point elements fill much of or the entire image space, as in diagram E and photo 9, the image structure is defined by the these arrangements and by the division of space imposed by the edges between the ordered and unordered parts. Photos 11 and 16 are examples of points arranged in relatively strict order. The severity of the arrangements is mitigated in photo 16 by the light and dark lines in the structure of the leaf and in photo 11 by the differences in the hubcaps and the red and green colored stripe of corrugated tin sheeting. Photos 2, 9, and 14 show the contrast between unordered compressed masses of points in part of the images and tightly ordered arrangements in other areas. Just as with points, bundles of loose, unordered lines

8 Brightness contrast, Warm color balance

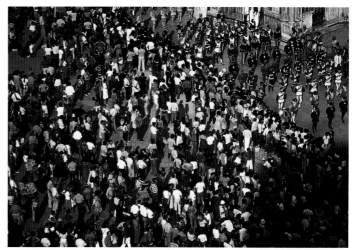

9 Brightness contrast, Oblique lines, Visual lines

10 Brightness contrast, Visual lines, Hued–hueless contrast

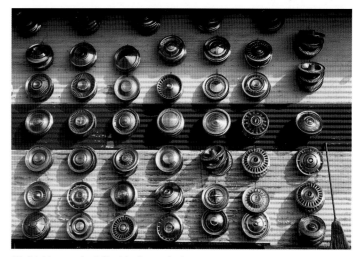

11 Brightness contrast, Hued–hueless contrast

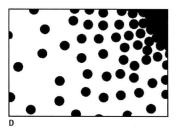

D

E

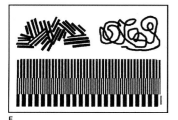

F

Diagrams D-F
The contrast between regular and disordered structures of points and lines is a well known means of artistic organization.

and tightly arranged groups of lines can also form shapes and surfaces (diagram F). Photos 12 and 15 show that close, evenly spaced lines can impose a rigorous visual structure on part of or the entire image. Less austere structures formed by lines are illustrated in photos 3, 7, and 8.

Repetition and Rhythm

The rhythm resulting from a repeating visual element can be calm and motionless or dynamic with visual movement.
The simplest structure that yields a visual rhythm is the "one-plus-one-plus-one" pattern, a simple repetition of elements of the same size and always the same distance from each other (diagram G). Such an even rhythm based on points is to be seen in photo 11 (wheel covers), and based on lines in both

photo1 in the parapet wall and in the construction of the glass roof in photo 12. Already a change to "two plus two plus two" increases the visual tension of a row of points. The visual tension in these simple arrangements can be made quite dynamic if only some distances are shifted, for instance, were one to generate a "one plus two – plus one plus two" pattern (diagram H). Arrays of point elements will have more visual tension, dynamism, and movement where the shapes, sizes, colors, or tonal values vary among the elements. A moderately steady rhythm originating from a repetition of elements with the same or similar characteristics can contradict an implied movement (Diagram I).

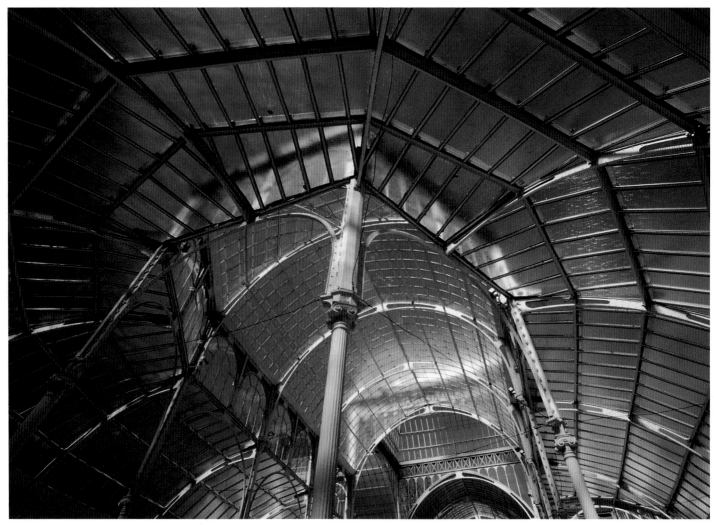

12 Oblique lines, Cool color balance

Raster and Pattern

A raster is usually a very fine-grained and always strict order principle on a surface. As a special category of pattern, it is not generally a design element – unless it is used as an artistic means to evenly mark a surface. Grids serve as an element for the specific subdivision and resolution of a surface and are mostly based on systems of consistent measurements. So long as the viewer can recognize each individual element despite the variety of small shapes, the effect of a pattern develops. The borders between raster, grid, and pattern are flowing, are felt subjectively, and probably also depend on the viewing distance. Very small, very many, and above all very evenly arranged elements result in the impression of a "raster". The priority of patterns develops as a visual effect from an accumulation of

small materials or from a multiplicity of small objects. Large numbers of similar objects seen from a distance or from a high viewpoint also have the effect of patterns (photos 9, 10). By plays of light and shadow, overlays of lattices and fences, or transparent structured materials such as glass and textiles, and so on, subjects can be covered by a pattern or a raster. Photos 1, 13, 14, 16, 17, and 18 show very finely divided elements, which either cover parts of the picture, fill out the entire image plane, or which completely overlay a subject. The black-and-white squares with the buckets of plaster behind the shop window, the bright spots on the leaf, and the shadow over the table and chairs still work as patterns, since the individual points, squares, and lozenge shapes are clearly visible. Photo 18 is different from the others cited

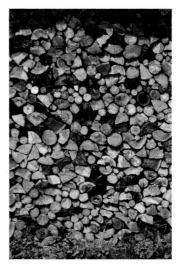

13 Warm color balance

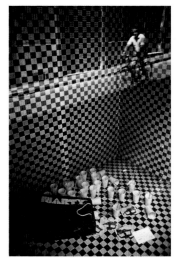

14 Dominant point, Oblique lines

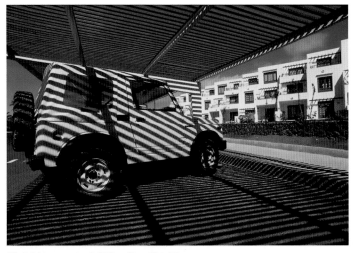

15 Brightness contrast, Oblique lines, Visual lines

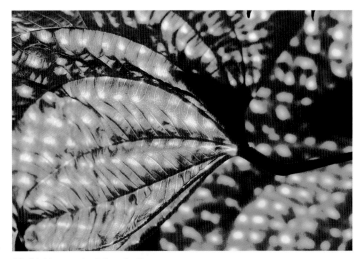

16 Brightness contrast, Irregular lines

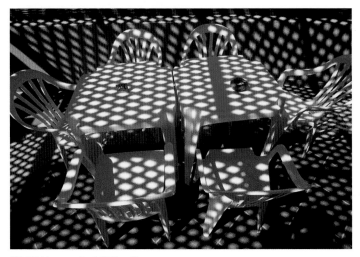

17 Brightness contrast, Oblique lines

18 Dominant point, Horizontal lines, Vertical lines

G

H

I

Diagrams G-I
Evenly lining up several design elements results in a repetition. Look for repeating contrasts to form a rhythm.

above in that the mesh of the net overlaying the subject is so fine as to have the effect of a raster.

Detail and Texture

Subjects which frequently have detail and texture can be divided roughly into the fields of nature and culture. Natural objects, such as plants, sand, stones, water, etc., very often have detail of varying complexity and texture of varying degrees of roughness, softness, smoothness, or other quality. Large groups of animals or humans seen from a suitable distance tend to form visual masses showing detail, or if closely packed, appear as shapes defined by texture (photo 9). Each field contains in turn numerous topics that show detail and texture. For example, the field "plants" encompasses

seeds, fruits, leaves, bark, blooms, grasses – and these are only some topics that could be enumerated. Also the field of "culture" has various large fields, which subdivide themselves for their part again into topics. Thus the field "architecture" is divided into the topics of houses, roofs, walls, fronts, and so on. If one takes many photographs of a particular topic, one quickly becomes aware of the need for further categorizations. Roofs can, for example, be made of straw, wood, brick, slate, or other materials.

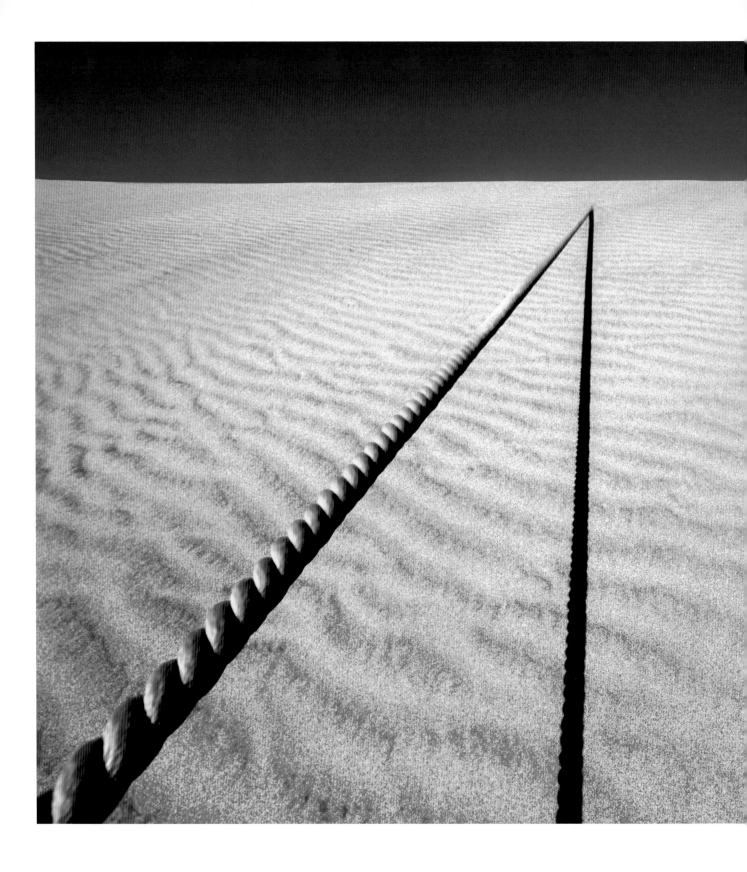

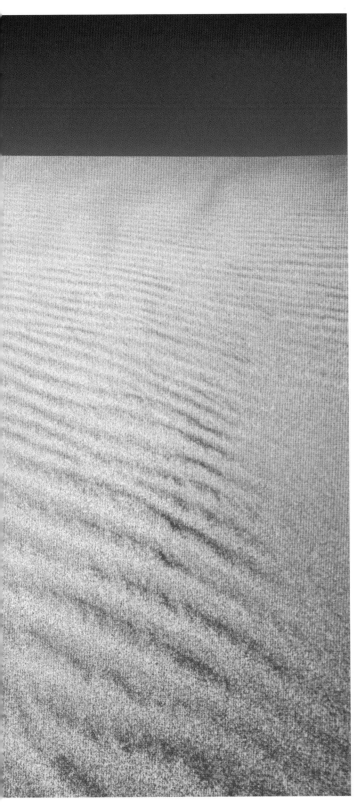

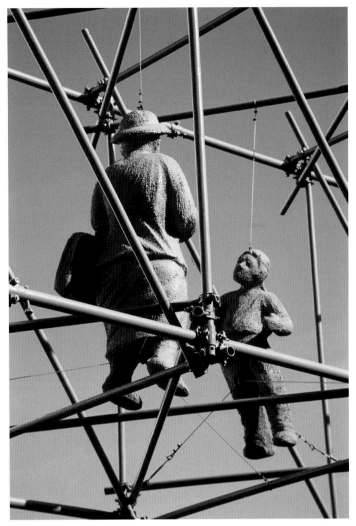

The Line

Lines are an active means of organizing an image. If one follows the progress of a line in a composition with the eye, one clearly feels a movement within and often beyond the edges of the image plane. Another aspect of a line is particularly interesting: the same line that divides a surface or shape also forms the boundaries of the smaller surfaces or shapes resulting from that division.

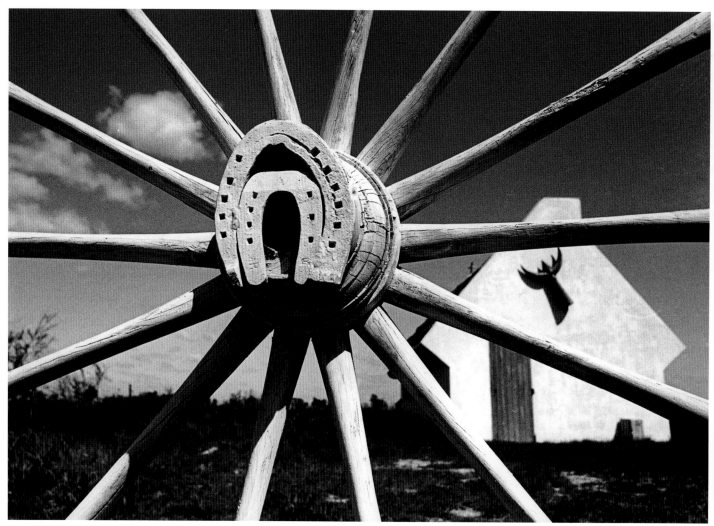

1 Brightness contrast, Two points, Horizontal lines

Emergence of and Forces Acting on a Line

A point by itself is quiescent, having no tendency toward visual movement. An apparent movement can result toward other design elements from optical tensions with other points or with the border of the image. This complete stability is negated if the point is moved and produces a line. With its dynamic tendency to move the eye, a line is the strongest contrast to the static point.

The Emergence of a Line

The fundamental design element, the point, is produced by some form of directed energy. In photography this is either a source of light, a beam of light, or the reflection of light from a small bright surface. This directed energy leaves traces (points) on the film material. Now if the light spot or the camera moves during a long exposure time, multiple images of the moving light point will result in a line (diagram A). Time exposures of driving cars, races, and so on in the dawn or darkness are well-known subjects, which show the phenomenon of the emergence of lines in photographic imagery (photo 8). Since in each case the eye naturally sees the points themselves in motion and not the "lines", the photographic result can contain surprises.

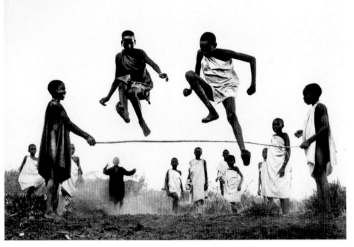

2 Brightness contrast, Visual shapes

3 Brightness contrast, Point, Textural detail

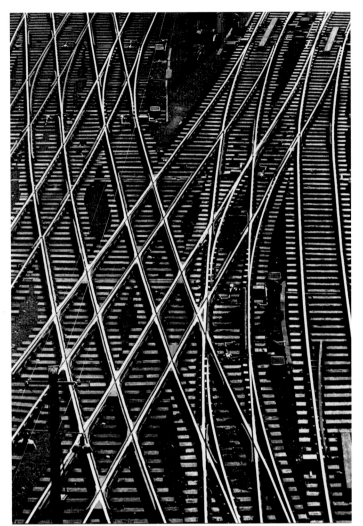

4 Brightness contrast, Textural detail

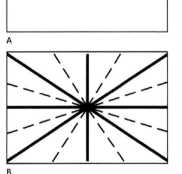

A

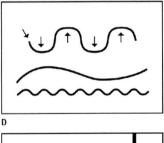

B

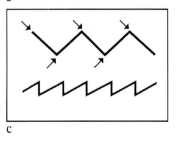

C

D

E

F

Diagrams A-F
Lines are traces of moving points. The horizontal, the vertical and the diagonal are the most important straight lines. Changes of direction in the line's progression can result in a gentle, active, or even aggressive line character. In addition to its primary effect of causing the eye to move, the line has two additional effects in an image of simultaneously dividing a surface and thereby creating smaller surfaces.

Satisfying results presuppose experience with this first experimental handling of the photographic medium, because the exposure times must neither be too long nor too brief. Film registers light energy all over the image and is not limited just to that originating from the lines. If a source of light or a reflection is already, for example, a line, moving the camera in a linear fashion perpendicular to this line develops a lighted surface. The blue surfaces in photo 9 originated from a steady movement of the camera to the left. Artists using other media can create, control, and correct lines directly in front of the artist's eye. For example, a drawing can be worked with pencils, charcoal, or pens, and a painting canvas with brushes, spatulas, and so on. This visible developing process is not available to users of the photographic medium, and a correction within the

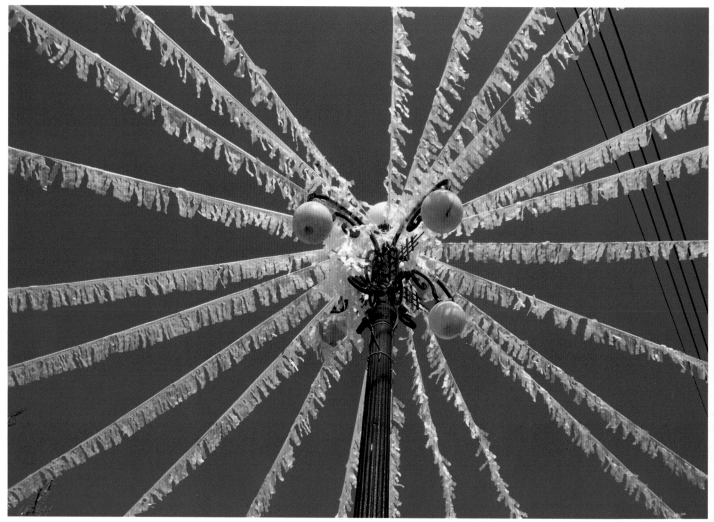

5 Visual shapes, Vertical lines

image was achievable for a long time only by repeating the entire photographic procedure. Today one can decide whether another exposure is prudent or whether a correction with a computer and photo editing software might be faster and cheaper to achieve the goal. If the design elements point, line, and shape are already clearly visible in the subject, then the photographer can naturally use the possibilities of the medium to compose an image. The means for this are the choice of the focal length, point of view, and exposure time.

6 Vertical lines, Cold-warm contrast

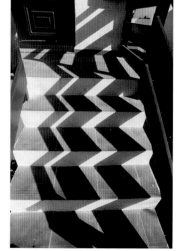

7 Horizontal lines, Brightness contrast

The Straight Line

The most basic line originates from a steady force acting to move a point in a single direction. The line runs infinitely if the force does not cease. The straight line is, therefore, the most constrained type of infinite movement. Because an image plane is a finite surface, a line can encourage one's eye to move only as far as the picture edge, and outside of the image only in an imaginary sense (diagram A). One differentiates with straight lines between three typical basic kinds: horizontals, verticals, and diagonals. Oblique straight lines (always with respect to the image surface) are deviations from these basic kinds of the straight lines. A representation of the typical basic kinds and some deviations of the straight line are shown in diagram B. The arrangement of the spokes of the wagon wheel,

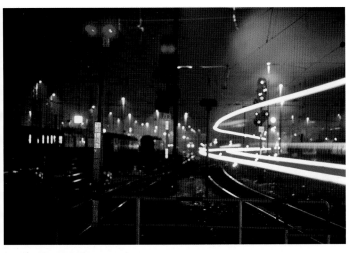

8 Visual lines, Brightness contrast

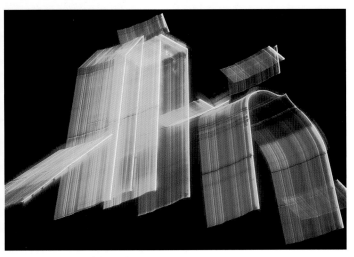

9 Brightness contrast, Color purity

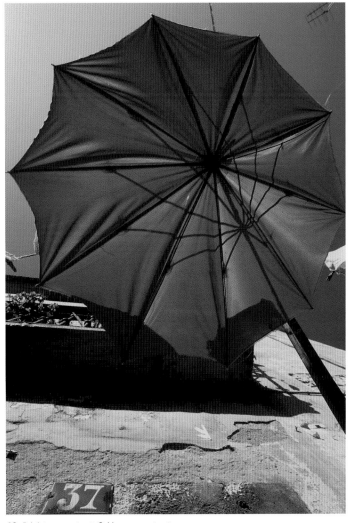

10 Brightness contrast, Cold–warm contrast

the garlands, and the staves of the umbrella around a center show some of the variety of images one can achieve with similar uses of the simple straight line (photos 1, 5, 10). Also many natural subjects, such as blossoms and leaves, often have such an arrangement of straight lines, which "radiate" evenly from a center in all directions. If two forces act alternately with the same strength on one moving point, the straight line changes its direction of motion, and an active "zigzag line" (diagram C), develops from the angles. One uses these angles, among other things, in decorations and particularly in writing (photos 6, 7, 11, 16). A wavy line can be the result of the simultaneous action of several forces acting together or against each other in different directions along the track of a point's movement (diagram D and photo 17).

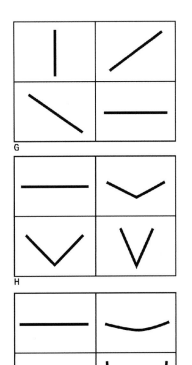

G

H

I

Diagrams G-I
Only diagonals can rise or fall and, thus, change their character. Two forces acting mutually on one point develop an angle. If several forces influence the movement of one point at the same time, straight lines are deformed into curved lines.

The diagrams G, H, and I show sections and individual variants from diagrams B, C, and D. Diagram G shows in isolation the three basic types of straight lines: the horizontal, the vertical, and the diagonal. The diagonal can appear to move in opposite directions, namely as a rising or as a falling diagonal.
Diagram H shows that forces acting successively with the same strength and for the same length of time, but from different directions, produce angles of different degree measures.
The diagram I shows that forces acting simultaneously, but with upward and downward directions on the movement of a point, result in evenly elbow-shaped curves. The angles and elbows with openings facing upward could "catch" or hold their contents. Angles and elbows opening downward could cover or hide something.

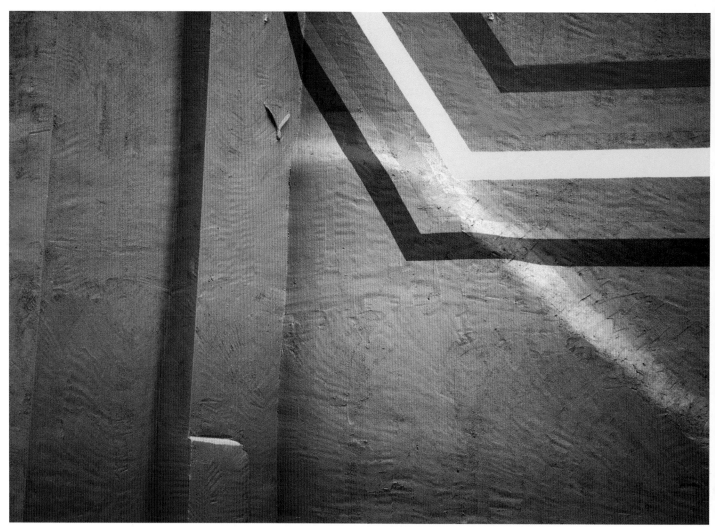
11 Brightness contrast, Cold–warm contrast

The Basic Properties of Lines

Apart from the tendency to cause the eye to follow its course, the line has two further primary properties, which nearly contradict each other, but arise simultaneously nonetheless. These are the properties of dividing surfaces or shapes and of forming new surfaces or shapes from those divisions. In the instant that a line forms on a surface, that line divides the surface. This division develops simultaneously new, smaller surfaces (photo 12). Dividing a square or rectangular surface with a horizontal or vertical line creates two smaller rectangular surfaces. Diagonals divide a rectangular surface into two triangles. Any line that traverses an image plane from one edge to any other edge without crossing or touching another line divides the image space

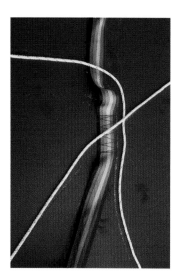
12 Warm color balance

13 Brightness contrast

into two secondary shapes. A closed loop (a line that returns to its starting point) that does not touch any edge or cross itself also divides the image space into two secondary shapes (diagram E and photos 15 and 16). If a line in its progression from one picture edge to another picture edge crosses itself once, the primary surface area is divided into three parts of different shapes and sizes (diagram F and photo 14). If a closed curve crosses itself once, for instance forming a figure "8", then three shapes result: two inside the loops of the eight and one outside of the eight. Secondary shapes, which result exclusively from the dividing property of lines, become what are called "line-active" surfaces or shapes. It is characteristic of line-active surfaces that the color, texture, and tone are identical inside and outside the shapes formed

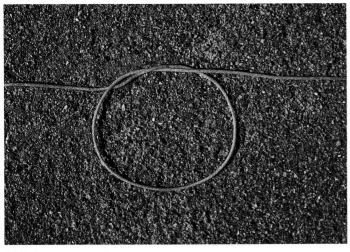
14 Texture

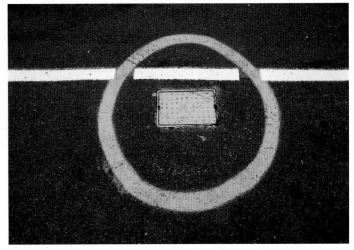
15 Brightness contrast, Texture

16 Brightness contrast, Texture

17 Brightness contrast, Contrast of lines

by lines (photos 4, 14-16). Varying the color, texture, or tone of a secondary shape will increase its visual weight (photo 13).

Visual Shapes

A straight line can cause only a simple, direct surface division. Only a line whose direction changes several times in its progress on a surface can form additional visual shapes that are more or less obvious to the viewer's eye (photos 2, 3, 7, 16, 17). Besides dividing space, lines create shapes. Shapes are complete when a line returns to its starting point either by intersecting two edges of the image frame or by forming a closed loop. However, lines often change direction or stop before completely forming a shape. In such cases, if the ends of the line are sufficiently close, the eye will step in to supply the missing section to complete the shape. With the "zigzag line" in diagram C it is not difficult to see roof-shaped triangles as well as triangles standing on points. In each case the eye fills in the imaginary third edge of the triangles with relative ease. The eye does not see so clearly, though, the optical semicircles that would close the curves in the wavy line in diagram D. The quality of the picture's composition depends also on the visual shapes that develop between lines or other shapes. This effect may neither be ignored nor forgotten during the work. These visual shapes should not be too small in relation to the picture area. If they are, they may create instability in the composition. The ideal situation is for one large visual shape to contrast with other, smaller ones. When photographing live, active subjects, it is advisable to take several photographs in order to achieve an optimal interaction between lines, shapes, and visual shapes (optical forms) (photo 2).

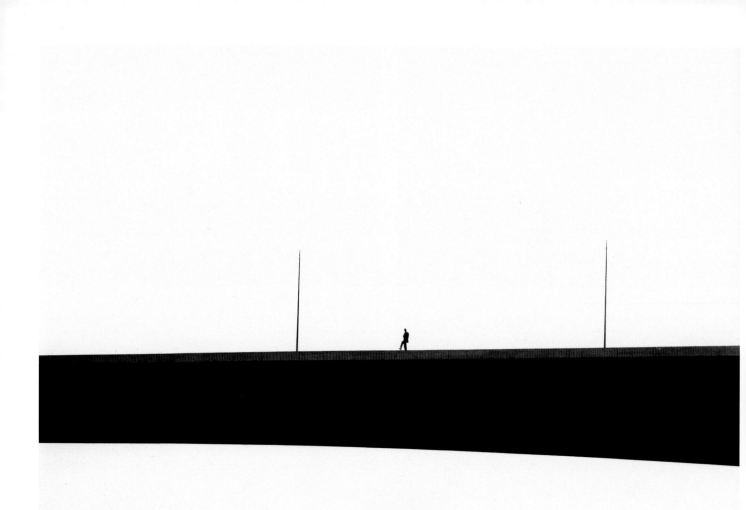

1 Point, Vertical lines, Brightness contrast, Quantity contrast

Horizontal Lines in Landscape and Portrait Formats

The horizontal line is one of the symbols for balance. It is a symbol for absolute equilibrium. Our visual experiences with distant, open landscapes and seascapes program our minds to associate the horizontal line primarily with landscapes (scenery) and the horizon line. At the same time the horizontal line as a horizon signifies distance and a feeling of coolness.

Format Choice and Surface Division

Our visual field has a predominantly horizontal aspect because our eyes lie next to each other horizontally. Rotating one's head to the left or right easily doubles the extent of the visual field (and becomes a panorama). This property of the human visual experience will often transfer to the choice of the picture format. During the conversion of 3-dimensional subjects to 2-dimensional pictures, the landscape format is used most commonly. The landscape format is the traditional format for landscape pictures. The rectangular image plane in the landscape format has an inherent visual stress between the horizontal upper and lower picture edges in relation to the left and right vertical picture edges. This stress between the horizontal

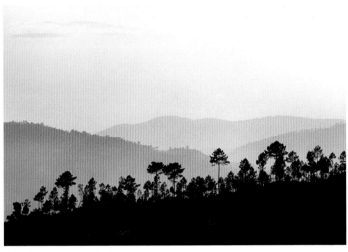

2 Brightness contrast, Visual lines

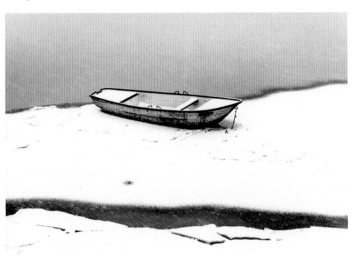

3 Dominant point

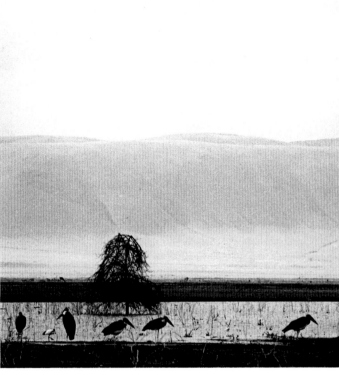

4 Visual lines, Quantity contrast

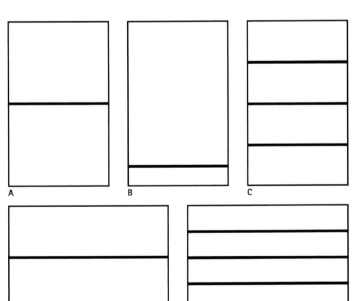

A B C

D E

Diagrams A-E
A viewer's initial reaction to a
horizontal line in an image is as the
"horizon". The horizon line can be
placed anywhere in the entire height
of the image plane. In the portrait
format a horizontal line strengthens
the visual impact of a surface division.
Without a visible horizon in the
picture, the upper or the lower picture
edge can become the "artificial
horizon".

edges of pictures in the landscape format emphasizes the effect of a horizon or other horizontal lines within a subject. A single horizontal line in a picture gives the impression of a natural horizon. The horizontal, as a cool, restful line, is most appropriate for the landscape format, which already possesses the same cool characteristic. The movement space of a horizontal line reaches obviously from the left to the right picture edges of a format. Besides, it is logical that a horizontal line is longer in the landscape format than in the portrait format. For the viewer the horizontal line in the landscape format has a sufficient space for free eye movement, while visual motion in the portrait format is stopped by the right picture edge. The strength of the surface division, which is a function of lines of all kinds, is most clear with short straight distances. Thus the horizontal

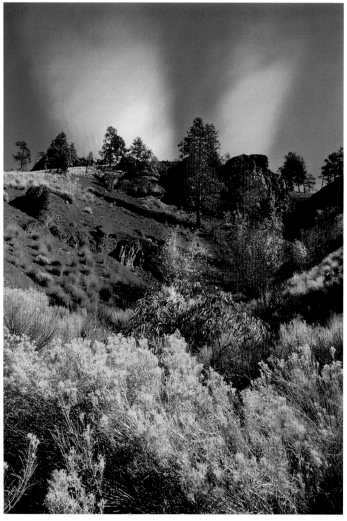

5 Brightness contrast, Contrast of contours

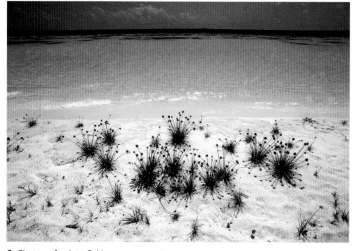

6 Clusters of points, Cold-warm contrast

7 Brightness contrast, Simultaneous contrast

line in the portrait format has a stronger surfacedividing character. A centered horizontal line in the portrait format forms two stubby rectangles that develop a clear visual stress between the upper and lower halves (diagram A, photo 10). The 35mm picture format has external proportions of 2:3 (24x36mm), which approximate the harmonious measure conditions of the golden section. The 35 mm frame used in the portrait format gives a visual impression of being somewhat narrow relative to the height, or a bit tall relative to the width. Successive horizontal divisions reduce this mildly unsettling visual effect. This is particularly the case with a horizon placed relatively low in the frame to show lots of sky (diagram B and photos 4, 9) or a horizon placed near the upper picture edge (photos 6, 11). Numerous horizontal lines in a portrait format

divide the image space into narrow rectangles or strips lying one on top of another and enhance the impression of breadth (diagram C, photos 18, 19). This situation creates a visual conflict between the cool, horizontal lines and the warm, vertical format. At two points on the height of a portrait format, a horizontal line can divide the surface into square and rectanglar compartments (diagrams F and G), wherein the "down" is stressed when the square is at the bottom (the foreground, the landscape, photo 5) and the "above" in the other case (the sky). In the landscape format a centered horizontal line divides the format into two narrow rectangles in the aspect ratio of 1:3 (diagram D and photos 12, 13, 15). If still more horizontal lines are added, then they divide the surface into very narrow rectangles or strips (diagram E

and photo 16). A number of horizontals in the landscape format suggest depth and lead the eye into the most remote areas of the picture.

Real and Artificial Horizons

The "absolute horizon" is that perfect horizontal line of a water surface lying in the far distance or a perfectly level landscape. The line along the upper edge of a mountain range, a hilly landscape, or even a forest lying in the distance will never be perfectly horizontal, but can only yield the impression of a "horizon". In addition there are many subjects with graduated, multilevel horizons (photo 2). The effect of a horizon does not only result from landscape subjects. The impression of a horizon will transfer easily to other horizontal lines and

elements so that a feeling of a so-called "artificial horizon" can develop. In the two following cases one of the picture edges becomes the artificial horizon. With landscape photographs in the landscape format taken from a high point of view that lack a horizon line, the upper (horizontal) picture edge acquires the character of a horizon (photo 3, 7, 14). In photographs of the sky without a visible landscape detail, it is the lower picture edge which comes to replace the horizon. With the portrait format the horizontal picture edges are so short that the effect of an artificial horizon develops only very rarely (photo 17).

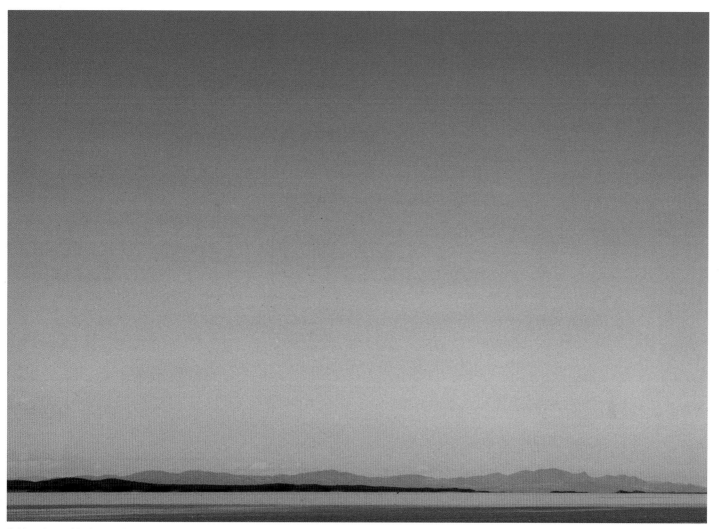

8 Monochrome color balance, Quantity contrast

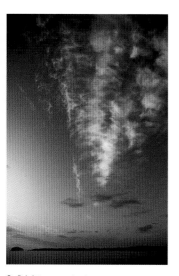

9 Brightness contrast,
Contrast of contours

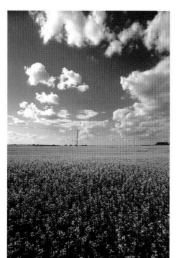

10 Complementary contrast,
Cold–warm contrast

11 Dominant point, Textural detail

Harmony and Tension

To achieve harmonious divisions of lines or surfaces, it often helps to use the proportions of the golden section. The height of each format contains two points at which the surface can be divided harmoniously by a horizontal line. These points are at different heights within the image plane. The choice for one of the two points depends on the desired height of the horizon, coupled with the decision to stress the foreground or the sky. To find these points is very simple. Folding a piece of paper in half three times divides its width or height into eight rectangular segments (diagrams H and I). These form the basis for the harmonious ratio of 3:5. Three units below the upper picture edge or three units above the lower picture edge mark the harmonious divisions after the golden section.

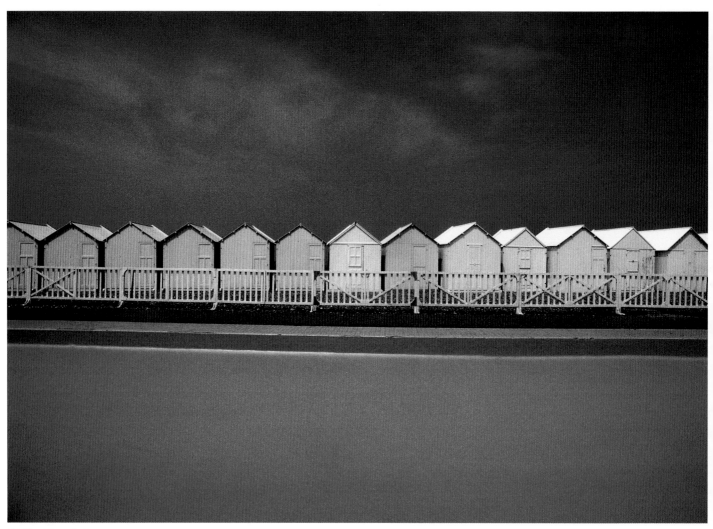

12 Visual lines, Quality contrast

F

G

H

I

Diagrams F–I
The middle position for the horizon line is generally to be avoided, especially in the portrait format. Harmonious surface divisions can be found according to the golden section.

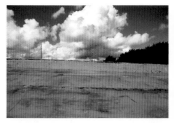

13 Brightness contrast, Cool color balance

14 Brightness contrast, Cool color balance

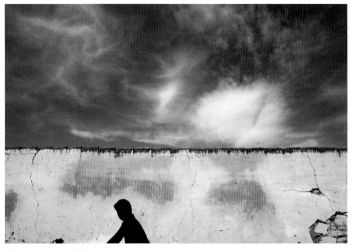

15 Dominant point, Complementary contrast

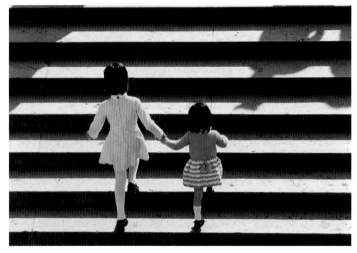

16 Dominant point, Oblique lines

17 Cold–warm contrast

18 Points, Vertical lines

19 Visual lines, Cold–warm contrast

With the 2:3 aspect ratio of the35mm format, in the portrait mode, these points are nearly identical to those forming a square within the rectanglar image frame (diagrams F, G), the squares are approximately 10% shorter in height than the 5:8 position). The division into eight units also marks the center of the surface – for a horizon placement which should often be avoided. The critical points for a surface division with harmonious tensions lie in each case a unit over or under the center (diagrams H and I). A mid-positioned horizontal line causes a division of the image frame lacking in visual tension, until other compositional elements that are above or below the horizon or the horizontal line are taken into consideration (photos 1, 10, 12, 13, 15). All other placements of a horizon or a horizontal line in the image plane vary from being rich to very rich in visual tension. For example, the decision to place a horizon very close to the lower or the upper picture edge creates strong visual tension (photos 4, 6, 8, 9, 11).

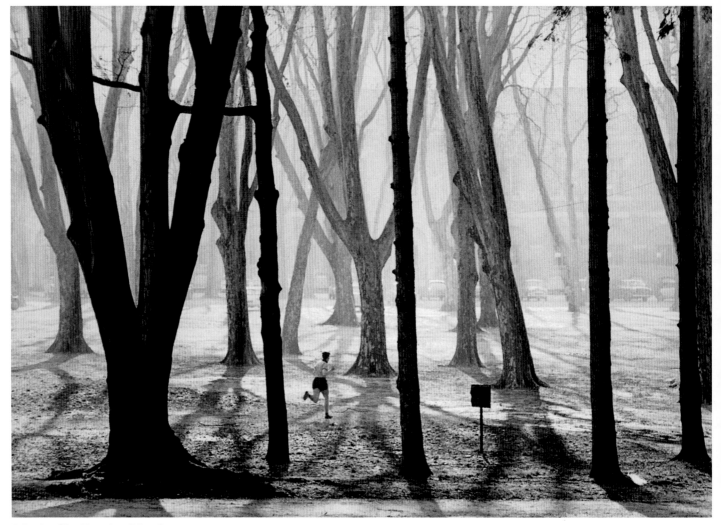

1 Dominant/disturbing points, Oblique lines

Vertical Lines in Landscape and Portrait Formats

The visual experience of height and size is certainly one of the primary experiences every person has in the earliest period of waking consciousness. Besides, other people play an essential role. The effect on an infant or toddler before a standing (adult) person is that of perpendiculars and nearness. Nearness and warmth are the associations one makes with the perpendicular, in contrast to the distance (depth) and coolness of horizontals.

The primary straight lines in contrast

The primary straight lines, horizontals and verticals, are already present as the edges of a rectangular image surface, are in complete contrast to each other, and create a visual tension at the earliest moment of the viewing experience. For the square, with sides of equal length, this contrast is very restrained. On the other hand the tension between horizontal and vertical edges of rectangles can be noticeable even to an untrained eye. This tension-contrast between horizontal and vertical lines becomes even more clear if the lines are used within the image as compositional elements. If either horizontal or vertical lines appear in a composition alone, then this contrast refers to the tension between the lines in the composition and the opposing

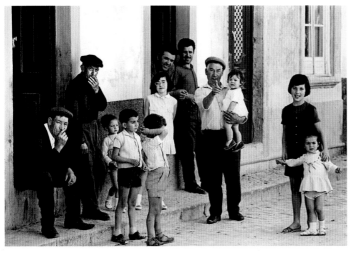

2 Oblique lines, Brightness contrast

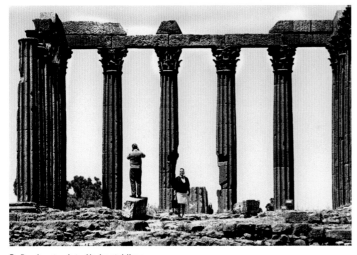

3 Dominant points, Horizontal lines

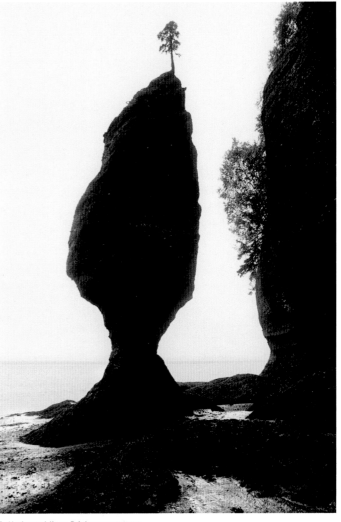

4 Horizontal lines, Brightness contrast

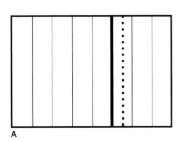

A

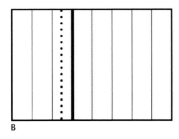

B

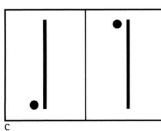

C

Diagrams A-C
Vertical lines have a particularly strong surface-dividing character in the landscape format. The golden section can guide one toward harmonious divisions of the image space. Small compositional elements can strengthen or interfere with the stability of vertical lines.

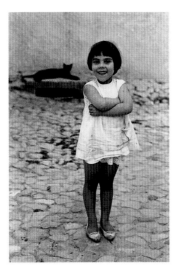

5 Dominant point, Brightness contrast, Textural detail

edges of the image plane. The contrast becomes clearest with one or more horizontal lines in a portrait format or one or more vertical lines in a landscape format. In each case the shorter edges of the image space are repeated within the image and thus their optical weight is strengthened, balanced, or exaggerated.

Movement and Equilibrium

A straight line in the image creates an impression of expansion and movement. This movement is from left to right with horizontal lines.
The direction of motion felt with vertical lines at first is from the top (as "from above") downward. But the impact of a vertical line on the lower picture edge, the support area for the picture, generates a

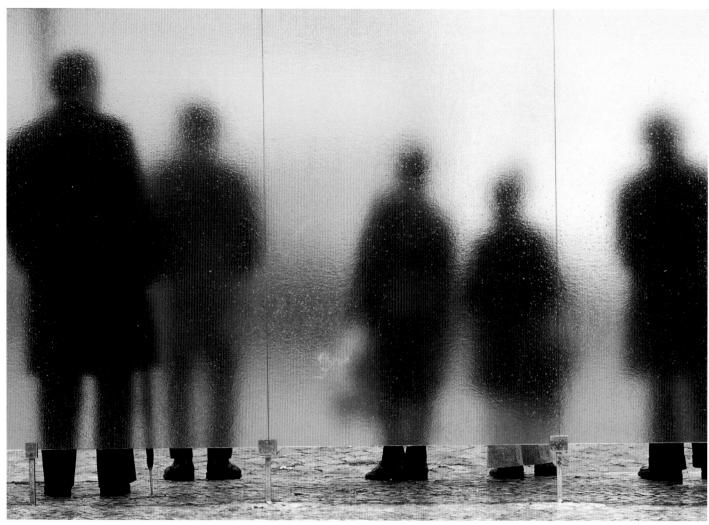

6 Visual shapes, Brightness contrast

visual resistance to this downward movement. This resistance is smaller for an upward vertical movement so that an imaginary continuation of visual movement in this direction beyond the upper edge is rather possible. The first differentiation a person learns of directions of motion and their relationship to each other is from left to right (horizontal) and from above downward (vertical). These directions are at right angles to each other. The horizontal-vertical structure of the right angle, which also determines the edges of the picture format, is expected to be the basis for composing pictures. Even if no direct horizontal or vertical composition elements are to be seen in the picture, lines and shapes in the image are noticed as deviations from these basic directions. Picture compositions derive their effects and tensions above all by the application of

contrasts. In formal terms, contrasts exist, for example, between point and line, short and long lines, or line and shape. The application of these formal contrasts in a composition immediately raises the problem of balance. That is, the artist or photographer has to consider the situation of contrasting design elements carefully with each composition, in order to protect the equilibrium within the image. So for example, a point placed toward the bottom of a vertical line can enhance its visual stability. However, if the point is placed near the top, then the equilibrium of the vertical line can be disturbed, because visual weight of the point may make the vertical line look tilted toward the point (diagram C and photo 5). Similarly, a point placed slightly above or below one end of a horizontal line has a tendency to make the line appear tilted in

7 Textural detail, Contrast of hue

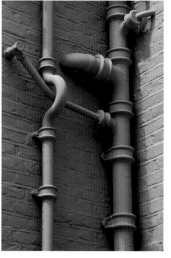

8 Monochrome color balance

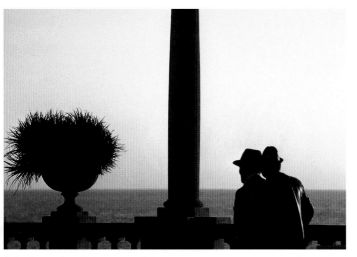

9 Dominant points, Horizontal lines, Brightness contrast

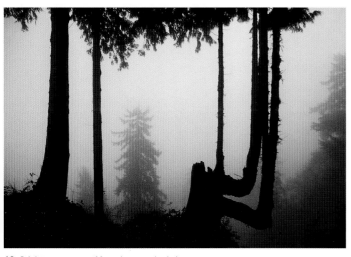

10 Brightness contrast, Monochrome color balance

11 Brightness contrast, Monochrome color balance

the direction of the point.
This effect can be exaggerated
if a point is above one end of
the line and a second point is
below the other end; the
horizontal will no longer look
horizontal, but will look tilted
toward the two points.

Surface Division and
Surface Formation

The visual effect of a surface
division is unobstrusive with the
calm, cool flatness of horizontal
lines and becomes clearer, as
described above, only in portrait
formats. The height, the direct
proximity, and the warmth of
vertical lines are felt not only
because of the lines, but even
more intensively because of the
strength of the surface-dividing
properties. In this case, too,
surface divisions have the
clearest optical effect across
short distances. Every continuous

or nearly continuous vertical
line in a landscape format
clearly divides the surface. In
the portrait format the image
plane is divided by vertical lines
into very narrow tall surfaces or
tall rectangles (photos 4, 8, 11,
13-15). In contrast to the restful
passivity of narrow reclining
rectangles (such as develop with
the division of a landscape
format by horizontal lines), the
narrow upright rectangles in a
portrait format are active, but
often only occupy a small area.
The position and thus the effect
of the surface-dividing vertical
line in the landscape format is
felt very intensively. Thus, a
vertical division in the middle of
the horizontal format disturbs
one's viewing experience in an
almost physical manner. The
calm recumbent rectangle of
the landscape format, with the
harmonious aspect ratio of 2:3,
divides into two compact,
almost square rectangles with

aspect ratios of 3:4. The strength
and visual proximity of the
verticals and the symmetry of
the two surfaces can make it
difficult or impossible for the
viewer to put the composition
lying behind the verticals back
together and see it as a visual
unity (photo 9). Vertical lines
which divide a surface into the
harmonious proportions of the
golden section are no less clear
in their effect of dividing
horizontal formats, but are less
harsh and direct than the
centrally placed vertical.
As already described above, the
two possible points for dividing
a length according to the
golden mean are to be found by
folding an appropriately sized
piece of paper in half three
times along one length. The
resulting eight units can be
divided, beginning from the left,
into the relationship of 3:5 or
5:3. The third fold from either
the left or right edge of the

image divides the image plane
in a harmonious manner.
In each case the larger of the
two developing surfaces is
almost a square (diagrams A
and B, whereby the dotted line
in each case indicates the square
in the rectangle). The exact
construction for the division of
a length in the proportions of
the golden section is shown in
diagram D. Starting with a line
segment AB, construct a right
triangle such that the height AC
(the shorter leg) is one half of
AB (the longer leg) and the
angle CAB is 90 degrees. From
vertex C mark a distance along
CB, the hypotenuse, equal to CA
and call that point D. Then from
point B mark a point E along AB
equal to the distance BD. The
point E now divides the length
AB according to the golden
section. Diagram E should
clarify for the reader that the
golden section is a division
defined by a particular ratio of

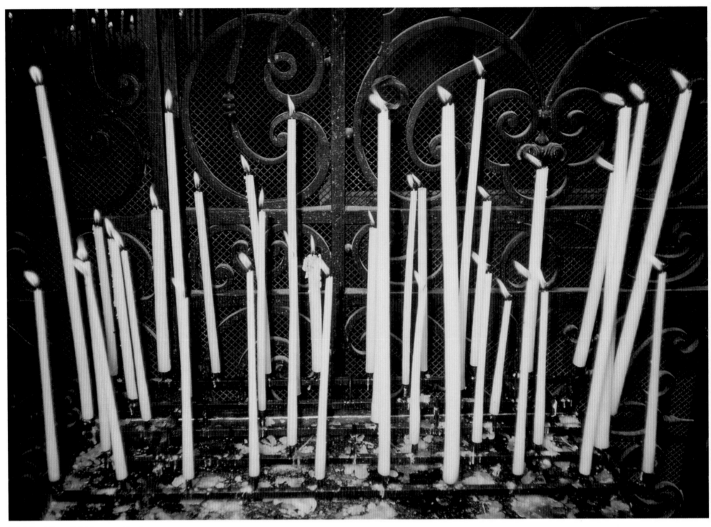

12 Visual lines, Brightness contrast

lengths: the short length is to the longer length as the longer length is to the whole length, i.e. a:b = b:c. Diagram E shows an example of an approximate golden section where the 2:3 (0.67) ratio of the short lengths a:b is almost equal to the ratio of the longer length to the whole length, where b:c is 3:5 (0.6). The sequence of proportions approximating the golden ratio becomes 2:3, 3:5, 5:8, 8:13, 13:21 and so forth. The proportion 2:3 is also that of the most-used photographic format, the 35mm frame. The common print formats, 10x15 cms, 20x30 cms or 40x60cm, preserve this ratio. Diagram F shows the property of diagonals in a rectangle, in that any rectangle formed from placing a corner on a diagonal has the same height:width ratio as the original, large rectangle.

13 Warm color balance

14 Cool color balance

15 Brightness contrast, Point, Texture

16 Horizontal lines, Cold-warm contrast

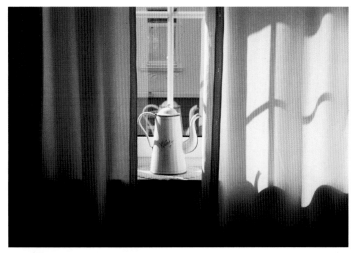

17 Dominant point, Brightness contrast

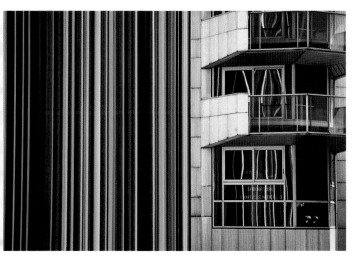

18 Quantity contrast, Colorfulness

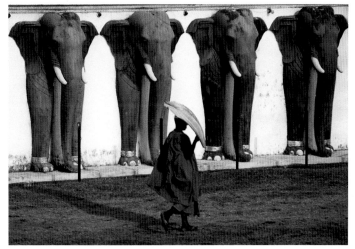

19 Dominant point, Visual lines, Oblique lines

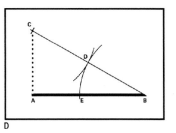

D

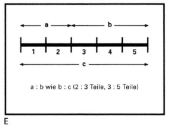

E

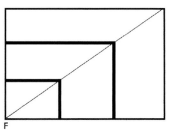

F

Diagrams D-F
It is possible using a standard geometric construction to divide any length according to the golden section.

Applications of Vertical Lines

The perpendicular line can be used economically as a single compositional element or to induce a high degree of visual tension (photos 4, 9, 11, 13, 14). The single vertical line in an image is always clearly apparent; therefore, its position, length, and thickness must be determined very carefully. When subjects are controlled by several vertical lines, it often requires the artist to search for an optimal point of view in order to find a harmonious or tension-rich division of the image space. Different lengths and thicknesses, and, above all, different distances between the vertical lines must be considered (photos 1, 2, 6, 8, 10, 12, 16, 17). Vertical lines equally distant from each other create a simple visual rhythm (photos 3, 19). If numerous vertical lines are very close together, they can have the optical effect of being a broad horizontal line or a surface with a linear texture (photos 12, 15, 18). Then the impression of spatial depth of the horizontal line is somewhat offset by the influence of the verticals.

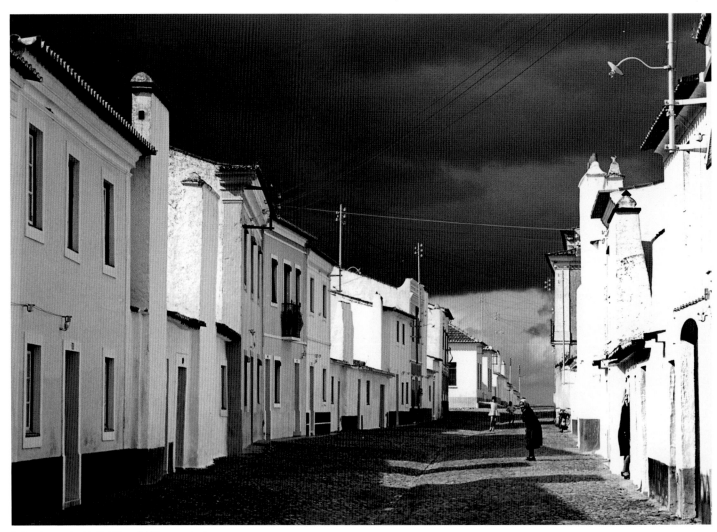

1 Dominant point, Vertical lines, Brightness contrast

Diagonals and Oblique Lines in Landscape and Portrait Formats

The horizontal, the vertical, and the diagonal are the most basic kinds of straight lines. Horizontal and vertical lines appear very frequently in the design of pictures. In addition, rising and falling diagonals or the combination of a diagonal and its corresponding visual (imaginary) diagonal are elementary means of organizing an image. Using oblique lines in a composition places high requirements on the feel for space.

The Diagonal in the Frame

Only if the image plane is a square, do the diagonals form equal 45-degree angles with each of the other straight lines – the horizontal and vertical edges. The temperature of the diagonal is in between the extremes of the cold, horizontal line and the warm, vertical line. If the image plane is rectangular, the diagonals form different angles with the other straight lines in each case. With formats using the harmonious 2:3 aspect ratio, diagonals in the landscape format result in angles of 55 degrees to vertical lines and 35 degrees to horizontal lines. With direct diagonals, a viewer's eye does not feel the differences of these angles as being of great significance. Both visually and in the temperature of the line, diagonals mark a middle area in the rectangle.

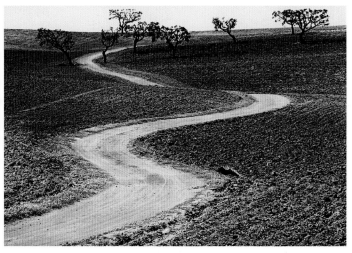

2 Visual lines, Horizontal lines, Textural detail

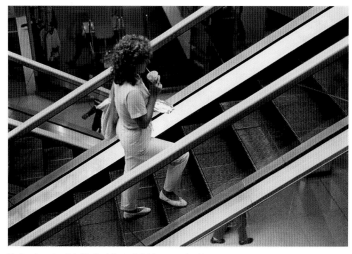

3 Dominant point, Vertical lines, Brightness contrast

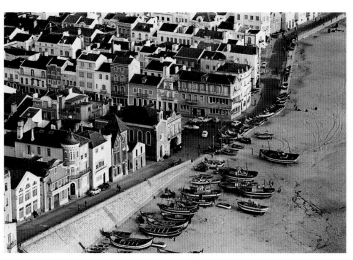

4 Visual lines, Brightness contrast, Textural detail

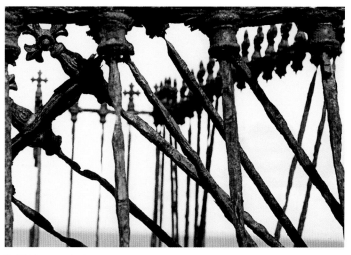

5 Brightness contrast

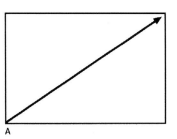

A

Diagrams A-C
A rising diagonal is felt as harmonious.
A falling diagonal forces the eye into
the lower right corner. A diagonal
divides a surface into two triangles.
A diagonal and the corresponding
visual diagonal divide a surface into
four triangles.

B

C

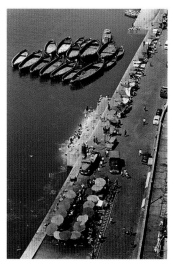

6 Visual lines, Clusters of points

Changing from the landscape to
the portrait format or vice versa
does not preserve the respective
effects of the diagonals. A line
which runs in the landscape
format from corner to corner,
rising or falling, acquires the
character of an oblique line
(diagram D). Also, the diagonal
in the portrait format changes
its effect in the landscape
format to that of an oblique line
(diagram E)

**Surface Division and
Movement of Diagonals**

As do all lines which run from
picture edge to picture edge,
diagonal and oblique lines also
have a surface-dividing charac-
teristic. Diagonal lines have a
strongly stimulating effect and
generally require the restraint of
a horizontal or vertical line to
keep one's eye in the picture.
Rising and falling diagonals

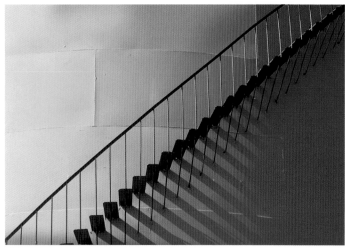

7 Vertical lines, Brightness contrast, Cool color balance

8 Dominant point, Texture, Warm color balance

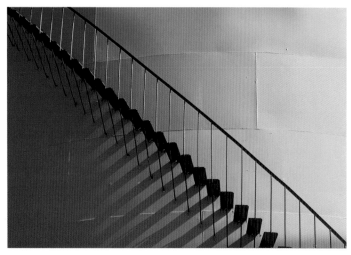

9 Vertical lines, Brightness contrast, Cool color balance

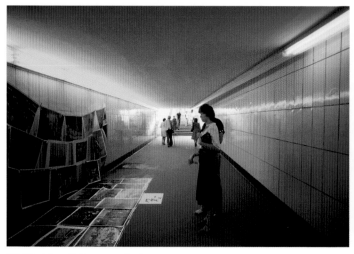

10 Visual lines, Cold–warm contrast

divide the surface in each case into two triangles. Here two movements develop. On the one hand there is the movement of the lines themselves. With the rising diagonal this movement is from the lower left to the upper right, with little tendency to leave the image surface via the upper right corner (diagram A and photos 3, 4, 7). Of the two, a rising diagonal has the more harmonious psychological effect and a lesser need for the visual restraint of a horizontal or vertical line. In the portrait format this diagonal is very steep and offers, therefore, to the viewer an increased visual resistance (photos 6, 15). With the falling diagonal this movement is from the upper left to the lower right – with the tendency to lead the eye out of the picture through the lower right corner (diagram B and photos 9, 11). This "slide effect" of the falling diagonal is even more exaggerated in the

portrait format. A vertical constraint is almost imperative to arrest the eye's tendency to leave the picture through the lower right corner. Such a vertical element is often referred to as a "stopper". The other movements result from the triangles. The movements of the imaginary counterdiagonals point into the corners of the triangles. With the rising diagonal these movements are thus toward the upper left and the lower right, and with the falling diagonal toward the lower left and the upper right. These optical movements of the triangles can only slightly affect, however, the main movements of the diagonal lines. The presence of a diagonal and the counterdiagonal creates an optical effect that, to a small degree, encourages one's eye to stay within the frame (diagram C). The optical movement of the four resulting triangles creates a visual stress

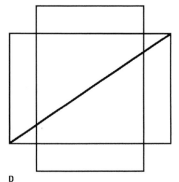

D

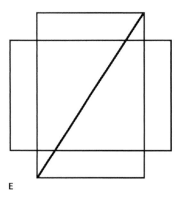

E

Diagrams D, E
The angle between a diagonal and the bottom edge is significantly less in the landscape format than in the portrait format. The steeper slope of the rising diagonal in the portrait format resists the eye's movement more strongly.

11 Brightness contrast, Complementary contrast

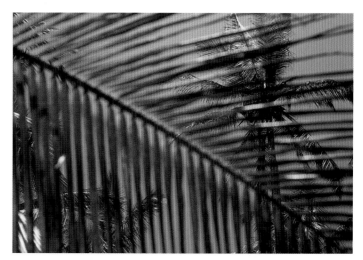

12 Line bundles, Complementary contrast

13 Brightness contrast, Texture, Single color

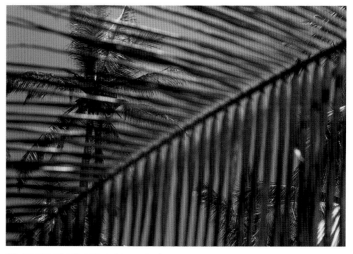

14 Line bundles, Complementary contrast

15 Dominant points, Quantity contrast, Textural detail

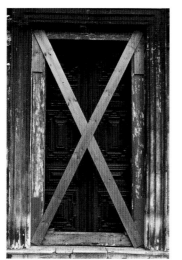

16 Brightness contrast, Vertical lines

point at the center of the image, where the vertices of the triangles meet. The center point often forms the vanishing point of a composition based on a central perspective (photos 1, 10).

Surface Division by Oblique Lines

Above all, horizontal and vertical lines and, with certain qualifications, diagonal lines, have a strong relationship to the surface and show little inclination to leave the surface visually. On the other hand, oblique straight lines, lines which run at angles somewhere between the vertical, diagonal, and horizontal, are alien to the image space and inject instability into the composition. This calls for the restful restraint of a horizontal or vertical line. Parts of the image plane can be visually cut off by oblique lines, especially if they are near the corners of the image frame. With respect to their relation to the image plane, two groups of oblique lines can be differentiated: those running through the picture center (diagram G) and decentralized

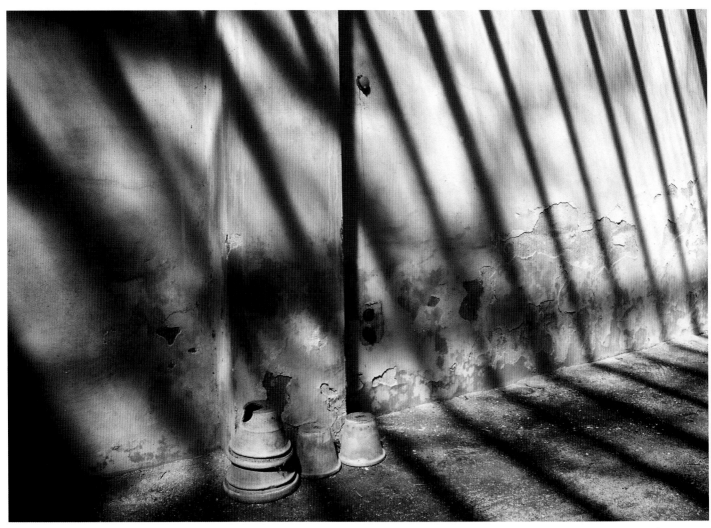

17 Dominant point, Vertical lines, Brightness contrast

oblique lines, which divide the image plane in arbitrary places (diagram H). A rhythmical repetition of oblique lines can lead to a vanishing point that is either clearly apparent within the image frame or that can be anticipated outside of the frame (photos 17, 20, 23). Compositions with oblique lines that do not pass through the center require a finely honed sense of spacial organization. Noncentered oblique lines emanating from near a corner can provide a good use of space and stabilize the composition (photos 5, 13, 18, 19, 21, 22).

Visually Scanning the Image Plane

When we look at pictures, our eyes move at first according to two ingrained habits. The instilled reading and writing behaviors, from left to the right

in our culture, are transferred conditionally to how one views a picture. Beginning at the upper left corner the eyes move back and forth from left to right and back again over the image plane, from the top down. Another quick scanning pattern is to scan the diagonals (diagram F and photo 2). Compositions with connections to the edges may oppose the progress of these scans. From this very quick, almost unconscious, scanning, a viewer makes an immediate evaluation of the success, or lack thereof, of the image's design and tonal distribution. This effect becomes most obviously apparent if pictures are reversed. In photo 7 with the rising diagonals, the change from light to dark running from left to right is felt as harmonious. The rising diagonal provides a gentle resistance for the eye and prevents the eye from leaving

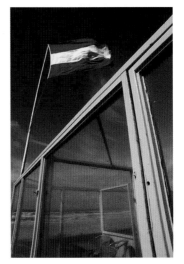

18 Dominant point, Cool color balance

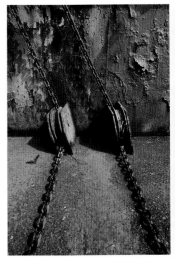

19 Two points, Warm color balance

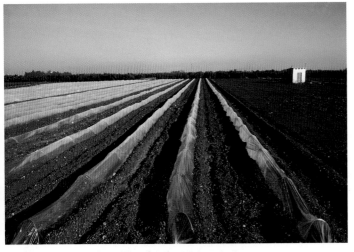

20 Dominant point, Horizontal lines, Complementary contrast

21 Visual lines, Brightness contrast

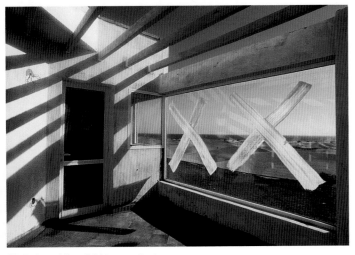

22 Horizontal lines, Brightness contrast

23 Brightness contrast, Cool color balance

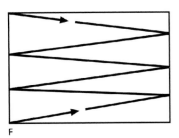

F

Diagrams F-H
Optical scanning of a surface usually begins at the upper left corner of the image. Oblique lines divide the image field into active small triangular surfaces. Problematic triangles thereby develop frequently in the corners of pictures.

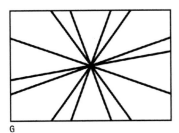

G

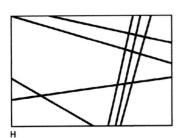

H

the image plane too quickly. With the reversed picture (photo 9), the brightest surface is at the right side and is felt to be too bright. This tonal distribution along with the falling diagonal suddenly becomes for the eye a "slide", which lets the viewer's eye slip downward right out of the picture. On the other hand with photo 12, the downward and diagonally upward line divisions dissipate the slide effect of the falling diagonal. If one reverses this picture, the upward movement of the rising diagonal is opposed by the strong, almost prickly resistance of the line divisions (photo 14). Apart from this instilled and deliberate consideration of the image, one's eyes scan the image field precipitately in rapid, jerky movements. These eye movements are called saccadic movements, so named by the French opthalmologist who first

described them, and take place unconsciously. Only in scientific experiments can these movements of the eyes be proven. The way in which these eye movements "draw" over the image field, flowing from one visual attraction to another, is also the basis of recognition and of recognizing objects. These very rapid eye movements end at the point which represents the highest attraction value for the viewer. This "rest point" can naturally differ from one viewer to another in the same picture. Clear lines and intersections of lines can create such visual rest points anywhere throughout the design. The material or suggested crossing point of a diagonal and its counterdiagonal is also a rest point for the eye. It is, in most instances, better and more interesting if this point is not placed too near the exact center of the image (photos 1, 8, 10, 16).

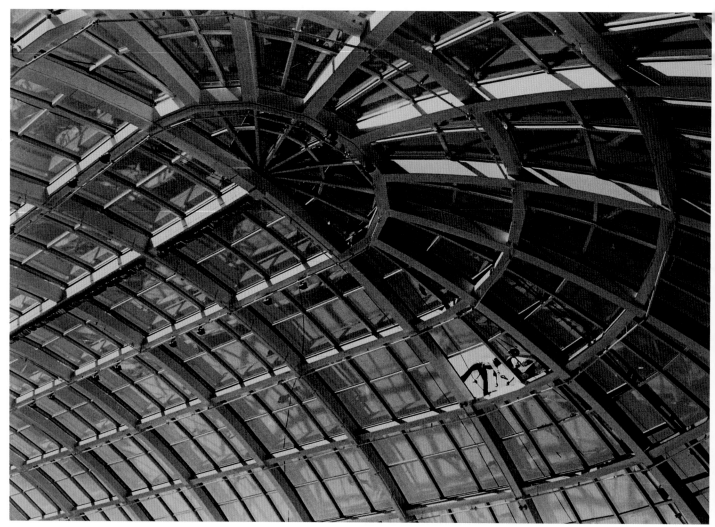

1 Dominant point, Oblique lines, Circular shapes

Irregular Lines, Groups of Lines, Line Contrast, and Line Division

The "line" as a design element can occur in many variants and different contexts. The expression and the effect of line cover a very large gamut. The most intensive optical and artistic tensions develop if natural lines and linear structures are present in the image with manmade lines and line structures.

Straight Lines and Irregular Lines

The absolute straight line drawn with a ruler is to a large extent a human invention. In nature the apparently perfect straight line is only nearly so. A horizon line at sea, in the desert, or on a savannah, etc., only works because the naked eye cannot perceive the small unevennesses of wave, sand, grass, or rocks at such large distances. As already described, the most frequently arising primary straight lines, horizontals and verticals, have a limited, passive force of expression. When the subject of the image determines that horizontal or vertical lines should materially or visually intersect with the edges of the image, these lines support the dual property of lines: dividing surfaces and in so doing, creating new, smaller surfaces or shapes. This dual property of

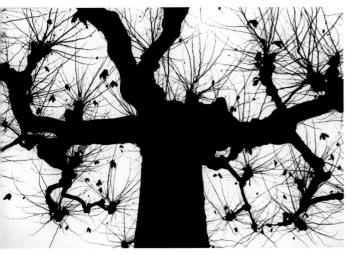

2 Brightness contrast, Visual shapes

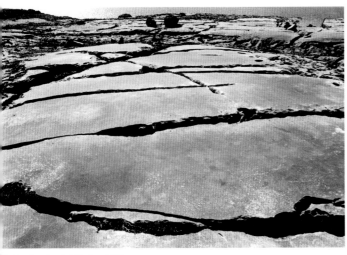

3 Dominant point, Horizontal lines

4 Brightness contrast

Diagrams A-C
A directional change in the progression of a line interrupts and changes its movement. Curved lines can vary from being portions of a circle's circumference to being completely irregular in progression. A line that varies in thickness and thinness along its length is characteristic of the so-called "artistic line".

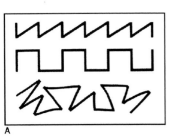

A

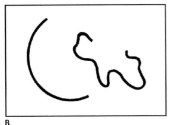

B

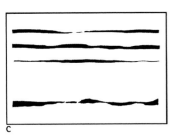

C

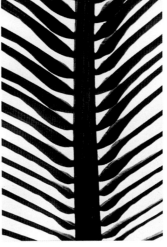

5 Brightness contrast

simultaneously dividing surfaces and forming new surfaces is a principle applying to all lines. The optical effect and thus the direct perception of these forces by the viewer are most clear with uncomplicated designs. Horizontal and vertical lines themselves have only a passive psychological effect. Any line of irregular progression offers, however, additional visual attractions, which divert from the effects of the basic properties of the line on the eye. Diagonal and oblique straight lines are the simplest types of line to convey a feeling of activity to a viewer. If a straight line changes direction repeatedly in a regular or irregular manner, an active or even aggressive line effect (diagram A) develops. In a clear contrast to the straight line stands the curved or crooked line, which can fall into two categories. Into the strictest set of geometrical curves fall

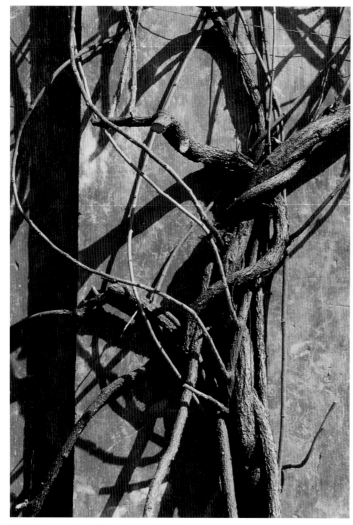

6 Brightness contrast, Monochrome color balance

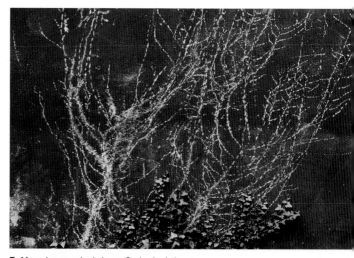

7 Monochrome color balance, Cool color balance

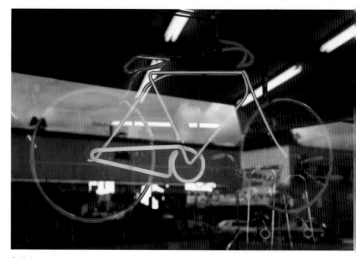

8 Brightness contrast, Hued-hueless contrast

those lines which are complete circles or sections of circles. Although nearly perfect circles and portions of circles exist in nature, the strictest geometric curves are products of human culture. The strict, geometrical circle is a strong example of the shape-creating property of lines. The gentle activity of the curve becomes much more assertive with the irregular line, which is a curved line with completely free progression. Although people may claim to be able to "fabricate" irregular lines, truly irregular lines actually arise only in natural situations (diagram B). The visual effect of the different types of lines starts with the consciousness and then the "hand" of the artist or photographer. An irregular line directly divides the image surface only when it touches at least two of the picture edges (photos 2, 12, and 17, among others); this is true also of all

the straight lines discussed above. Geometrically curved or completely irregular lines may not necessarily have any contact with the picture edges. The progression of a line develops an actual or a visually imagined shape in an image as an effect of the shape-creating property of all types of lines. As will be discussed in a later chapter on "figure-ground" or "positive-negative" shapes, with any isolated shape, a free standing shape formed by a line (the "figure") is surrounded by the "ground" or negative shape, whose outside delimitations are the picture edges (photo 8).

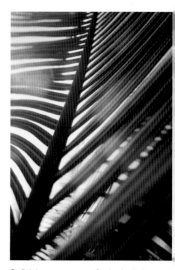

9 Brightness contrast, Cool color balance

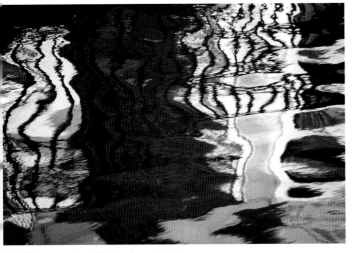

10 Brightness contrast, Hued–hueless contrast

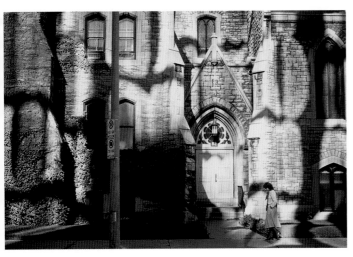

11 Brightness contrast, Monochrome color balance

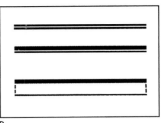
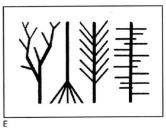

12 Brightness contrast, Cold–warm contrast

13 Brightness contrast, Cool color balance

The Character and Variation of Thickness of Lines

Products of our culture include cables, cords, wire, and hoses, etc., which can form irregular lines. But as a rule, the feel of these lines is often harsh and unrelenting, as the line-forming materials are industrial products used for specific purposes.
In their character of visual movement, these lines are thus rather boring. In natural settings there are stems and grasses, which have a uniform thickness along a straight course for a certain length; however, these are rather the exceptions. Natural objects usually have lines of varying or tapering thickness with an active irregularity of progression. These active natural lines in plants are clearly visible to anyone. The linear structure of bushes and trees is easily visible only in the winter or with dead

plants. Placing a plant or tree against a neutral background to exaggerate the tonal contrast stresses the lines all the more clearly (photos 2, 4, 5). Also effective in pictures, as shown in photos 3, 11, and 13, is the artistic contrast of the strong, thick line to the thin line and the variation in the thickness, the swelling and shrinking, of lines, sometimes to the point of completely disappearing. The viewer's eye supplements short interruptions of lines to achieve visual closure (diagram C).

Diagrams D–F
Contrasting lines with different or varying thicknesses, paths, and characters are standard, expressive artistic design tools.

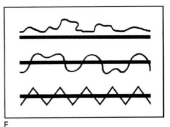

14 Brightness contrast, Monochrome color balance

Line Contrast, Lines, and Line Groups

The compositional scaffolding of
most images is the arrangement
of the real and visual lines in
the frame. Interesting contrasts
can increase the artistic effect.
Two line contrasts that easily
come to mind are short lines
placed near or against long lines
or thick ones against thin, as
shown in diagram D. Placing
lines of different character next
to each other increases visual
tension (diagram F and photos
15, 16). Manmade lines mixed
with natural ones results
automatically in contrasts the
artist can exploit (photos 4, 6,
19, 20, 21). In a picture where
contrast of lines dominates
the composition, perceiving the
lines and the associated groups
of lines occurs almost simulta-
neously (diagrams D, E). Within
the realm of contrasting lines
an artist or photographer can

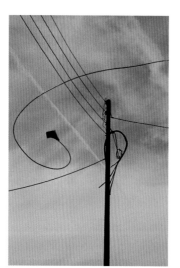

15 Dominant point, Vertical line

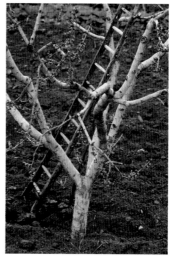

16 Cold–warm contrast

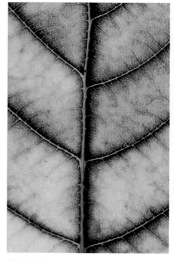

17 Brightness contrast,
Monochrome color balance

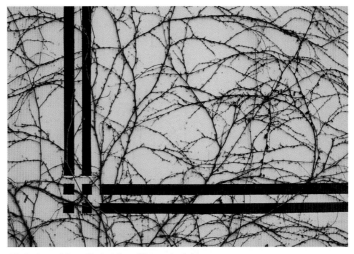

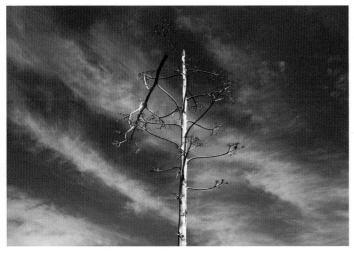

18 Vertical line, Cool color balance

19 Horizontal lines, Vertical lines, Warm color balance

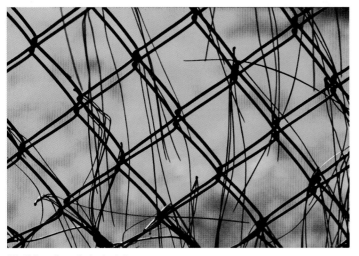

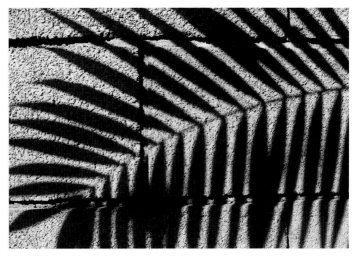

20 Oblique lines, Cool color balance

21 Brightness contrast, Monochrome color balance

produce varied effects and visual weightings. If a line is accompanied by a second or by several other lines, the distance or the space between the lines is immediately important. If lines run close to each other side by side, new (negative) visual lines (photos 19, 21) immediately come into being between them. If the lines are further apart, so-called visual surfaces come into being, where the eye visually connects the line ends with each other (photos 10, 12). The cultural activity "writing", using different straight and crooked, primarily short lines, can create many real and optical shapes (photo 14).

Line and Line Division

The nature of the phenomenon "line" is certainly embodied in outlines or edges, branching lines, collateral lines, and line division. The example "tree" is built around this system of lines: the trunk, the limbs, the branches, the leaf stalks, and the veins (diagram F and photos 2, 4, 5-7, 9, 17, 18). Among manmade systems of lines, we are familiar with road systems with main streets and side streets, rail systems, and others. In the specialized architectural arena of greenhouses or glass roofs, there is a very austere arrangement of main lines and collateral lines (photo1). It is not surprising that the main line must also be the thicker one (photos 2, 5, 9, 17) in relation to the collateral lines. The primary effect on a viewer of a continuous line – usually also the longest one – is as the main, most important line (photo 21).

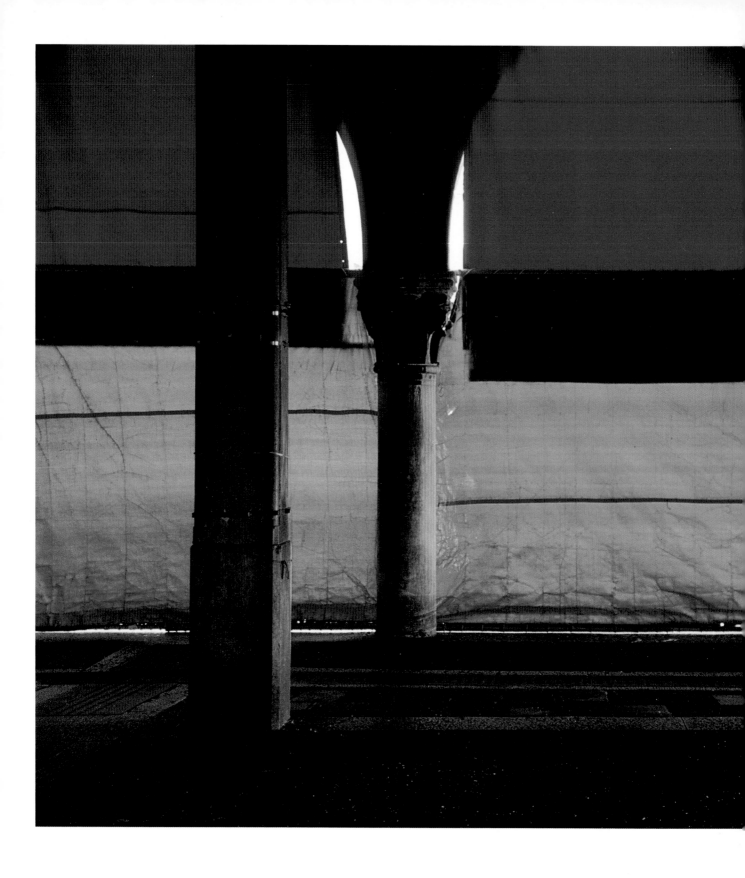

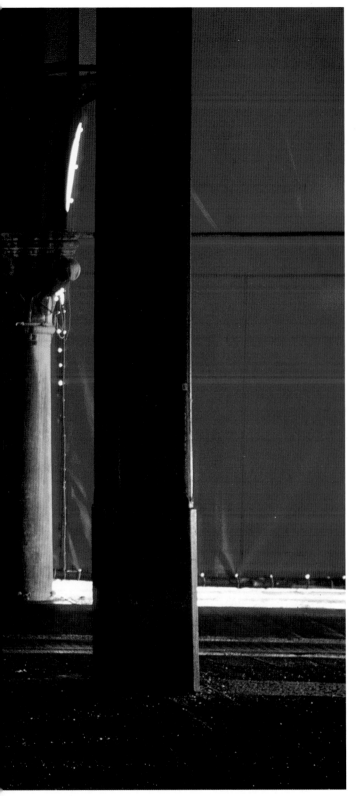

The
Shape

Shape is the design element by which areas of tone and color are bounded within or allowed to cover the entire image frame. In contrast to the design elements point and line, a shape usually carries a greater visual weight. Shapes are differentiated as compositional background, as components of a composition, as forms when there is shading, or, more rarely, as figures or as visual or color masses.

1 Horizontal lines, Brightness contrast

Rectangle and Square as Shape and Image Plane

The surface actually has three levels of visual effect. With larger viewing distances these surface levels work from the outside inward, from the large to the small. That means, it goes in stages from the presentation surface over the image plane to a shape (form) as an element of the picture design. During direct viewing of a picture from the optimal viewing distance, the effect of the surfaces is turned around – from the inside outward – from a shape as a design element in the picture over the image frame to the presentation surface.

Types and Use of Surfaces

The primary image plane is the surface on which one hangs, places, or enacts a composition: the presentation surface. The size of a presentation surface is practically unlimited. With fireworks, a kite flying show, or the like, the sky is the surface on which, for a usually short period, something is "presented". The presentation surface for a stage or a cinema screen is also analogous to the image plane for the same reasons. As for photographs and paintings, the presentation surface may be the wall of an exhibition, a calendar, or a page in a book or magazine. In nearly all cases a presentation surface can also be completely filled out with a picture and become identical with the image plane. An example would be the full-bleed single side or double page pictures in a book or

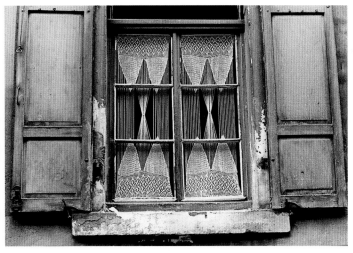

2 Textural detail, Triangles, Brightness contrast

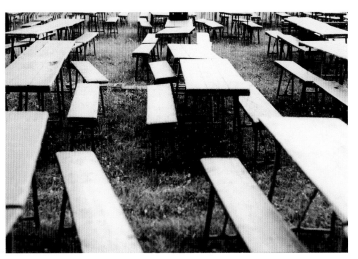

3 Brightness contrast

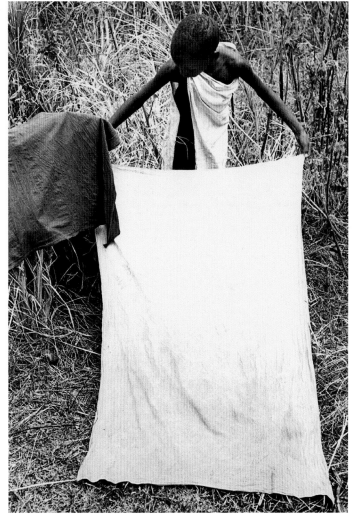

4 Dominant point, Textural detail

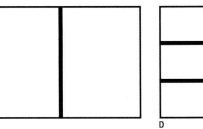
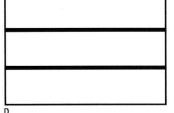

A

B

E

C

F

D

Diagrams A-F
Straight lines can divide the classical image formats into smaller squares or rectangles The visual resistance of the picture edges and the visual weight within the image plane are felt always downward and to the right.

magazine. The edges of image planes and presentation surfaces are traditionally straight-sided with right-angle corners, thus a rectangle or a square. Our culture has produced other media in varying shapes which are used as presentation surfaces or image planes. These other shapes of, and media for presenting, images are most commonly the circle (in the form of a cookie jar, record, CD, clock, etc.) or – more rarely – the oval, hexagon, and octagon. However the primary interest to an artist or photographer is the effect of the shape of the image surface and of the shapes used in the composition.

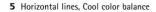

5 Horizontal lines, Cool color balance

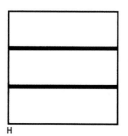

6 Brightness contrast, Contrast of hues

7 Dominant point, Complementary contrast

Visual Effects of Shapes

The clearest effect of "shape" on an image plane develops for square, rectangular, or other geometrical or irregular shapes with even color density or tonal value. Shapes defined by color or tone are called surface-active (and at the same time line-passive) shapes. The delimitation of a shape is determined by its color or its tone. Directly adjacent to a new shape or its negative shape begins the background. Shapes, which are delineated by lines, are called line-active (and at the same time surface-passive) forms. A visual surface which is formed only by points, by a broken line course, or by a combination of both of these design elements has the smallest visual impact as a surface and the smallest visual weight.

Visual Weight in the Rectangular and the Square Image Frames

It is well to reiterate the difference between the image plane and shapes on the image plane. The rectangle and the square as image frames have clearly felt visual stresses between the upper and lower and between the left and right edges. The lower edge, the area on which the image rests, feels substantial and heavy, as if under the pull of gravity, while

Diagrams G-L
Squares can be divided into rectangles, rich in visual tension, or into smaller squares, mimicking the original shape. The situation of a square in an image can be static or dynamic.

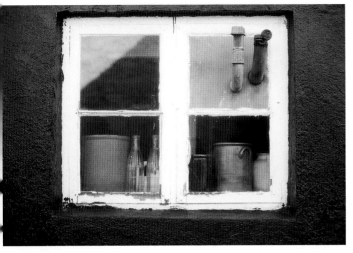

8 Brightness contrast

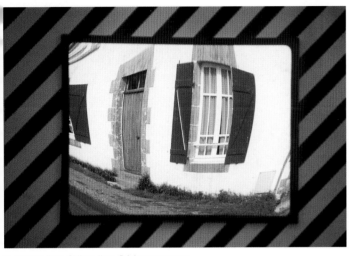

9 Vertical lines, Oblique lines, Brightness contrast

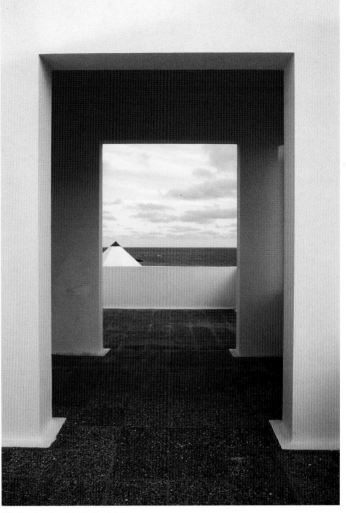

10 Dominant point, Horizontal lines

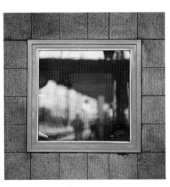

11 Dominant point

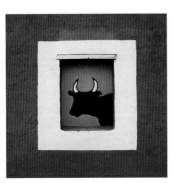

12 Brightness contrast

the upper edge feels rather open and light. The left side, because of our viewing and reading habits, is the visual "entrance" into the image. The right side means the edge, the end, the delimitation of the subject. Therefore, in examining a square or other right-angled image plane, a viewer derives different feelings of visual resistance from each of the picture edges (diagram C). In addition, different areas of the image have different visual weights (diagram F). These visual qualities and weights of the image planes and the presentation surfaces also have consequences for the design and the presentation of pictures. For example, to convey to a viewer the feeling that a shape is accurately centered in a design or picture, it must be placed somewhat higher than the exact center on the respective surfaces.

Division of Rectangles and Squares

Vertical and horizontal lines can divide any rectangular or square surface into smaller rectangles or squares with their property of dividing surfaces while simultaneously creating new surfaces. Depending upon the number and combination of the dividing lines, rectangles divide into smaller rectangles (diagrams B, D) or into surfaces that visually approximate squares (diagrams A, E). Rectangles (diagrams G, H) or squares (diagrams J, K) can develop in divided squares.

Passive and Active Shapes on the Image Plane

In the "normal position", thus vertical-horizontally aligned, both rectangles and squares are passive, static shapes with no noticeable tendencies toward

13 Two points, Vertical lines, Contrast of hues

visual movement. Here the square with its 1:1 aspect ratio without tension (diagram L and photos 11, 12) is still more restful and more passive than the rectangle with its different aspect ratios (photos 6, 7). In addition the rectangle in the portrait format achieves a small increase of active effect (photos 4, 5, 10). Surprisingly, the square and the rectangle can be dynamic and active if they are shown as standing on a corner. Here the activity (visual movement) of the dynamically standing square goes nearly evenly upward and downward as well as to the left and right (diagram M and photos 14, 15, 19). A rectangle standing on a corner performs something of a "balancing act" (photo 18). Squares and rectangles viewed from edge-on or from a corner appear distorted according to optical laws and have the feel of being visually active (photos 13, 16, 17).

Shapes on the Image Surface

An image designed with a (passive) square shape within a square image format, a horizontal rectanglar subject in a landscape format image, and a vertical rectanglar subject in a portrait format image signify a repetition of the shape of the external format within the image plane (photos 4, 6, 7, 10). With a central positioning of these shapes on the image plane, no compositional design problems develop. If a dominant shape in the image contrasts with the format, for instance a rectangle in a square image or a square in a rectangular image, design issues can develop between the dominant shape, the format shape, and the negative space or background in the image. The design problems are slightly different from case to case, depending on whether

Diagrams M-O
Classic compositional schemes based on the square, which is low in visual tension, are typical of the Romanesque (diagram M) and baroque

periods (diagram N). The vertical rectangle, which carries significant visual tension, is the basis of the compositional lines of gothic art and architecture (diagram O).

14 Horizontal lines, Cold–warm contrast

15 Brightness contrast

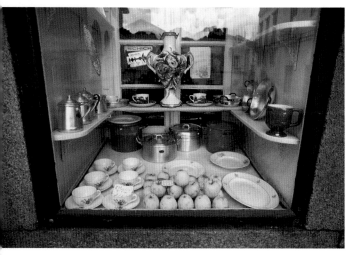

16 Textural detail, Oblique lines

17 Dominant point, Detail

18 Visual lines, Detail

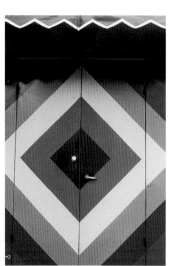

19 Contrast of lines, Cold–warm contrast

there are to be one or several squares in either type of rectangular image, or whether vertical rectangles are to be composed in a square image (photos 1, 2, 3, 5, 8, 9).

Classic Compositional Designs

The square and the rectangle have always been the bases for compositional templates of different artistic styles and cultural epochs. Here the divisions and subdivisions of the surfaces mostly referred to painting and architecture and were used on both 2-dimensional and 3-dimensional surfaces. The square was the basis for the compositional schemes of the Romanesque and the baroque periods (diagrams N, O). The central vertical and horizontal lines, coupled with the circle within the square, stress

passivity in Romanesque art. On the other hand, the pattern shows activity and movement for the baroque period with the diagonal, the counterdiagonal, and the active square inscribed within a restful square.

The surface area for the gothic compositional pattern is the vertical rectangle. Apart from the special stress of the square, which offers a stable basis to a composition, use of the diagonals and the triangle pointing upward produces a feeling of rising movement (diagram O).

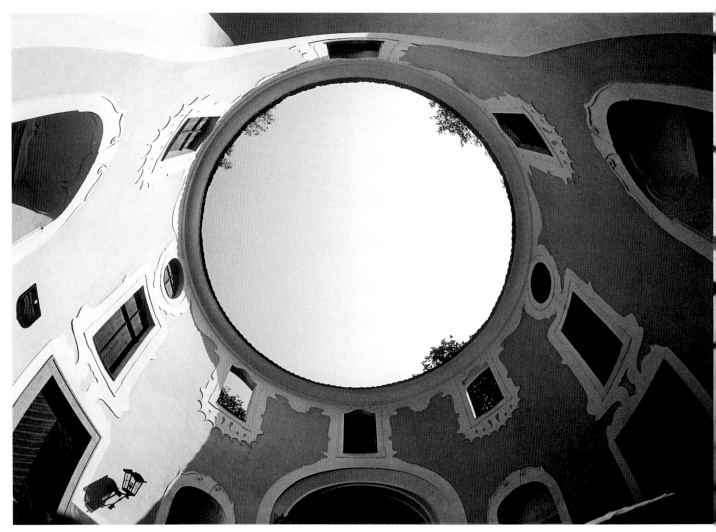

1 Visual lines, Brightness contrast

Circle, Triangle and Oval as Design Elements

A viewer recognizes and categorizes shapes according to the specific structural characteristics of the respective shapes. Once a viewer has learned the name and characteristics of a shape, he/she will recognize it even when it has been modified or abstracted. After having learned about "triangles", a child will recognize one regardless of whether it is smaller or larger, brighter or darker, crisply outlined or not, or even standing on a vertex.

Circle and Triangle, as Presentation Surfaces

Everyone obtains fundamental visual information from the outlines of shapes. This visual information is not restricted to only one medium, but can be exploited in photography or combined with other pictorial, graphical, or typographical techniques and designs. Squares and rectangles are the basic, neutral shapes for all visual information technologies. Like the square standing on a point, the two other basic geometrical shapes, the circle and the triangle, as shapes in themselves, actually have a stronger visual dominance. This shape dominance permits only a conditioned use of these forms as image plane and information surface. The triangle has among its applications, for example, traffic signs and gables on a roof in a painting of a house. The circle is still more

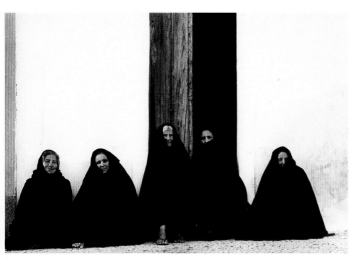

2 Vertical lines, Brightness contrast

3 Dominant point, Brightness contrast

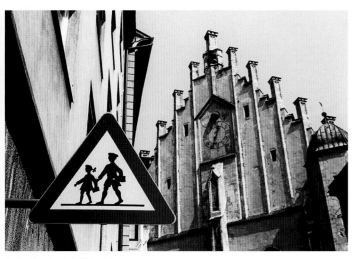

4 Dominant point, Oblique lines

5 Oblique lines, Brightness contrast

A

D

B

E

C

F

Diagrams A-F
Placing one or two circles on a rectangle always forms a design problem with the remaining negative space. Only the oval fills out the image's area harmoniously.

frequently used in our culture. The circle and its variant, the oval (the shape of video discs, round and oval decorative boxes, wall-mounted plates, etc.), are more frequently used than the triangle as image planes and presentation surfaces.

Stability and Movement of Objects

The two-dimensional surfaces of the basic geometrical shapes are related visually to specific three-dimensional objects. The square is analogous to a cube, the rectangle to a right parallelepiped, the circle to a ball (photo 11), and the triangle to a pyramid (photos 14, 17). The weight and stability inherent in cubes and right parallelepipeds can be challenged or negated by standing them on a corner or on an edge. The pyramid has a heavy base and a sharp peak in

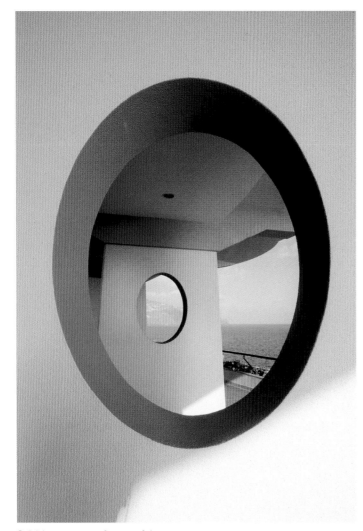

7 Brightness contrast, Contrast of shapes

6 Brightness contrast, Contrast of shapes

8 Dominant point, Warm color balance

each case, and thus possesses significant visual stability. Only in experimental images is a pyramid placed upside down, so that the vertex pointing downward bores itself visually into the ground. The shapes and forms of square/cube, rectangle/ right parallelepiped and even of triangle/pyramid with a possible, usually upward visual movement toward a vertex, do not have a tendency to move visually from their place in an image. Their effect is primarily static, without any inclination to leave their occupied space. Being placed flat on the ground keeps "down" always down and "up" always up. The ball however is more unstable. It has only a momentary "up" or "down", and in the next instant can occupy another space. A movement and a change in the situation of a ball can be quite real; but, in addition, the viewer's knowledge that a ball could roll can excite the visual sensation

of "rolling" in an image. On an even surface any part of the ball can be up or down. A ball can convey no visual feeling that it could, for example, stand on its head. Only painted or marked balls, for example a globe, can have a clear, recognizable up and down.

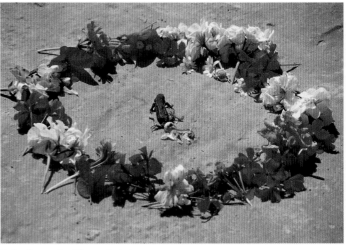

G

H

Diagrams G-H
A circle in the lower part of a portrait format sits heavily, almost "perches" on the lower edge, while a circle near the upper picture edge almost seems to float.

9 Dominant point, Horizontal lines, Cool color balance

10 Dominant point, Brightness contrast

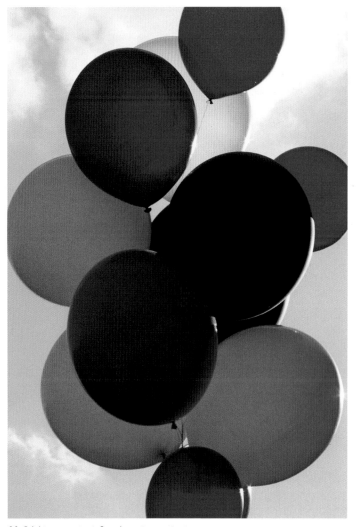

11 Brightness contrast, Complementary contrast

The Visual Weight of Shapes

With shapes in an image, their visual weight and position play a large role within the image plane. The visual weight results primarily from the manner of the shape's formation. Visual shapes formed only by points have a small weight, whereas line-active shapes, those formed by lines, carry a somewhat higher visual weight. Only when a shape corresponds to the full image surface is the full visual weight of a shape reached. The second factor for the visual weight is the size of a shape on the image area. The third factor affecting the visual weight is the lightness or darkness and/or the color intensity of a shape. A large, dark circle, for instance, carries significant visual weight in a composition. A small bright form on a darker background also carries significant visual weight.

12 Detail, Complementary contrast

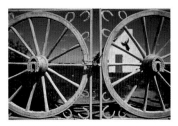

13 Two points, Vertical lines, Cool color balance

Stability and Movement of Shapes

For the stability or possible visual movement of shapes or forms on an image plane, above all their placement in the image is decisive. The circle actually does not have a substantial tendency toward independent movement. The most intensive "resting" situation for a circle, is one inside a square, touching all four edges. However, in rectangular image fields, problems with balance and tensions result between the shape "circle" and the remaining background, the negative shape. The leeway for positioning a circle in a rectangle is not large. A very central position is the quietest solution (diagram A and photos 1, 9). Slightly shifting the circle to the left or right quickly results in a disturbance in the balance of the image and must be compensated by other

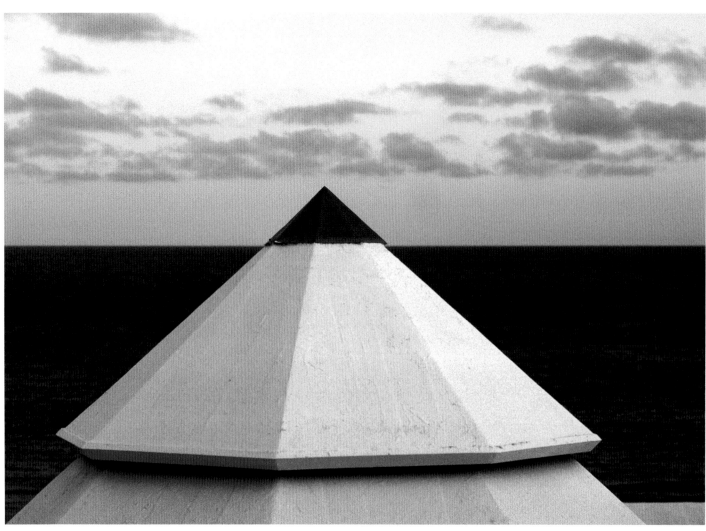

14 Dominant point, Horizontal lines

compositional elements (photo 10). A clear positioning near one of the short sides is unfavorable with compositions in the landscape format. In the portrait format the short sides are above and below, and a circle seems to sit on the ground (diagram G) or to float (diagram H). Compositions with two circles result in other problems. With smaller complete circles, a narrow strip of the image plane remains free (diagram D and photo 12). Larger circles filling out the image plane must overlap (diagram E and photo 5) or be cut at the edges and shown as incomplete. The visual strength of the circle is so strong that viewers will imagine the completion of a cut circle outside of the image plane (diagrams B, F and photo 13). To the category of "circle" naturally also belong the semi-circle, the quarter circle, and various other sections of circles. If a viewer

Diagrams I–N
Diagonal and oblique lines running from one picture edge to another divide the image plane usually into triangles. Triangles with an upward component of motion are noticed first. The visual movement of triangles is a function of how acute the angles are and their positions in the image. Sharper looking angles catch and move the eye with more authority than angles of larger measure; however, equilateral triangles, with three equal 60-degree angles, show no priority of direction.

I

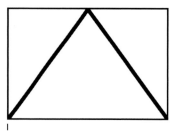

J

K

L

M

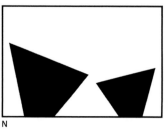

N

84

15 Dominant point, Brightness contrast

16 Horizontal lines, Vertical lines, Hued–hueless contrast

17 Textural detail, Brightness contrast

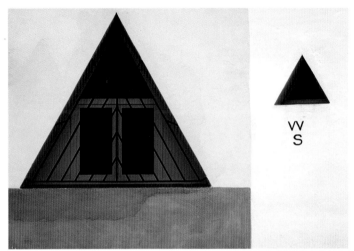

18 Horizontal lines, Vertical lines, Quantity contrast

looks at or photographs a circle from a flat angle, the optical distortion results in an oval (photos 3, 7, 8). The oval has an easy tendency to move or to expand in the longitudinal axis. For these relatives of the circle, the rectangle is an ideal image plane (diagram C and photos 6, 8). The triangle shows a clear visual activity in its own right and as a component in an image. Oblique or diagonal lines that run at angles to the picture edges and intersect both a vertical and a horizontal edge will form triangles. Here the triangles with a clear base (bottom) are the dominant shapes or the "figures", while the other developing triangles form the negative or the "ground" shapes (diagrams J, L and photos 15, 19). With a double diagonal division the weighting of the triangles is equivocal. Depending upon the viewer, the circumstances during the

19 Dominant point, Horizontal lines, Vertical lines

viewing, or the character of the design, the upper and lower triangles may have greater visual weight, while at other times the right and left triangles may be the more weighty (diagram K). If triangles are located freely in the image plane, their implied movements are affected by their external outlines and their situations in the image space. A triangle can be relatively balanced with three equal side lengths or unstable with two or three sides of different lengths. An equilateral triangle neutrally placed in the image has only a slight tendency toward movement in any of the three directions, whereas other types of triangles also placed freely in the image space show a clear "arrow effect" along the longitudinal axis (diagram N and photos 15, 16). An equilateral triangle shows a directional or an arrow-like character only if one of the sides of the triangle runs parallel to a

picture edge. Upward pointing triangles have a firm "base", parallel to the lower edge, which supports the upward motion (diagram M and photos 2, 4, 14, 17, 18). Triangles pointing downward show downward movement, but their standing on a vertex also makes them visually unstable (diagram L). Naturally a composition with triangles can produce clear visual movements to the left or right (photo 19). Imaginary supplementing of triangles, which goes beyond the picture edges, is not as compelling as with circles. One's eye is rather challenged to discover triangular shapes in the negative spaces, or background (diagram N).

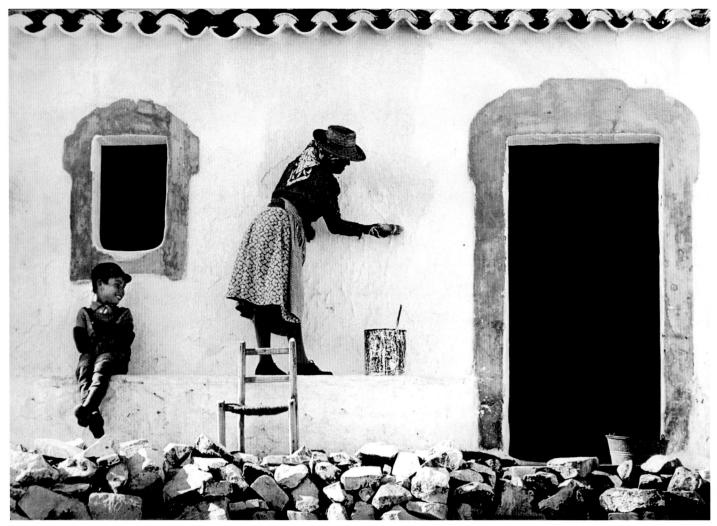

1 Vertical lines, Brightness contrast, Detail

Variants of Shapes, Irregular Shapes, and Contrast of Shapes

Shape is actually defined by the outline of an area in contrast to the respective surrounding field. In a picture on a two-dimensional surface, the viewer only sees the shape of a 3-dimensional object as a partial view. When the viewer recognizes articles and natural objects, he/she recalls from memory earlier visual experiences that supplement and complete the one-sided partial view in the imagination.

Variations in the Geometry of Shapes

The primary geometrical shapes are the square, the circle, and the equilateral triangle. Both the two-dimensional basic forms and their three-dimensional counterparts, the cube, the ball, and the three-sided equilateral pyramid, are absolute and cannot be improved. These basic shapes and other geometrical shapes are products of human cultural invention. To this category belong, as do many other geometrical forms, the results of combining into one shape any two of the basic shapes. One can develop from the square and the triangle the trapezoid, from the square and the circle the oval, and from the circle and the triangle a round-sided three-cornered figure (diagrams D, E, F). Shapes invented by mankind must surely be classified as late-term

2 Visual shapes, Brightness contrast

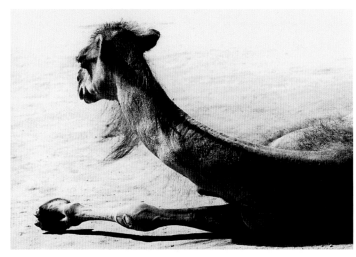

3 Horizontal lines, Diagonal lines

4 Vertical lines, Contrast of lines, Brightness contrast

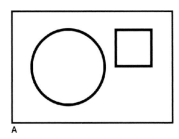

Diagrams A-C
Placing different shapes together in an image is another well known artistic technique. Contrasts of shapes can arise from differences betweeen a round and an angular shape, geometrical and natural shapes, different natural shapes, or well known to unknown shapes.

5 Brightness contrast, Detail

inventions. Already without visual aids many geometrical forms can be found within different fields of nature with the naked eye. For instance, the sun and the full moon, river deltas, flowers, leaves, and mushrooms, even animals and animal products (for example jellyfish, rolled up hedgehogs, some insects, nests, eggs, or honeycombs).

The Variety of Natural Shapes

The boundary between geometrical and natural shapes is fluid. One can name natural shapes only conditionally as irregular shapes. Many natural shapes are tied to direct or super-ordinate terms. The irregular shape of the outline of a leaf, a bush, or a tree becomes immediately defined as a leaf, a bush, or a tree – and not as an abstract

6 Horizontal lines, Brightness contrast, Textural detail

7 Brightness contrast, Cold–warm contrast

8 Horizontal lines, Oblique lines, Brightness contrast

concept of shape with an irregular outline (photo 6). With more exact knowledge of botany, for example, the identifications become even more precisely maple leaf, rose bush, or birch tree. Although the outlines of shapes can vary a great deal (and naturally also in their surface and tonal values), shapes are differentiated primarily according to an allocation to a group of objects and only rarely according to an allocation to a group of shapes. Shapes in nature change constantly. These processes of change are directly observable only in rare instances. For the most part these are growth processes and seasonal metamorphoses for plants and animals. But there are also changes that happen over longer time scales that vary from years, to decades to centuries, and even longer. Changes in landscapes, sand dunes, mountains, rocks, or cliffs (photos 2, 9), may be

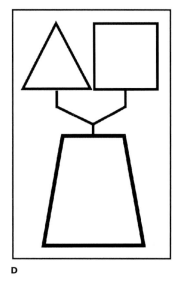

D

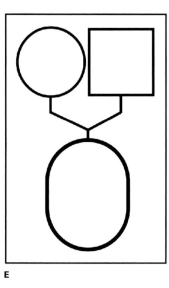

E

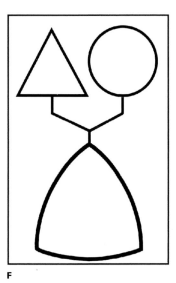

F

Diagrams D-F
As mixing two first-order colors creates a second-order color, so mixing two primary shapes, triangle, square and circle, creates the secondary shapes of the trapezoid, oval, and round-sided three-cornered figure.

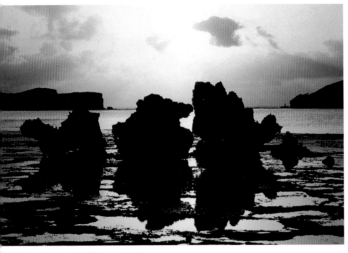

9 Brightness contrast, Warm color balance

10 Texture, Warm color balance

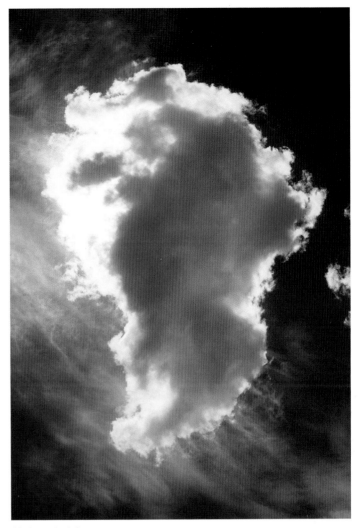

11 Cool color balance

noticeable only in comparison with very old photographs. Anyone can observe waves and clouds changing constantly, for example. A picture of a volatile shape is thus a fixed, nonrecurring formal condition (photos 7, 11). A continually changing outline of shapes naturally occurs with all live beings, humans and animal, and is an important factor in the quality of an image's design. A shape is not seen in isolation here as a "shape", but is always tied to the category or specific name of the recognized figure. Among animals, for example, are cats, dogs, cows, and so on, or for humans there are children, girls, boys, women, or – possibly – additional differentiations by age, race, and social status (photos 1, 3, 4, 14). Naturally the image quality of a shape results from a correctly selected moment of exposure (for example, at a peak of action, or "decisive moment") and the

12 Horizontal lines, Cool color balance

harmony of a favorable photographic point of view and selection of lens focal length. Apart from general snapshots this is particularly decisive for top-quality sports photography and animal photography.

Situation, Contour, and Recognizability

A shape that we would easily recognize in a normal setting, but which is depicted in an unusual situation in an image, does not generally create a new shape. Triangles, squares, or rectangles remain triangles, squares, and rectangles – regardless of their position within the image. If one replaces the abstract concept of "shape" with the name of the recognized article – be it a known plant, animal, person, and so on, as usually occurs during the rational recognition process –

89

13 Horizontal lines, Oblique lines, Brightness contrast, Cold–warm contrast

then a chair may be tipped over, a cat may be jumping, or a person may be standing on his head, and the viewer will still recognize the shape as a chair, a cat, or a person. Even when a shape is distorted because of being viewed from unusual perspectives, the viewer most often accepts and correctly recognizes it. In such cases, the viewer's mind "corrects" the shape without judging the quality of the image in the same instant. It is also possible to interfere with or prevent one's ability to recognize an object or shape. The photographer can show or conceal details of objects by choosing an unusual point of view or lens. Most of our experience in seeing familiar objects is from a "normal" view or perspective; that is, from eye level with either some horizontal scanning to the right and left or a point of view with a slight upward or downward angle.

14 Cold–warm contrast

15 Cool color balance, Brightness contrast

16 Vertical lines, Contrast of lines, Cold–warm contrast

17 Horizontal lines, Cold–warm contrast

18 Brightness contrast, Cold–warm contrast

19 Texture, Brightness contrast, Two-color scheme

20 Brightness contrast, Warm color balance

Viewing the same objects from directly overhead or from underneath can obscure familiar details and make recognition difficult or impossible. Many subjects, especially live subjects, offer many different, visually striking aspects for making images of the shape or contour. The best known example would be the frontal and profile views of people in portrait photography. Besides the geometrical shapes and irregular shapes that can be recognized and named immediately, there remain the completely irregular shapes. Shapes with completely irregular outlines are the norm in natural subjects or can arise in the culture field as inventions of artistically active people (photos 5, 10, 12, 13, 18-20).

Contrast of Shapes

Since the image format is usually a geometrical shape (square or rectangle), it can itself form a contrast to the shape of a component in the image. On this primary level a contrast of shapes, however, only exists with simple compositions where a single shape clearly dominates the image (photos 6, 11, 12). Generally a contrast of shapes refers to the visual play of different shapes in the image. Contrasts of shapes can be between different geometrical shapes, geometrical and irregular shapes, and between two or more irregular shapes (diagrams A, B, and C and photos 1, 4, 7, 8, 12-18, 20).

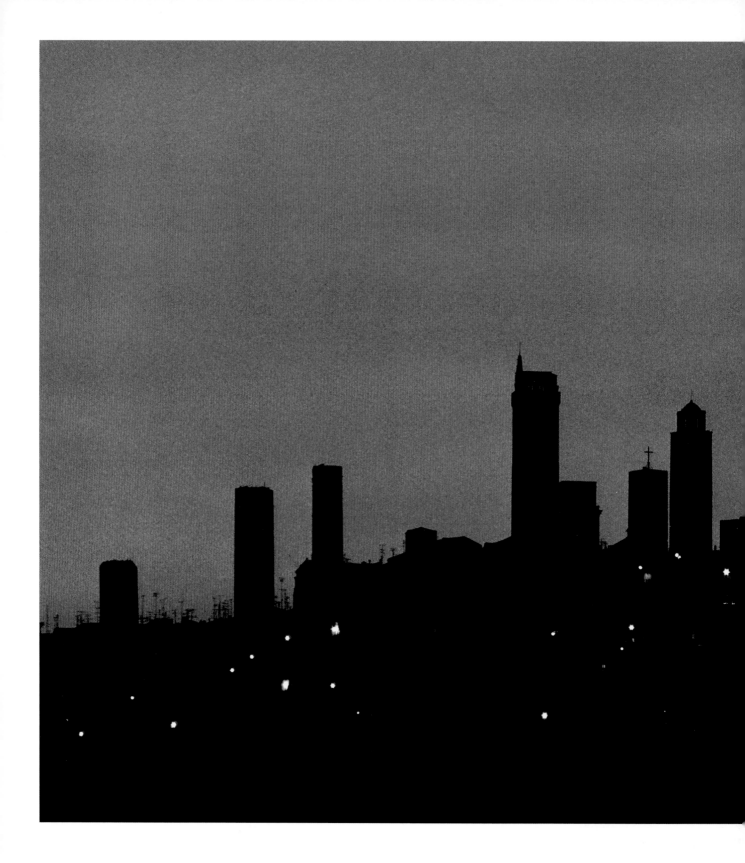

Universal
Contrasts

Within the realm of design and color, an artist or photographer
has a choice of many methods and contrasts to use or not in
creating an image. On the other hand the universal contrasts
are almost always present in a picture: concrete or abstract
shapes, differentiations in the lightness and darkness of
monochrome or colored tones, and – despite the limitations of
the two-dimensional surface – a certain spatial effect within
the picture.

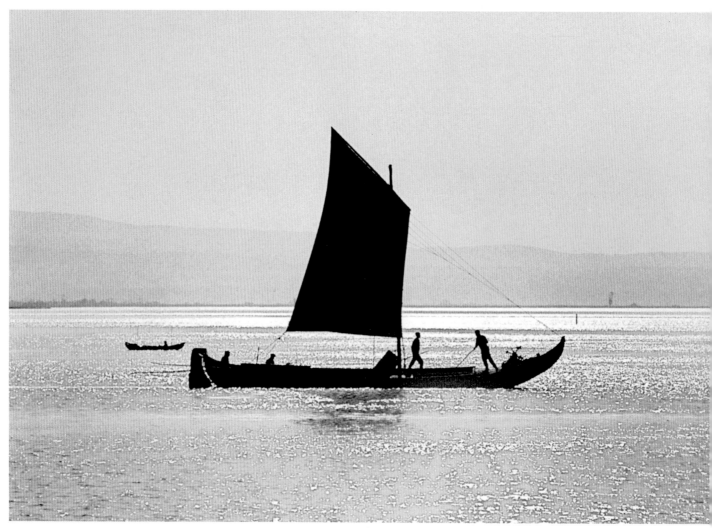

1 Horizontal lines, Vertical lines, Brightness contrast

Figure and Ground: Positive and Negative Forms

The process of seeing a picture involves recognizing and mentally arranging the main object (subject), possible secondary subjects, and the background, which may not be of great significance. The image planes are usually divided into foreground, middle ground, and background. The first shapes to be recognized become, initially, the positive form – the figure. A further shape lying behind, or the remaining part of the image plane, is designated as the negative form – the ground. Ideally the negative form supports the visual effect of the positive form.

Recognizing Shapes and Objects

The use of different contrasts can enhance a viewer's recognition of a clearly defined shape. The clearest possible tonal contrast is absolutely necessary for black-and-white photogaphy. As a visual phenomenon, a bright shape on a dark background is much more influential than the same shape in a dark tone on a bright background (diagrams E, F). Tonal contrast in color pictures often couples with a contrast of hue and/or a quality contrast (the degree of purity of the color). Indistinct tonal contrasts or contrasts of hue, or colors with similar tonality reduce the visual separation between and impede the clear recognition of the main subject and the background (diagrams G, H). The design of any image can be reduced to an abstract structure independently of

2 Vertical lines, Triangles, Brightness contrast

3 Detail, Brightness contrast

4 Oblique lines, Brightness contrast

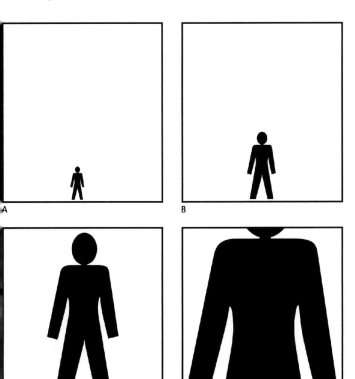

A

B

C

D

Diagrams A-D
The back-and-forth effect of changing one's focus from the figure to the ground and back again represents the basic figure-to-ground problem. This visual effect of one's focus alternating between the figure and ground because of a competition between elements in the image that have nearly equal visual weight is referred to as "figure-ground flip". The positive form (figure) and the negative form (ground) interact with each other to produce the various possible visual effects.

whether it is built around geometrical, irregular, or a mixture of geometrical and irregular shapes. Here the viewer's ability to break the design into "foreground figure" (positive form) and "background" (negative form) depends more on the viewer's feelings than ability to recognize. If a shape is identical to a material object that the viewer can classify or categorize, the viewer will recognize and focus upon it first. An ability to recognize a material object or an illustration of that object depends on the viewer's knowledge, experience, and education. Really in terms of an image's content or meaning, one can "recognize" only what one knows. Rational perception is thus above all recognition. The more comprehensive a viewer's education or specialized knowledge, or the greater the number of pictures one has seen, the more contents and

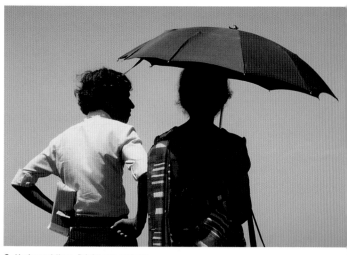

6 Horizontal lines, Brightness contrast

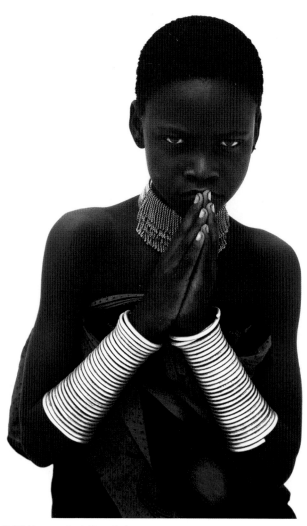

5 Brightness contrast, Linear texture

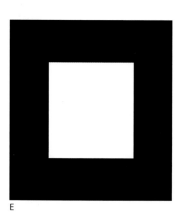

7 Horizontal lines, Vertical lines, Detail

details one will recognize and connect to other experiences. Education and knowledge are naturally not evenly distributed among all people, but in no small measure are related to the parents' income, ages, education, occupations, and fields of study, as well as many other factors. Generally one can assume, however, that an image developed within our cultural milieu will be recognizable also to viewers of similar cultural background. Furthermore since the general level of education is so high in our cultural arena, many people recognize the content and message of illustrations from other cultures. The pure process of recognizing can be impaired by influences in the surrounding visual field. Apart from too little tonal contrast or contrast of hue, still other factors can disturb the process of seeing and recognizing the figure or article. On the one

Diagrams E-H
Equally sized shapes can appear to advance or recede, or appear to be larger or smaller, according to how the background is treated. Low tonal contrast or similar tonal values of colors will complicate the perception process.

E

F

G

H

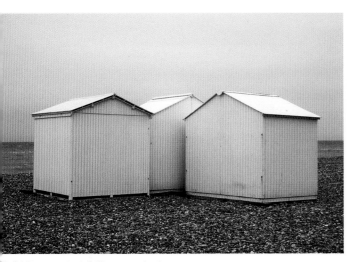

8 Brightness contrast, Cold–warm contrast

10 Vertical lines, Detail, Brightness contrast

9 Visual lines, Detail, Cold–warm contrast

11 Brightness contrast, Oblique lines

hand, a contrasty surrounding field with a lot of detail (photo 3) or diverting colors, as shown in photos 10 and 11, interferes with the viewer's perceiving and recognizing the main subjects. On the other hand any kind of an overlay of shapes or articles by plants, lattices, screens, structural materials, or other such items (photo 14) also impedes recognition.

The Visual Weight of a Shape on the Image Surface

The visual weight of an abstract or a material shape is determined primarily by its size in the image. A small or very small shape (in relation to the surface area or image plane surrounding the shape) has the visual weight of a point – perhaps even a disturbing point. A shape's dominance in weight or size

excludes the background. Only if a shape is large enough can it work as a visual mass and oppose the background (photos 6, 11). Which size in relation to the image plane is necessary for a shape to arrive from the effect of being a point to the effect of being a mass, depends on the subjective feeling of the individual viewer. Between the extremes of too small a figure and a shape's occupying much of the image space (photo 12), visual weight relationships between figure and ground are continuously variable (diagrams A–D).

Figure-Ground Contrast

The terms "positive shape" and "negative shape" sound abstract, but include, however, the shapes of all kinds of things – geometrical shapes as well as natural shapes: circles, triangles, and

12 Brightness contrast, Cold–warm contrast

13 Brightness contrast

14 Visual lines, Textural detail

15 Texture, Contrast of shapes, Complementary contrast

squares along with trees, clouds, people, and animals. The designation of this contrast as "Figure-Ground" is less abstract when a geometrical shape is felt as the figure. "Ground" means background, or depth, so that figure-ground contrast designates also proximity and distance, foreground and background. In the simplest application a clear shape stands as a bright, dark, or solid colored surface, or as a silhouette against a neutral background with the clearest possible tonal or color contrast (photos 1, 5, 6, 11). Often the interrelation between positive form and background (negative form) is experienced, however, not only as two layers, but as multilayered. A small shape stands before a larger shape, which in visual terms is both the negative shape for the smaller form and for itself a positive form before a background which represents

still further depth (photos 2, 5). The more shapes and colors that are used in a composition, the more complicated becomes a formal image analysis of the interrelation of positive and negative forms. In contrast to images with clear simple shapes, when there are two- and three-fold shapes, repeated shapes, and multiple shapes that coalesce into surface-filling structures, the figure-ground contrast plays only a subordinate role (photos 3, 14, 15).

Change of the Positive-Negative Priority (Figure-Ground Flip)

Only in compositions reduced to one or a few simple, nonover-lapping shapes, is the allocation to positive or negative valuation clear. Already if two shapes overlap, those material or visual shapes lying behind form part of

the negative surface to visual or material shapes in front (positive shapes). In addition, the rear shape stands against a background, which is a negative shape for both of these other shapes. A surface or a shape can be, therefore, the negative shape for another surface or shape, its background, and be at the same time a positive shape, which is again surrounded by another negative shape. In classifying positive and negative shapes in a composition, one can analyze a picture from the outside in or from the inside out. A strong example here is the portrait of a young African woman in photo 5. The bright background is the absolute negative shape, which is limited on the left, above, and right by the contour of the figure. The strong light-dark contrast stresses the large positive form of the total figure. Within the overall figure the bright

6 Brightness contrast, Cold-warm contrast

7 Brightness contrast, Monochrome color balance

18 Texture, Brightness contrast

bracelets against the dark cloak and skin are eye-catching small positive shapes. The cloth and skin form the background, the negative shapes, for the bracelets. Going into still more detail one finds positive and negative shapes in the cloak, where black or blue sections stand as small positive forms on blue or black surfaces. The positive-negative priority of a surface or a shape can change in this manner. A material analysis of all levels of any composition can identify the simple or changing positive-negative priorities of shapes and surfaces (photos 2, 9, 19). For a subjective picture evaluation, such an analysis is not always necessary. The effect from two or three shapes combining visually into one single, large, complex figure (photos 7, 8) is enhanced by a clear positive-negative contrast between the large shape and the background.

19 Brightness contrast, Three-color scheme

A clear visual effect of looking through an opening (referred to as "frame-within-a-frame") can develop from dark shapes on three or four sides of a frame, such as an open door or window, limiting the normal movement of one's eye within the image. The effect of hollow or empty shapes can be so intense that the viewer will readily accept these shapes as figures (photos 4, 16, 17). Also an overlying shadow can have the quality of a dominant shape (photo 18). The contours of two or more identical positive shapes can form negative shapes of sufficient visual interest that a viewer's eye moves back and forth between the positive and negative shapes in a "figure-ground flip" without settling down (photo 13).

1 Dominant point, Vertical lines, Oblique lines

Tonal Contrast, Light and Lighting

The process of recognizing an object or image of an object usually takes only fractions of a second. Clear and pronounced contrasts assist this process. This applies to all our senses. Apart from the contrasts of loud and quiet (hearing) and cold and warmth (touch), it is above all the contrast of bright and dark (sight), which informs one's first sensory experiences. While the extremes that can be felt of noises and temperatures are relative, the contrast between lightness and darkness has absolute extremes with white and black.

Tonal Contrast in Black and White Images

The darkness of neutral black and the brightness of neutral white with all the intermediate stages from the darkest to the brightest neutral gray tones represent the field of the light-dark, or tonal contrast. In black-and-white photography, tonality is the only means of design available to stimulate visual perceptions in a viewer. To be able to perceive positive and negative shapes, their size, kind, quality, and surface character, the tones in black-and-white photography are the only artistic means available to the viewer. Weakly developed tonal contrasts – black against black, white against white, or minimally differentiated gray tones – complicate or prevent shape recognition and understanding of the picture's content. The transition from the

2 Visual lines, Visual shapes, Vertical lines

3 Dominant point, Textural detail

4 Vertical lines, Oblique lines

brightest to the darkest tones through the gray tones is most often smooth in black-and-white pictures (diagram A and photos 3, 5). That is, the number of gray tones cannot be designated unambiguously. Some subjects, however, show a clear separation of the gray tones (diagram B and photos 1, 4). Using darkroom techniques or computer manipulation, gray tones can later be changed or isolated (tonal reduction or tonal separation).

5 Dominant point, Textural detail

Diagrams A–C
The progression from a bright to dark tonality or color can be shown either in clearly graduated steps or as a continuous, flowing transition without visible steps. This is the case for both the transition from pure black to pure white and the transitions of all hues from dark through pure to light.

A B C

6 Irregular lines, Simultaneous contrast

7 Irregular shapes, Detail

8 Active lines, Contrast of lines

Tonal Contrast in Color Images

The processes of perception and design are determined in color photography not only by variations of tones, determined by white and black, but naturally also from colors. More exactly said, the hues of the pure colors are not those of the neutral, colorless tones of black, white, and the grays. The brightness-to-darkness gradient of the pure primary and secondary colors runs from yellow, the bright extreme, to violet, the dark extreme. In the case of the pure colors, the original color may be lightened with white, darkened with black, or degraded with another pure color (diagram C, photo 6), as well as acquire a different density. Each pure color can, therefore, have a brighter or darker visual effect. Each individual color, as well as two, three, and more pure colors,

make different statements to and have different effects on the viewer, and can usually be used in the widely acknowledged color contrasts. Some color contrasts are loud and clear, but others are in part very sensitive interrelations of colors, the effects of which are often perceived only after some effort in the viewing process. Now a viewer's goal in studying any picture is to identify the artist's message and to understand how the artist's arrangement of elements conveys or supports that message. In addition, at the same time, the means of design and the applied artistic contrasts used in an image work on the viewer's perception. Here there are "visually louder" and "visually quieter" elements of the picture and color design. A viewer will naturally consider these more or less quickly; they catch one's eye immediately or must be analyzed consciously. A

9 Point, Vertical lines, Complementary contrast

strong light-dark contrast will "push to the front" in a color picture, and those shapes and the contrasts of shape will be strongly emphasized. This visual effect will usually support the recognition process, but subtle color contrasts will simultaneously be overwhelmed. In black-and-white photographs, all formative and artistic means, as for example the line and line types or tension-rich contrasts of size, are always coupled with tonal contrasts. A color picture can get along, however, without (or almost without) any tonal differentiation among the colors. The converse of that is also valid the more clear or intense a brightness contrast is in a color picture, the more it competes with the subtler color effects. Shape and brightness have the primary effects, whereas the colors, their visual effects, and the color contrasts are often only felt or seen as

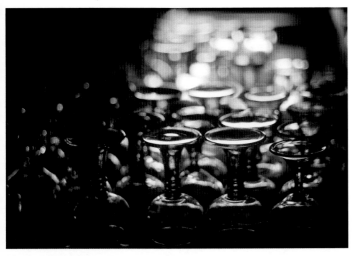

10 Detail, Cold–warm contrast

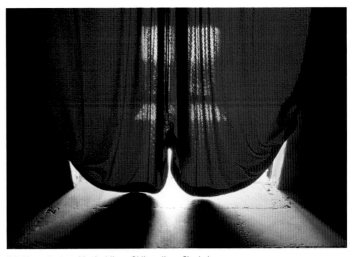

11 Linear texture, Vertical lines, Oblique lines, Single hue

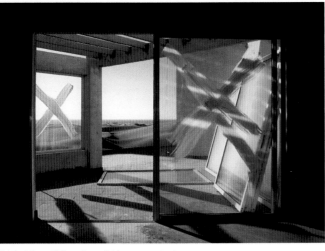

12 Vertical lines, Oblique lines, Cold–warm contrast

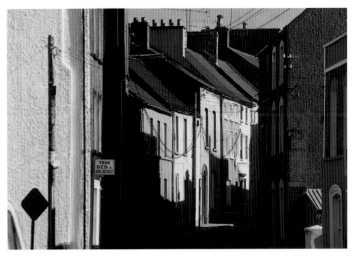

13 Vertical lines, Oblique lines, Cold–warm contrast

secondary effects (photos 8, 12). An intense color can stand up to a strong brightness contrast (photos 9, 11, 13, 19). If a shape-defining contrast of tones is not congruent with an (rationally recognized) object, the viewer will experience some irritation (photos 7, 12, 13).

Tonal Distribution in the Picture

Small areas in an image that contrast strongly with their immediate surroundings receive priority in a viewer's consideration. One's eye is especially attracted to and, to a degree, visually isolates small dark areas distributed in a bright or very bright (high key) picture (photo 2). Small bright marks distributed over a dark or very dark picture induce the eye to jump from one bright spot to the next bright spot following an imaginary "path of light" through the picture. Compositions that allow one's eye to "read" or scan the image from left to right are felt as harmonious and calm. Therefore, a sequence of bright areas commencing in the upper left corner or left side of an image permits the eye to enter the image in the customary manner. At the same time, scanning the diagonals allows one to form an impression of the image's overall tonal distribution. If the left side or upper left quadrant of the image is dark, the eye has to overcome a strong visual habituation or must seek an unusual entrance into the image from the right side or the bottom (photos 10–12, 19). Within the picture, the eye moves throughout the design in so-called saccadic eye movements, jumping back and forth between light and dark areas or colors, before it settles on the subjectively most important point in the picture.

Light and Lighting

The interactions of light and color can be very clear but also very complex. Thus an actual situation or, with some limits, an objective picture of an actual situation can lead most observers to clear, similarly felt perceptions, but also to less unequivocal, very subjective perceptions. In black-and-white pictures the abstract reduction to black, white, and gray tones takes from us the familiar differentiations offered by light and color. Every kind of light and every source of light will transfer as black, gray, and white tones. The known differences between warm and cold, natural and artificial light are not immediately apparent in a black-and-white picture. Only

103

14 Visual triangle, Oblique lines, Complementary contrast

15 Dominant point, Oblique lines, Cold–warm contrast

16 Vertical lines, Oblique lines, Detail, Cold–warm contrast

by recognizing the subject can the viewer draw conclusions about the sources of light and the lighting conditions which prevailed during a photographic exposure (photos 1, 4, 5). The conversion of colors into black-and-white tonal values is an abstraction. Neither the color tonal contrast, the color quality (the purity of the hue), nor other important color contrasts are recognizable. A viewer can only assign abstract colors to individual bright or dark areas in a black-and-white image when the subjects in the picture are known physical objects (for example, trees or plants as shown in photo 3) or objects with known coloration (for example, an orange or the fire shown in photo 5). In color pictures, light and lighting get other weightings. The type and quality of a light source can often influence the visual competition among the tonal

and color contrasts and the visual effects of color. Harsh daylight, directed sources of light, and back lighting will as a rule support strong tonal contrasts (photos 4, 6, 9, 10, 11, 13, 19). Soft, indirect light reduces tonal contrasts and the intensity of colors (photos 14, 15, 16, 20).

Diagrams D, E
The spectrum of normal daylight is composed of approximately equal contributions of each color.
The spectrum of an electric light bulb shows a clear overweighting in the yellow-orange-red wavelengths.

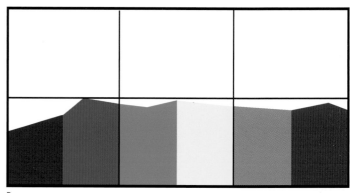

D

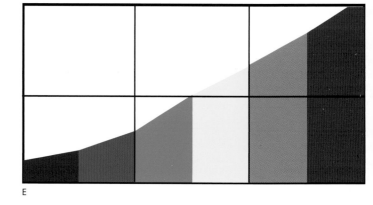

E

17 Dominant point, Rectangle

18 Oblique lines, Cool color balance

19 Dominant point, Warm color balance

20 Oblique lines, Circles, Cold-warm contrast

Light, Color, and Film

Black-and-white film abstracts all light into varying grades of neutral light and dark tones. Easily differentiated reproduction of tones is possible with monochrome film emulsions of low, medium, or high sensitivity. Color film is quite different in that it also reacts to the color temperature of the respective source of light. White light (sunlight) includes the basic elements of all colors. When a prism splits a ray of sunlight into the spectrum of the visible pure colors, the wavelengths from red to violet are approximately between 400 and 700 nm. Any physical object, the entirety of our material world, is in reality colorless. An object's color is a function of the wavelengths of light emitted from it or reflected from it. Any object absorbs certain wavelenghts of

light and reflects others so that the particular mix of reflected light produces the object's visible color. Different light sources emit light wavelengths of very different composition. Sunlight has a color temperature of 5,400 Kelvin and is fairly evenly comprised of all the wavelengths of visible light (diagram D), whereas incandescent light bulbs shine at 3,200 Kelvin and, as with fire, are overly repre-sented in the warm portion of the visible spectrum (diagram E photos 19, 20). Other artsy light sources stress other wavelengths, as for example neon light (pho-tos 16, 18). Besides the DIN/ISO palette of low light sensitivity (low DIN/ISO, or "slow-speed films") with relatively high contrast reproduction and high sensitivity (high-speed, or "fast" films) with relatively soft reproduction of light and rays of light, color negative and color slide films are marketed

with spectral sensitivities corresponding to the most important light sources used in photography. Daylight film with 5,400 Kelvin records all daylight situations more or less neutrally. If the color temperature of the light is less than 5,400 Kelvin (for example, at sunrise and sundown, photo 17), all pictures become warm-toned, more yellowish, more reddish. If the color temperature is higher than 5,400 Kelvin (directly overhead midday sun or overcast sky) the overall tone in color pictures becomes cooler, with a blue cast. For high-quality neutral color reproduction of art or other subjects in indoor lighting, which tends toward warm tones, there is film balanced at 3,200 Kelvin. With filters from the B row (Blue, in the steps 3, 6 and 12), the spectral sensitivity of daylight films can be transformed into that of indoor films (the full effect requires a B-12 filter).

1 Dominant point, Horizontal lines

Representation of Space, the Effect of Focal Lengths

As has been mentioned already, the first part of the process of looking at a picture is the process of rational recognition. Here all of the viewer's past experiences within the range of seeing are recalled and compared with the picture and the details therein which can be recognized. These "experiences of seeing" refer to the three-dimensionality of objects, to the actual dimensions and shapes of well-known objects and subject elements in the image, as well as the possible relative importance of several elements to each other.

The Three-Dimensionality of Material Objects

A child's first deliberate visual experiences with objects in his/her surroundings make it clear that most things are like one's body in that there are many different possible views of the same object. These visual experiences arise particularly because a very young child constantly changes points of view and eye levels. Within the child's respective space, there is thus a constantly changing point of view on the objects in his/her environment. Our "touch and taste senses" from hands and mouth actively support our "visual sense". Experiences obtained from touching articles (and in the early phase also from the child's putting them in his/her mouth) give the child information about rough and smooth surfaces, corners, points, edges, roundness,

3 Visual lines, Vertical lines, Texture

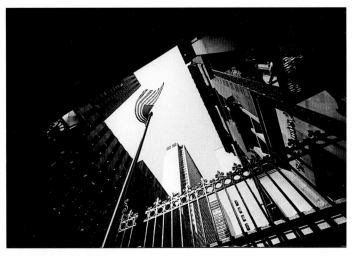

3 Visual lines, Horizontal lines, Brightness contrast

4 Dominant point, Oblique lines

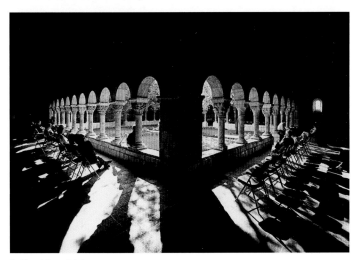

5 Visual lines, Brightness contrast

Diagrams A-F
Our own eye level determines one's perception covering the span from left to right and from looking down to looking up. Perspective lines likewise are one means of conveying to the viewer impressions of space and depth.

hardness, softness, and possibly also the taste of the respective articles and the materials of which they are made.

Space and Eye Level

The eye level of a viewer looking horizontally or at the horizon defines for each viewer whether one may at other moments be looking up or down. For example, when looking large distances across a landscape, the horizon, lying in the distance, will lie at eye level for each viewer regardless of his height. The horizon can naturally be placed at any height within the frame, but placement near the upper or lower edge conveys the impressions of looking respectively downward across the ground into the distance or upward into the infinity of the sky. Actually tilting the camera upward or downward is very

6 Vertical lines, Cold-warm contrast

7 Vertical lines, Circles, Cool color balance

8 Vertical lines, Cold-warm contrast

often done in photographing interiors to emphasize the upward feeling of space to the ceiling or the expansiveness of the floor. A viewer will see some articles of furniture or other objects in the room from an overview situation and others, such as lights, from an underview. The simplified diagrams A, B, and C show a floating box regarded from three different eye levels. The dotted line marks an eye level looking horizontally centered at the mid-height of one side of the box (diagram B, with a flat, two-dimensional representation of one rectanglar side of the box). A lower eye level allows an upward view of the bottom of the subject (diagram A), while a higher viewpoint allows one to look down on the top of the subject (diagram C). In photo 1 the photographer's eye level is clearly above the step. At the same time the photograph's

point of view is shifted to the right of the step's center so that the short vertical side creates a stronger effect of linear perspective and, therefore, of depth.

Space and Perspective

A perspective representation in an image is one way to convey the impression of depth. With the central, or frontal, perspective the vanishing point of all lines which are not parallel to the picture edges remains within the image plane (diagrams D, E and photos 2, 6, 14, 15). With all lateral diagonal views (for example along a row of houses), only the vertical lines remain parallel to the left and right picture edges. There may be one or more than one vanishing point (for example, when one looks down to the right and left of a street corner)

Diagrams G-I
A viewer can judge whether one shape lies beside , in front of, or behind another shape only if one knows the actual sizes of the respective objects or if the surfaces overlap in a manner that is obvious to one's eye.

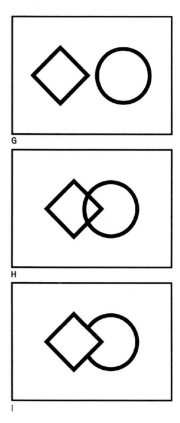

9 Vertical lines, Oblique lines

10 Visual lines, Vertical lines, Cold-warm contrast

11 Vertical lines, Oblique lines, Cold-warm contrast

that will lie outside of the image frame to either or both of the right or left sides (diagram F and photos 5, 9-11, 18). Already with a normal camera attitude (in the balance) compositional difficulties arise as a result of triangular sections in the picture corners. These issues with triangular sections in corners multiply if the camera is, in addition, tilted upward or downward (photos 4, 16). Also, with upward or downward points of view, there may be vanishing points outside of the top or bottom of the frame, possibly in addition to those beyond the right or left edges.

Further Means for Producing Spatial Effects

Overlapping objects and shapes (photos 8, 19), interesting large-small conditions, contrasts of sharp and indistinct elements

12 Dominant point, Textural detail

(photo 17), and the contrast from foreground to background of warmer to cooler, receding colors (photos 8, 11) are all means of representing space and conveying the visual effect of depth. Above all, however, light and shade on objects provide the viewer with information about their contours and three-dimensionality in front of or behind the image plane (photo 7). Also the tonal distribution of the subjects in an image plays a role, whereby a dark border bounding three or all four sides of a scene convincingly gives a viewer the impression of looking through an aperture onto a brighter part of the picture (photos 3, 4, 13); this effect is referred to as a "frame within a frame". That does not mean, however, that in principle "darkness" is to be equated with proximity and being in front. Diagrams J and K show how at times the bright and at other

13 Contrast of lines, Triangles, Detail, Warm color balance

times the dark forms are in the foreground. Overlapping shapes have an unambiguous effect of one being in front of the other only if a viewer can clearly discern the edges of the respective shapes (diagram I and photos 8, 11, 19). Crossed lines (diagram H) or unclear demarcations do not permit the viewer to define exactly which shape lies in front and which behind.

Lenses and their Effects

Producing a photographic image depends in great measure on the choice of lens. Exceptions include using photographic recording or printing media to produce images either with a pinhole camera (camera obscura) or by means other than using a camera at all. The "normal" lens, 50mm in the case of 35mm cameras and 80mm for 6x6cm

cameras, is called such because the angle of acceptance of the frame diagonal corresponds approximately to the horizontal span of unaided human vision, about 45 degrees. Focal lengths on the short side encompass the "moderate" wide-angle lenses of 35mm and 28mm, the wide-angle group running from, say, 17mm to 24mm, and the ultra-wide lenses of 15mm, the 16mm full-frame fish-eye, and the even shorter fish-eyes that produce a circular image. These circular image fish-eye lenses have been mostly out of fashion for a long time. However, use of the 16mm fisheye is easy to recognize from the extreme barrel distortion evident on any horizontal or vertical line that does not pass through the exact center of the image. The need to use this lens is sometimes forced on the photographer by the nature of the space to be photographed. But, in general,

14 Horizontal lines, Vertical lines, Oblique lines

15 Vertical lines, Diagonal lines, Oblique lines

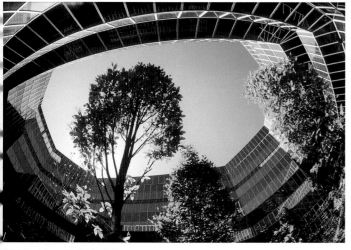

16 Visual lines, Cool color balance

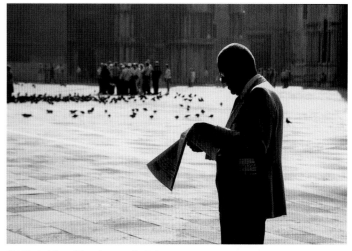

17 Vertical lines, Monochrome color balance

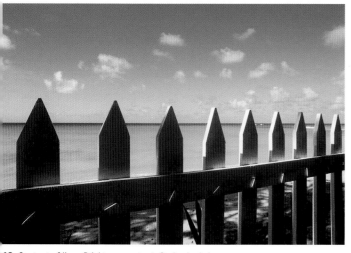

18 Contrast of lines, Brightness contrast, Cool color balance

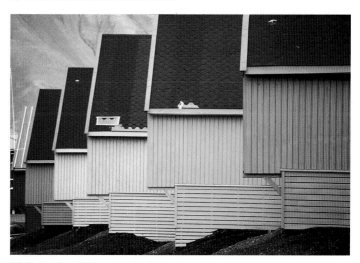

19 Vertical lines, Cold–warm contrast

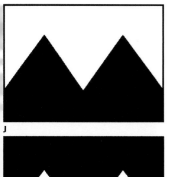

Diagrams J-K
Brightness and the darkness do not stand automatically for distance or proximity. The most important relationship is the lower picture edge with the movement from below upwards. Thus the dark "gables" stand before bright sky and the bright "gables" before dark sky.

good use of wide angle lenses requires increasingly careful technique the shorter the focal length. One must hold a camera exactly level vertically (photo 18), horizontally, or in both directions to render correctly the respective lines in a subject (photos 5, 10, 15), particularly in architecture. Tilting the camera upward or downward must be unequivocal so that the viewer clearly recognizes the resulting converging lines as the photographer's conscious decision (photos 4, 14). With images of irregular shapes, tilting of the camera may not be obvious or even discernable (photo 12). The so called "short" or "moderate" telephoto lenses run from about 80mm to 135mm. "Long" telephotos start at 180mm out to 400mm. These "long" lenses are useful for isolating slices of detail with an effect of moderate compression of the visual planes in scenic or

architectural photos, but these lenses are favored for many other types of subjects as well. The longer a lens' focal length, the more imperative it is to use a tripod or solid support to avoid blur owing to camera movement during the exposure. All wide-angle lenses support the impression of spaciousness on the two-dimensional surface by exaggerating the perspective and the sizes of objects between the foreground and background. Long focal-length lenses can convey impressions of depth only by contrasting the sharply reproduced detail in the plane of focus with the blurred, out-of-focus background or by showing shapes that overlap unambiguously.

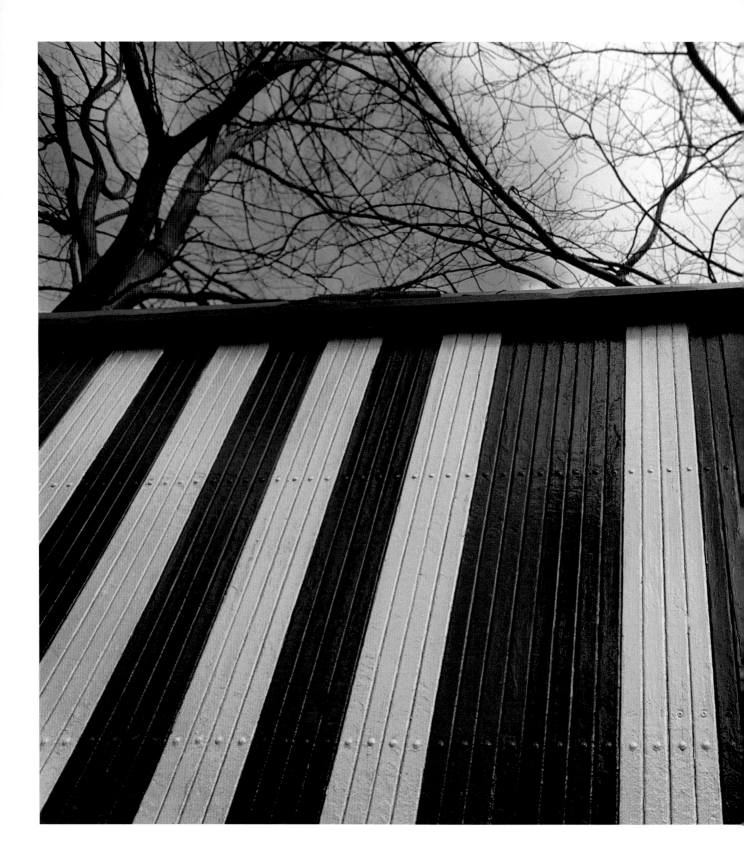

Color
Contrasts

Reactions to some particularly clear color contrasts and color effects, as, for example, color brightness contrast, contrast of hue, or complementary contrast, are virtually anchored in our genotype. Here color theory is only a confirmation of one's own feelings or sensations in reacting to an image. The primary reason to point out subtle aspects of color theory is to incorporate color theory into an analytical critique of a picture.

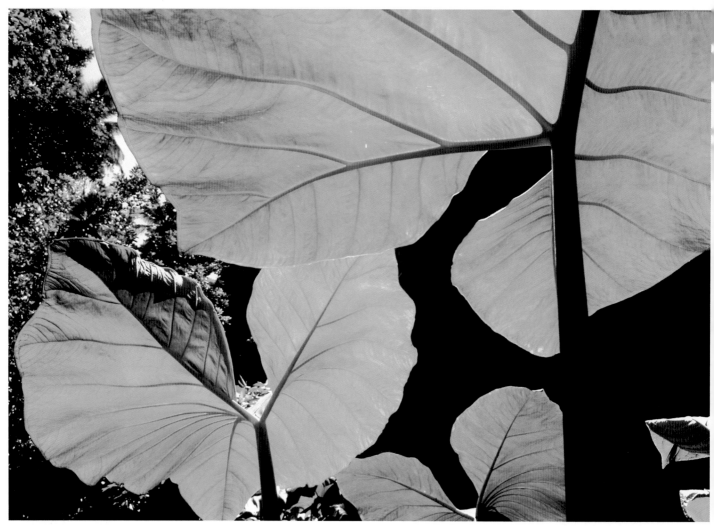

1 Brightness contrast, Detail

The Primary and Secondary Colors, Contrast of Hue

We need light to see and recognize colors. The first light of which we become conscious is sunlight. This light (between two hours after sunrise and two hours before sunset) is therefore the measure for our eyes optimally to recognize, define, and classify colors. Artificial light sources are available with spectral compositions that mimic that of sunlight, such as daylight-balanced bulbs and photographic flash systems.

The Difference Between Color and Hue

Standardized color designations are necessary and helpful, particularly in industry and for color printing. It is difficult for an untrained viewer to describe a certain color. Conversely, one can hardly expect someone to select successfully a specific color solely from a verbal description, given the almost innumerable possible nuances. In other words, colors and hues can be felt very subjectively. Apart from this possible subjective reaction of the viewer's affection for and dislike of particular colors, groups of colors have psychological and symbolic effects and meanings. Pure colors, such as the primary colors (blue, yellow, red) and the secondary colors (green, violet, orange), tend to affect most viewers directly and in similar ways. The group of pure blue

2 Brightness contrast, Detail

3 Visual lines, Vertical lines, Horizontal lines

4 Vertical lines, Texture

5 Horizontal lines, Oblique lines, Textural detail

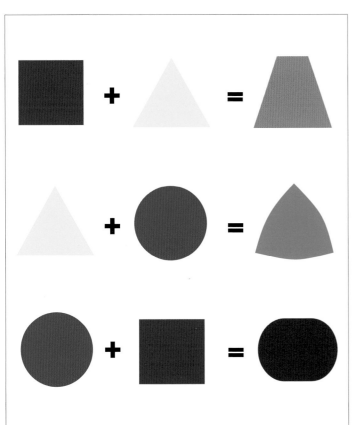

A

Diagram A
The secondary colors are developed by mixing two primary colors. If one could associate shapes with the primary colors, as do some pedagogues who match yellow with an equilateral triangle, red with a square, and blue with a circle, the resulting secondary set of shapes would be a mixture of the primary shapes. This idea is a teaching tool to put across the idea that colors can evoke emotional responses similar to those elicited by certain shapes.

colors recedes from the viewer and stands for passivity, distance and infinity (and concomitantly for coolness), for harmony, peace, and longing. The small group of pure yellow colors radiates brightly, stands for light (sun), activity and amusement, additionally, for envy and clear warning. The group of pure red colors communicates warmth and stability, and stands for proximity, excitation, strength, and heat (fire), and, in addition, for rage, noise, and danger. The pure green color group is alive, stands for freshness, vegetation (nature), springtime, fertility, hope, and for unripeness and poison. The violet colors stand for transition, boundaries, and imagination, as well as for authority and age. The color orange is luminous and often associated with gaudiness, cheap pleasure, and connected with exoticism and danger.

6 Vertical lines, Brightness contrast, Cold–warm contrast

The occurrence of colors can be roughly categorized into the colors of nature (landscapes, plants, flowers, animals, among other things, photos 1 and 16) and into those from human culture (all other illustrations). An unequivocal harmony of psychological and symbolic effect and meaning of color is most quickly achievable with photographs of natural settings (photo 1). Very often personal or artistic considerations drive color choices and applications in the cultural realm (photos 2, 3, 4, 12, 17).

Diagram B
The first order, or primary colors are a triad comprised of red, yellow, and blue and are generally perceived as having a "loud" visual or emotional effect.

B

116

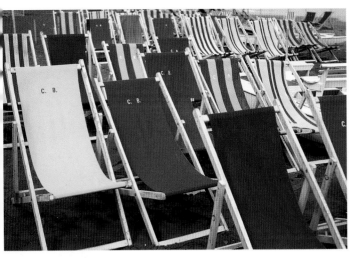

7 Oblique lines, Detail

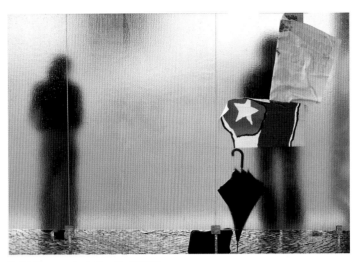

8 Brightness contrast, Quantity contrast

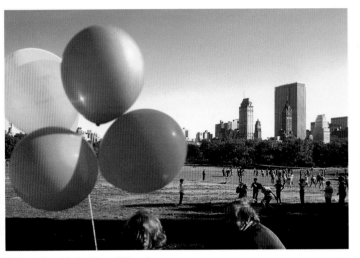

9 Visual lines, Vertical lines, Oblique lines

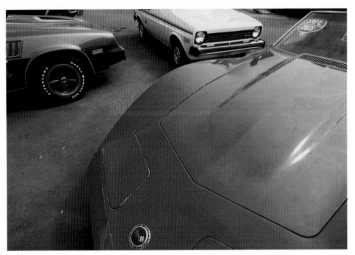

10 Dominant point, Oblique lines, Cold–warm contrast

Color Order and Shape Order

The three pigment colors of the first order are absolutely pure in each case: blue, yellow, and red. Thus a blue is neither greenish nor reddish; a yellow is neither reddish nor greenish; and a red is neither yellowish nor bluish. These three colors cannot be produced (materially) by mixing any other pigment colors: they are pure. From them, along with white and black, nearly all other colors can be mixed. Thus in each case a mixture of two primary colors produces a seconday color. From red and yellow one gets orange, green from yellow and blue, and violet from blue and red. For pedagogical utility, one can allocate a shape – a circle, square, and triangle – to the three colors of the first order – to blue (restrained) the (passive) circle; to red (heavy) the (static) square; and to

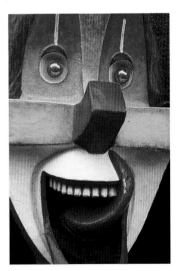

11 Dominant points, Horizontal lines

(active) yellow the (likewise active) triangle. Mixing the primary shapes into secondary shapes results for orange in the trapezoid, for green in the convex-sided triangle, and for violet in an oval (diagram A). These color shape associations were developed to teach artists about the emotional effects of color by recalling what had already been taught about their emotional responses to shapes. In everyday reality, there is no utility to this pedagogical system of color-shape.

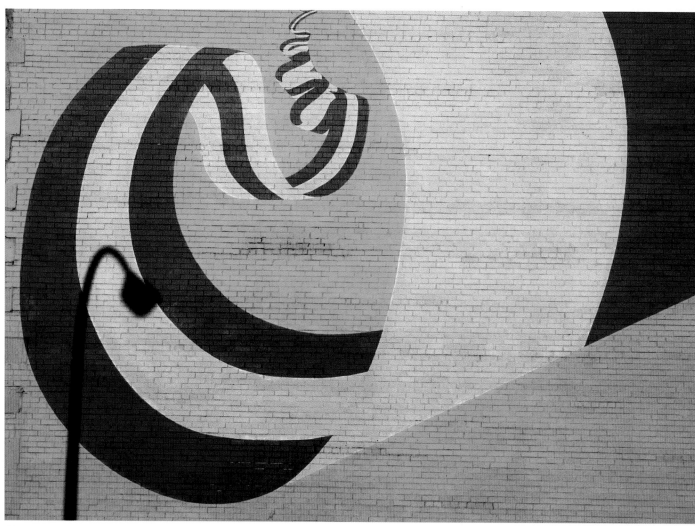

12 Dominant point, Irregular lines, Textural detail

Contrast of Hue

Contrast of hue is the simplest – and using the pure primary colors also the clearest – of the seven color contrasts. Contrast of hue does not demand much from the viewer's ability to see color nor from one's knowledge of the subjective effects of colors. Contrast of hue is most clearly evident with pure primary colors in their strongest brilliance and saturation and is very direct and loud, even merry, in its effect. The colors of carnivals (photo 11) and these colors' applications with the circus, on fairgrounds, and other entertainment venues use this loud and cheerful effect. Although already discernable with only two hues, contrast of hue only really becomes effective with at least three colors. The three primary colors form at the same time also the basic triad in either the color

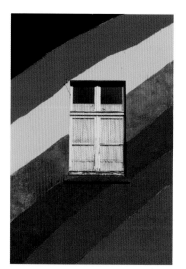

13 Dominant point, Oblique lines

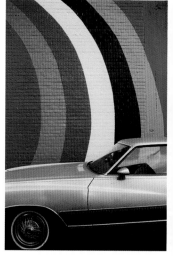

14 Dominant point, Textural detail

15 Visual lines, Horizontal lines, Vertical lines

16 Horizontal lines, Textural detail

17 Horizontal lines, Oblique lines, Squares

18 Visual lines, Detail

C

D

Diagrams C and D

A comparison of the triad of the primary colors – blue, yellow, red – with the secondary color triad *– green, orange, violet – shows the different intensity of the subjective color effects of these triads..*

circle or the vertices of the color triangle and the most direct and intense contrast among any three colors (diagrams B, C; photos 6-11). None of the three primary colors has any contribution from the other colors in itself; the contrast is harsh and absolute. This harshness is moderated if, for example, seconday colors are added to the image or form among themselves a contrast of hue (diagram D, photo 12). Also a change of the brightness or saturation of the color moderates the contrast. A contrast of hue can still be apparent in a multicolored image, but this contrast will then be subsumed in priority of effect to other contrasts and will not stand on its own (photos 15-18). Several single-colored (monochromatic) pictures placed together on a page next to each other can show the effect of a contrast of hue. So, for instance, the double

page spread of photos 1-5 in all their colors reminds a viewer of a spectrum. Graphic representations of the spectrum show likewise a contrast of hue. Photos 13 and 14 show quite free interpretations of the spectrum. Over and above the choice of how many of three (or more) colors to use, contrast of hue can be differentiated and used with subtlety, even cunning, in a composition (photos 6, 8, 9, 10).

1 Visual lines, Textural detail, Simultaneous contrast

Third Order Colors and Quality Contrast

The organization of colors into color orders and color qualities, with differences in saturation, purity, and brightness, refers to visual perception. Thus with appropriate training, one can assign to a color a set of exact parameters that allow another user to reproduce that color. Without knowing the systems of color notation and terminology, one can classify and designate colors only on a basis of emotion and personal evaluation.

Third Order Colors

There is no uniform and absolute color theory and thus also no concrete definition in our culture of what constitutes the third order, or tertiary, colors. One could reason that since a mixture of two primary colors yields a secondary color, that again mixing two secondaries will make a tertiary color. Mixing green and orange develops ocher, from orange and violet develops English-red (red-brown), and the mixture of violet and green results in olive green. The color triangle developed by George Field offers a convincing colorgraphic representation of this approach to tertiary colors (page 150, diagram D).
The points of the triangle are occupied by the primary colors, the sides by the secondary colors, and the center of the color triangle by the tertiary colors. Already between the

2 Horizontal lines, Vertical lines, Brightness contrast

3 Vertical lines, Oblique lines, Brightness contrast

4 Texture, Brightness contrast

5 Texture, Brightness contrast

6 Vertical lines, Circles, Cold-warm contrast

primary colors (blue, yellow, and red) and the secondary colors (green, orange, violet) one can observe a clear diminution of the luminosity of the respective tertiary colors. The tertiary colors have significantly lower purity and luminosity than the secondary colors and, naturally, much lower than the primary colors. In our natural and cultural environments the gray-tinted colors and the brown colors prevail along with the green tones, while the pure colors are usually rarer and then in smaller quantities. The tertiary colors of the color triangle (diagram A) – reddish-brown, ocher, and olive green – are also called "earth tones", a comprehensive term pointing to the origin of their pigments. The tertiary colors are the predominant colors found in nature: the red-brown in the earth and rocks, yellow ocher and ocher in sand, beaches and fields, and olive-green along with many other green tones in the plant world (photo 1). The tertiary colors or closely related ones are also, naturally, heavily represented in the human environment (photos 2-). Another logical arrangement for the primary and secondary colors is the six-part color circle, the smallest such color circle, developed by ohannes Itten.

ere the tertiary colors are formed by mixing two ad acent hues, as the secondary colors would have been made by mixing the primaries. o the six-part color circle logically expands into the twelve-part color circle by mixing the primary colors with each seconday color lying on either side. Thus, between each of the colors red, orange, yellow, green, blue, and violet, arise the six tertiary colors with hyphenated names from the colors from either side: red-orange, yellow-orange,

7 Vertical lines, Contrast of shapes

8 Contrast of shapes, Detail

9 Vertical lines, Oblique lines, Contrast of lines

yellow-green, blue-green (also called "cyan"), and blue-violet, and red-violet (diagram B). Strictly speaking, though, Itten's tertiary colors are only the chromatic mixing of adjacent primary and secondary colors, which are still closely related. The tertiary colors of the color circle, then, retain a relatively high degree of purity from the respective hues, contrary to the results in the color triangle (photos 11, 16). They differ in their brilliance and saturation only insignificantly from their neighbours in the color circle. To produce earth tones using Itten's system requires mixing a color in the circle with its complementary color or with black.

Diagram A
In the color triangle the third order (tertiary) colors arise from mixing two secondary colors.

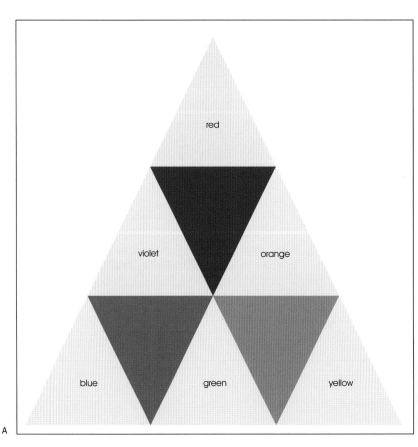

A

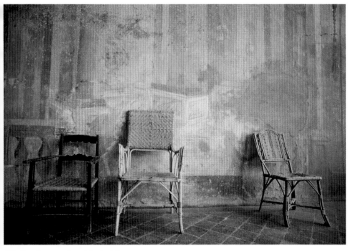

10 Dominant points, Vertical lines

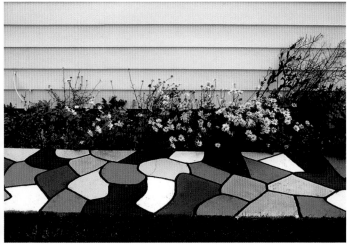

11 Horizontal lines, Contrast of shapes

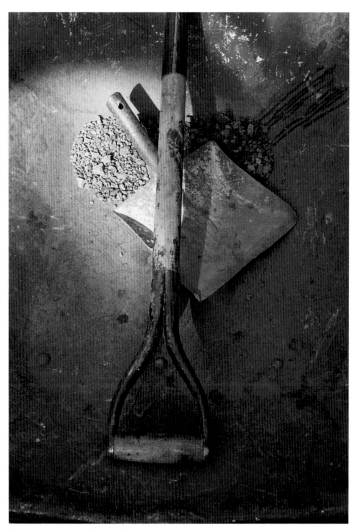

12 Dominant points, Vertical lines

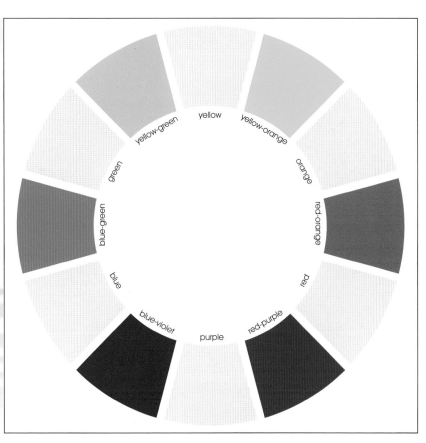

B

Diagram B
In the twelve-point color circle the tertiary colors are mixtures of a primary color and a secondary color. These new colors are designated using double names.

Color Quality Contrast

The designation of the quality of a color refers to its degree of purity. The degree of purity (luminosity) of the pigment colors that a viewer perceives and feels subjectively in an image is a function of the colors and their surroundings. Quality contrast is the contrast that exists in a picture between a pure color and one or more stages of degradation of that color (diagram C, photos 13–15). Quality contrast is best seen where there is only the one color present. The presence of a second color causes a quality contrast to recede into the background, especially if the second color introduces a cold-warm contrast between the two colors. Thus quality contrast consists of setting a pure color against duller variations of that color. All colors of the twelve-point color circle can be

123

13 Visual lines, Horizontal lines, Irregular lines, Textural detail

designated "pure" in terms of their absolute brilliance and saturation. These pure colors have the highest possible brilliance. There are several methods by which one can muddy or degrade the pure colors, and the colors and color groups react very differently to the respective manner of degradation. Mixing white, black, or neutral gray with a pure hue results in a neutral loss of brilliance or desaturation. The logical result is that mixing with white lightens a color (note that adding white does not increase the brilliance of a pure color), black darkens it, and gray will cause a moderate darkening. The differing reactions of colors to degradation are apparent for many of them in the manner in which the "new" colors are named. Thus, for example, since the blue-green colors react only slightly to mixing with white, the new colors are called "light

blue" or "pale green". However, the red-violet colors react so vigorously to mixing with white that the resulting new colors are called "pink" and "lilac", completely new color names. Mixing with more and more white will cause any color to lose its brilliance, become cooler in emotional effect, and run the risk of turning "sickly sweet". The blues and greens also hold up when mixed with black, becoming "deep blue" or "dark green". Violet, already the darkest of the pure hues, with black also becomes dark violet. The warm hues, however, the reds, oranges, and yellows, are extremely sensitive to any mixing with black, gray, or their complementary colors. While yellow is the brightest and lightest of all the pure colors, the slightest bit of black, gray, or violet will break its brilliance and muddy it, in the best case, to an olive green. Darkening

c

14 Vertical lines, Brightness contrast

Diagram C
The quality of a color is determined by the degree of its purity. Lightening and darkening colors does not reduce their purity. Desaturating a color reduces its purity.

15 Contrast of shapes, Detail

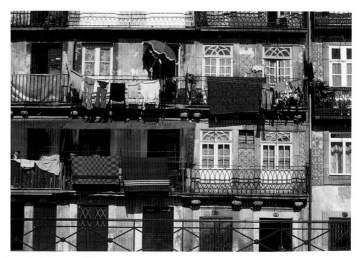

16 Visual lines, Horizontal lines, Detail

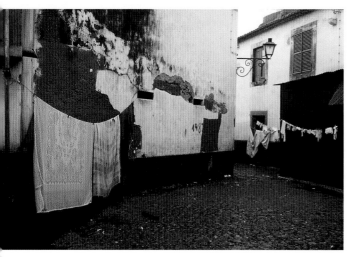

17 Vertical lines, Oblique lines, Detail

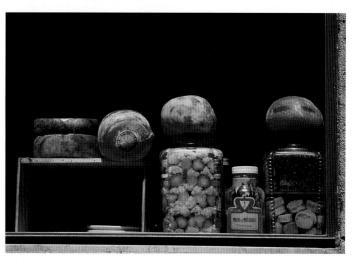

18 Visual lines, Horizontal lines, Detail

the red and orange hues yields a wide palette of browns. Mixing black with any color darkens it, very quickly reduces its brilliance, and breaks its purity. Neutral, hueless gray neutralizes and dulls the pure hues. Mixing a color with its complement, located diametrically across the color circle, muddies it and causes it to approach the tertiary colors of the color triangle, described above. Under exposure or over exposure (equivalent to adding black or white to a photographic image), artificial or natural reduction of light intensity (as at dawn or dusk), or back lighting corresponds in some measure to the darkening or muddying colors. Note that over and under exposing a photographic image affects the brilliance of the colors and not its saturation, as is commonly, but incorrectly stated even by a large number of professional photographers. Even the lightest

colors can be fully saturated. One can usefully think of underexposing as adding black and of overexposing as adding white to the image's overall color balance.

The Interaction of these Contrasts

The apparent luminosity of any color can be reduced or strengthened by the lightness or darkness of the respective surrounding field. The reserved nature of the visual effect of the tertiary colors can be reversed to some degree by a dark surrounding field. A neutral black, absolute darkness, has the largest effect for (visually) increasing the brilliance of colors. Among the three tertiary colors of the color triangle, there is only a minimal brightness contrast, and the differentiation from one color to the next

depends on the hue. The heightened brilliance caused by a dark surrounding field inevitably increases, however, the overall contrast of hue in the picture itself (photos 17, 18). Here the contrast of hue and the brightness contrast compete with each other visually. Images with colors lightened with white, muted colors (for example, in fog or rain, photos 8, 9), or faded colors (photos 10, 12, 13), have a reduced brightness and a vaguer hue.

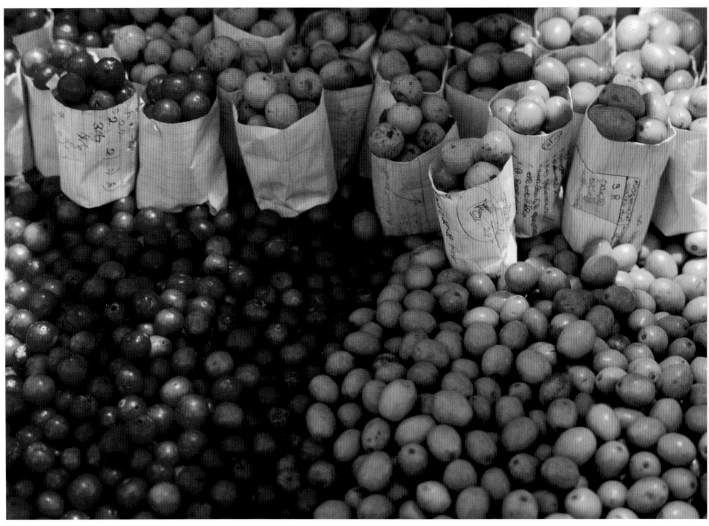

1 Visual lines, Detail, Cold–warm contrast

Complementary Contrast and Quantity Contrast

One component of a person's basic psychological disposition is a need for harmony and balance. A prolonged absence of harmony in one's life is not itself life-threatening in the same manner as a lack of such basic needs as food, shelter, or sleep, but it can eventually result in psychological damage. On the other hand, a life filled exclusively with harmony results in boredom and a desire to experience, at least occassionally, the tensions provided by contrasts.

The Neutral Value of Colors

One's first visual behavior in a new environment is a rapid scan to look at, or to see everything. In less than a second, one's eye records, evaluates, and judges all the bright and dark tones, colors, and their visual weights. A viewer feels that the sum of all the values is balanced if this averaging scan attains a value of a middle gray, the neutral value. One's psychic innate feeling will accurately register any imbalance. Visual oddities in the tonal balance, such as too much brightness or darkness or too little of either, or too much or too little of a color, are selectively evaluated in the next step of assessing the visual environment. At this point one's eye, along with the conscious mind, tries to find the reasons for the imbalances and the sources of the visual tensions in

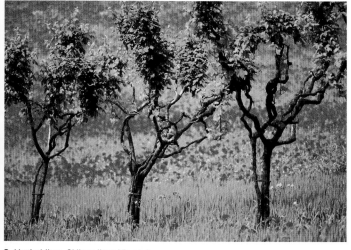

2 Vertical lines, Oblique lines, Visual shapes

3 Brightness contrast, Cold–warm contrastt

4 Horizontal lines, Detail

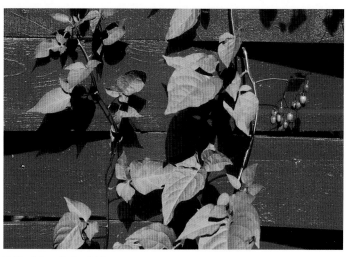

5 Visual lines, Horizontal lines

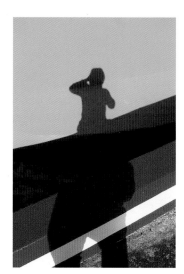

6 Vertical lines, Oblique lines

the subject. This effect is similar to seeing a middle gray when a disk painted with equal areas of white and black is rotated rapidly; the same thing happens if the disk is painted with appropriately opposed areas of complementary colors.

Complementary Colors and their Harmonious Quantities

All complementary color pairs are diametrically opposite each other on the color circle. The small, six-part color circle has only the three pairs of complementary colors formed by the three primary colors and the corresponding opposite secondary colors. These three color pairs – red and green, blue and orange, yellow and violet – are at the same time the color pairs which show the complementary contrast very clearly and directly. It is also clear that the color pairs in any of the three complementary contrasts can be referred back to the three primary colors. The optimal harmonious effect of two complementary colors depends on the correct quantity of surface area that each color occupies in an image. Each of the pure colors has a different luminosity, or brilliance. The brighter colors in the color circle (yellow and its neighboring colors) have the highest brightness, and the darker colors (violet and its neighbors) the lowest brightness. Using the brightness values of the colors allows one to determine numerical ratios for the harmonious quantities of the colors to each other. The easiest and still useful ratios of color allocations were determined by J. W. von Goethe. The brightness values of the primary and secondary colors in his system

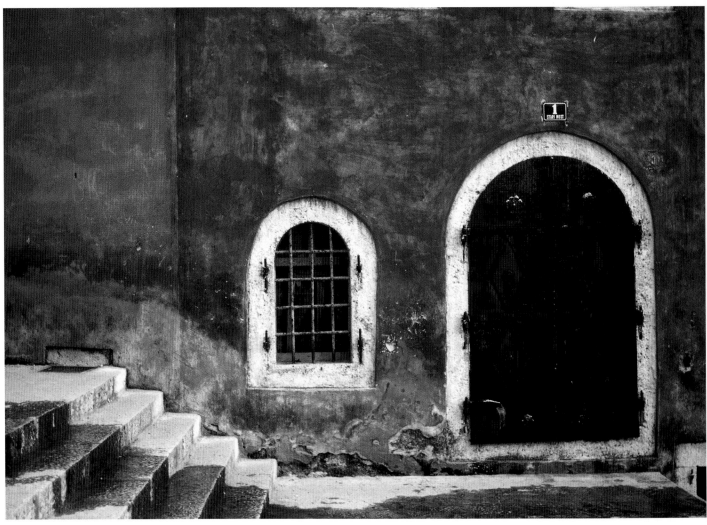

7 Vertical lines, Curves, Brightness contrast

A

*Diagrams A and B
Using the inverse ratio
of the brightness values
to determine relative
quantities brings
complementary color
pairs into harmonious
proportions with each
other.*

1:1

1:2

1:3

B

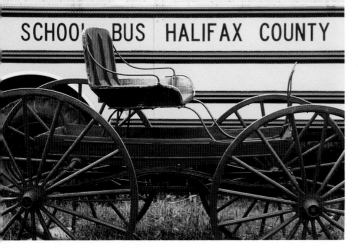

8 Horizontal lines, Oblique lines, Circles

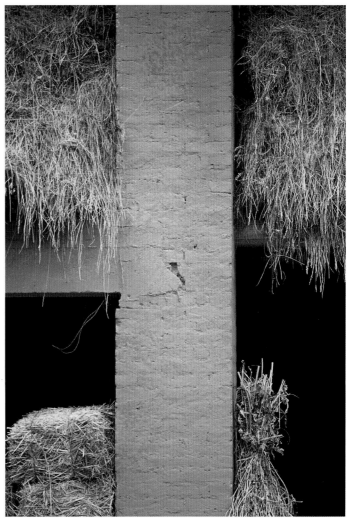

10 Vertical lines, Brightness contrast, Texture

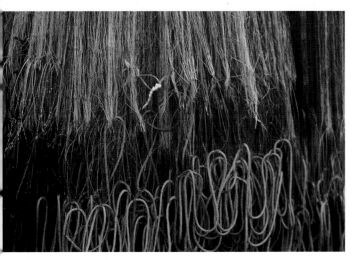

9 Vertical lines, Contrast of lines

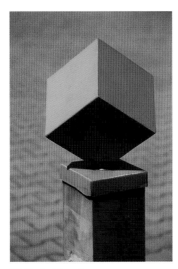

11 Vertical lines, Squares

are: yellow = 9, orange = 8, red = 6, violet = 3, blue = 4 and green = 6. For complementary pairs a total light value relation of 9 arises from yellow-violet: 3 (3 : 1), because yellow is three times brighter than violet. To achieve the same visual weight relationship from yellow and violet, the three-times-brighter yellow must occupy only one-third the area allocated to violet, the color with the lowest brightness. Therefore, the harmonious surface relation for the complementary color pair is yellow-violet 1 : 3. The quantitative harmony values of the complementary colors are reciprocal to the light values and are: yellow = 3, orange = 4, red = 6, violet = 9, blue = 8 and green = 6. On a color circle whose circumference is divided into 36 equal segments, the relative shares of these six colors can be shown, as in diagram A. Diagram B shows the surface

area shares of these three complementary pairs side by side. After the values of the complementary pairs, the harmonious surface area ratios also lend themselves to noncomplementary color pairs (for example, chartreuse or yellow-green: 3:6) or color triads (for example, yellow-red-blue: 3:6:8) for compositions with harmonious color quantities. This system of ratios also can be extended to the twelve-part color circle. For these tertiary colors with hyphenated names, the area values of both the right- and left-lying colors are added and then divided by two (for example, for blue-green: blue = 8 plus green = 6 gives 14; then, 14/2 = 7). So blue-green would have an area value of 7. However, these precise numerical values can be used only on a theoretical basis, because colors mostly appear not only as isolated surfaces that are difficult

129

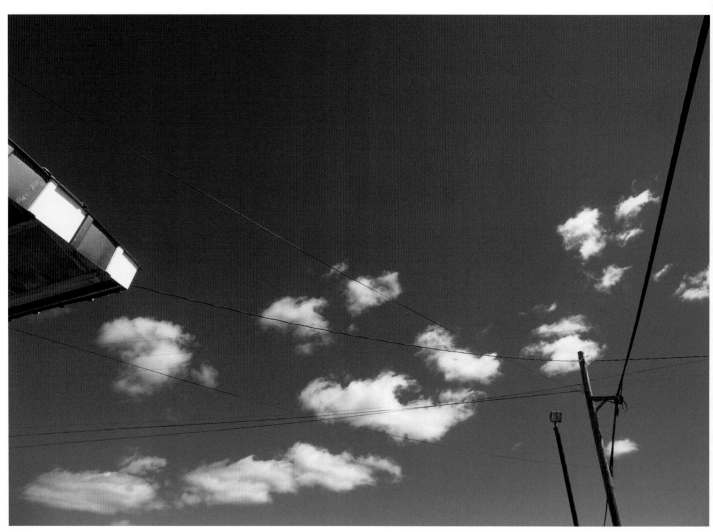

12 Dominant points, Visual lines, Oblique lines

to measure, but are distributed irregularly and have varying brightness values. Fortunately, the eye recognizes these values so well that we can generally count on our subjective feelings for visual balance. One can, of course, judge and apply harmonious color quantities with even greater confidence after developing a highly trained sensitization based on a sound theoretical knowledge. With a conscious search for subjects with clear pairs of complementary colors, it is noticeable that – not least because of the high proportion of green in nature – the most frequently encountered pair is red-green (photos 1-6). Photos 7-11 show subjects with other complementary color pairs.

Expressive Quantity Contrast

The ideal application of a complementary contrast is with color surfaces having the same visual weight as the ratios of the harmonious quantity-contrast. An expressive quantity contrast develops when large and small quantities produce a visual tension. While most viewers will experience the visual measuring and subjective feeling for well-balanced quantities with brightness contrasts and contrasts of hue in nearly similar manners, their reactions to tension-rich compositions can be very different. If one viewer feels a tiny amount in proportion to a large amount as interesting and rich in tension in a positive way, the same tiny amount is too small for another, while a third person would like to have the tiny amount be even smaller

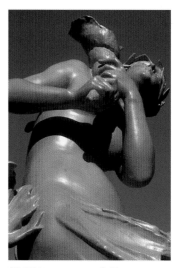

13 Brightness contrast, Cold-warm contrast

14 Brightness contrast, Cold-warm contrast

130

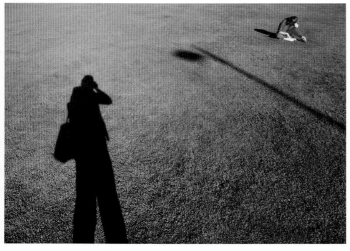

15 Vertical lines, Oblique lines, Texture

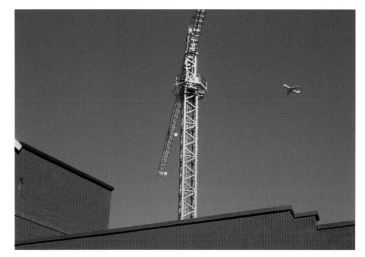

16 Dominant point, Vertical lines, Oblique lines

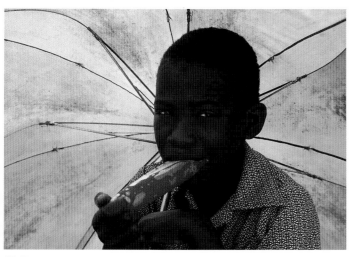

17 Oblique lines, Brightness contrast

18 Horizontal lines, Vertical lines, Texture

(photos 12, 15, 17). An expressive quantity contrast is thus in its optimal effect not absolute, but depends for its effect on many users' or viewers' experiencing similar subjective feelings. In its primary effect, an expressive quantity contrast is identical to the surface-dominating point. The educated eye almost compulsively returns repeatedly to any small bright, dark, or contrastingly colored element in a composition. Although red and green have equivalent brightness (1:1), a small red spot on a much larger green area (photos 15, 17) can visually hold its ground better than can a still relatively larger green shape on a red background (photo 18). The well known "red spot", frequently eliciting smiles from viewers when it is a person wearing red clothing, occurs often in contrast with large expanses of green and is, therefore, a common example of

19 Point, Vertical lines, Rectangles, Cold–warm contrast

an expressive quantity contrast. With two colors of different brightness, there are two stages of expressive quantities.
The first stage in such color tensions comes when the area of the brighter color, which to maintain visual harmony would be allocated the smaller area, is reduced even further. From the harmonious ratio of 1:2 for the pair orange-blue, quantity contrasts with ratios of 1:6, 1:12, or more have much greater visual tension (photos 14, 16). The second stage increases visual tensions by inverting, or even exaggerating, the respective quantity ratios. Thus, the ratio of 1: 2 of the orange–blue pair, might become 2:1, 3:1, or some other relation (photo 13). A small bright or dark surface-dominating spot can also form a size contrast (photo 19).

1 Horizontal lines, Vertical lines, Oblique lines, Brightness contrast, Detail

Cold–Warm Contrast

Usually there are several types of contrast at work in any picture. Since monochrome photography renders colors as tones, tonal contrast is the only means available besides the design elements with which to compose an image. With color photographs the design possibilities are extended by the seven color contrasts and different possibilities of applying them. The means and contrasts used in each case can complement or compete with each other.

Cold-Warm Contrast

The cold-warm contrast belongs with brightness contrast, contrast of hue, and complementary contrast to the set of color contrasts that can be clear and can absolutely dominate an image or can be weakened when used with restraint. Related to the pure colors of the twelve-part color circle, there are absolute extremes for two of these contrasts. For brightness contrast these are the colors yellow (the brightest hue) and violet (the darkest hue). The extremes for cold-warm contrast are cyan (blue-green) and red-orange (diagram A). Drawing a vertical line through the color wheel from yellow to violet divides it into left and right sides. On the left side the cool colors group themselves around the "cool" pole and on the right side the warmer colors around the "warm" pole

2 Two points, Vertical lines

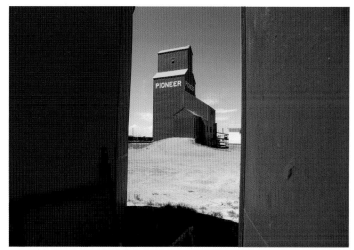

3 Dominant point, Vertical lines

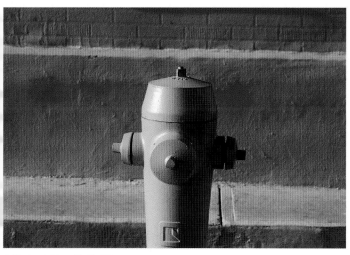

4 Horizontal lines, Vertical lines

5 Contrast of shapes, Detail

(diagram B). Only the coldest and warmest poles on the color circle (cyan and red-orange) are absolute in their priority of cold and warm. With all other colors, defining the cold-warm priority depends on whether the colors used strongly contrast in hue with each other (are far apart on the color circle) or weakly contrast in hue (are near to each other on the color circle). Although green is close to blue or cyan on the cool side of the color circle, it is the warmer color, being composed of some yellow (photo 9). However, the same green beside a yellow is the cooler color, by its proximity to the cold color pole (photo 5). Yellow is, thereby, beside green the warmer color, while it is the cooler color in contrast with orange or red (with their clear proximity to the warm color pole) (photo 13). The proximity or distance of the colors pairs to each other or to the cold and

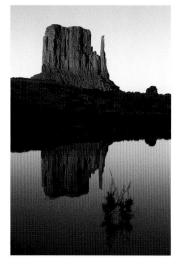

6 Horizontal lines, Vertical lines, Brightness contrast

warm color poles determines their cold-warm priority. Just as the bright-dark poles of yellow and violet, the cold-warm poles of cyan and red-orange also form a complementary color pair. Clearly, several contrasts most often contribute to the effect of a color composition, each having its own visual wight. An extreme brightness contrast has, without doubt in many cases, the largest visual weight and also is striking to viewers, who have not yet concerned themselves very much with the theories of composition and color. But a distinctively warm or cool color can quickly take a prevailing position during the processes of recognition and emotional reaction to an image.
The contrasting terms of cold and warm can be supplemented by or exchanged for other designations of contrast. Other polar names that have the

133

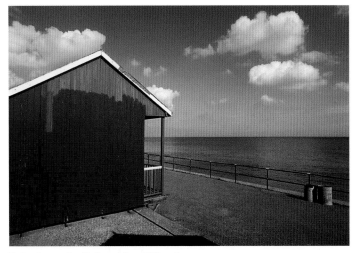

7 Dominant point, Horizontal lines, Oblique lines

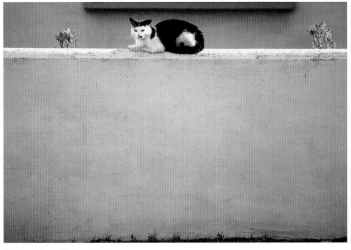

8 Visual lines, Horizontal lines

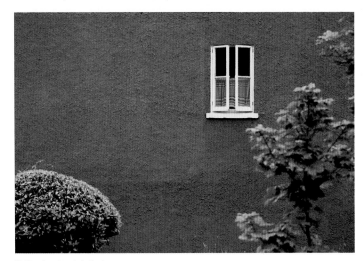

9 Dominant point, Texture

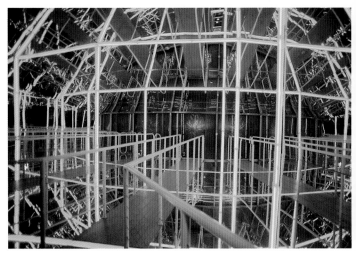

10 Vertical lines, Oblique lines

A

character of cold-warm include shady – sunny, far – near, reassuring – exciting, easy – hard, aerial – earthly, transparent – opaque, among others. One should understand that a cold-warm contrast of colors can elicit an intensified emotional effect from a viewer over and above the meaning of the content of these individual pairings. In connection with the contentwise meaning of these individual pairings one should understand that viewers can experience an intensified emotional effect resulting from the cold-warm contrast. Cold and warmth are temperature sensations that are not actually felt with the eyes. Therefore, anyone involved in the visual arts must habituate oneself to using the concepts of cold and warm and know how to translate this information into colors. Nevertheless, comparative psychological studies have

Diagram A
Cyan, as the pole of the cool side of the color circle, tends to recede from the viewer, while red-orange, the pole of the warm side, advances toward the viewer.

proven that in two rooms, one of which was painted in blue-green and the other in red-orange, people's body temperatures differed by several degrees between the cool- and warm-painted rooms.

Using Cold-Warm Contrast

Warm colors push visually forward, toward the viewer, while the cooler colors recede. An object in red-orange-yellow tones in the foreground of a scene before a bluish-green background exhibits the equations of warmth with proximity and coolness with distance (photos 2 – 5, 14, 15). A viewer's recognition of the compositional arrangement of objects in the image space is reinforced by the effect of the color distribution. In the opposite case of a cool-colored

134

11 Point, Vertical lines, Brightness contrastt

12 Visual lines, Horizontal lines, Vertical lines, Oblique lines

13 Vertical lines, Brightness contrast

14 Contrast of lines

brightest color

yellow

yellow-green · yellow-orange

green · orange

blue-green · red-orange

pole ← cold side | warm side → pole

blue · red

blue-violet · red-purple

purple

darkest color

B

Diagram B
The vertical axis connects the poles of the brightest color and the darkest color, dividing at the same time the color circle into cool and warm sides.

object in the forground against a warm background, the colors' emotional effects contradict the normal process of recognizing the content. However, despite a short-term feeling of irritation, one's recognition process will prevail over the message of the colors in genuine illustrations of natural or environmental subjects (photos 18, 19). With an abstract composition nothing stands in the way of the colors and their emotional effects (photo 16). A cold-warm contrast is clearly perceptible with pairs of complementary colors, or, at least, colors clearly in separate parts of the color circle. A very subtle cold-warm contrast develops if the colors of a composition are closely related (close to each other on the color circle). Pictures may use, for example, only – or predominantly – colors on the warm side of the color circle (photos 11 – 14) or almost

15 Horizontal lines, Oblique lines, Brightness contrast

solely colors from the cool side of the color circle (photo 7 – 10, 18). The warmth or coolness of colors in such situations becomes much more subtly related to the individual color's proximity to or distance from one of the warm-cold color poles. The "warm effect" of warm colors increases the contrast with cool colors and also increases the cool effect of the cold colors.

This mutual effect is not limited only to two-dimensional compositions. It refers also to a succession of color pictures (slide shows, calendars, and the like) or color pictures placed next to each other (multi-vision, pairs and rows of pictures, exhibitions, layouts in books or magazines).

16 Visual shapes, Irregular shapes

17 Brightness contrast

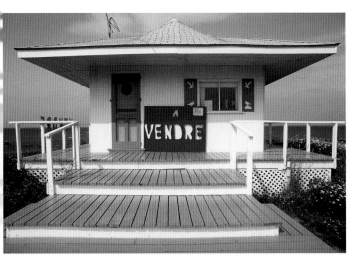

18 Horizontal lines, Vertical lines, Oblique lines

19 Horizontal lines, Vertical lines, Brightness contrast

20 Horizontal lines, Vertical lines, Contrast of shapes

Color Theory and the Theory of Color Photography

Color theory relates the colors in our environment that are visible to our eyes along with their subjective effects and their expression in the various arts, such as paintings, photographs, sculpture, and architecture. The theory of color photography, including color print technology, describes the technical way to obtain very genuine reproductions of the colors in a color photo-graph. There is a counterintuitive, inverse relationship between the subjective cold and warm feelings of visible colors and their respective color temperatures measured in degrees Kelvin. The warmest color, red-orange (fire) in color theory has the lowest color temperature for printing technologies (photo 17). The coolest colors (blue, blue-green, and green) have, along with the

21 Brightness contrast, Three-color scheme

blue sky with overhead sunlight, the highest color temperature. The cold-warm poles of color theory and of the theory of color photography are opposites, in a manner of speaking. In general, though, the larger meaning for us is in the correspondence between a knowledge of color theory and knowledge about the psychological effects of the visible colors. Here we can note that, with some exceptions, a parallel exists between our body's sensible feelings of warmth and cold and the cold-warm psychological effects of the colors. We feel the yellow-orange candlelight, the red-orange fire (photo 17) warmly, and these colors are also the warm colors of color theory. The blue-green of icebergs and the interiors of glaciers also corresponds to our reactions to the cool colors in color theory.

1 Horizontal lines, Vertical lines, Brightness contrast

Actual Color and Apparent Color, Simultaneous Contrast

For color printing and other uses of colors, precise standard names were developed to regulate the exact hue, density, and purity of every single color. When considering almost any scene, our eyes are simultaneously attracted to many colors and bright or dark areas. Besides, it is nearly impossible to classify a single color according to its color standardization.

Real Colors

The difficulty of recognizing, from the standpoint of brightness and hue, the exact place of a single color in a standardized color ensemble is to be found in the phenomenon of actual, or true, color and apparent color. In this case, the idea of actual color is a striving for measurable constants, while apparent color factors in the surrounding environment of that single color to deal with the subjective effects on that color through the viewer's active consideration processes. The concept "actual color" refers to the physically-chemically determinable and analyzable pigment of the color. The true color, thus the pigment or mixture of pigments forming the hue, remains unchanged at the moment of the viewer's respective consideration. The chemical processes by which pigments change occur, as a

2 Brightness contrast, Cold–warm contrast

3 Visual lines, Brightness contrast

4 Oblique lines, Brightness contrast, Cold–warm contrast

5 Vertical lines, Oblique lines, Irregular lines, Brightness contrast

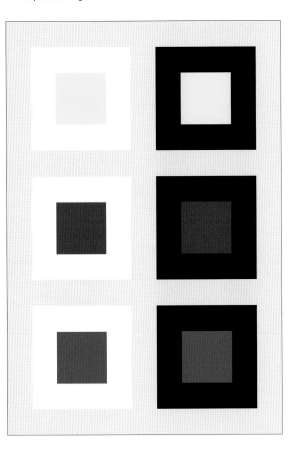

rule, over long periods of time. Here the problem for making photographs is the stability of pigments and media to exposure to light, especially ultraviolet light. Exposing many artistic and photographic media to too much ultraviolet light can cause loss of brilliance from fading or actual changes to the original hues over time. But also chemical processes can destroy colors, pictures, and slides. Thus industrial waste gases can destroy paintings, while chemical residues have destructive consequences for negatives, slides, or prints. Seldom are such processes of destruction so quick that they

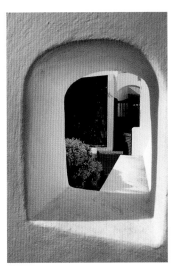

6 Vertical lines, Oblique lines, Brightness contrast

Diagram A
The easy example of placing the three basic colors in each case on white and on black backgrounds clearly shows the influence on the visual effect from adjacent colors.

A

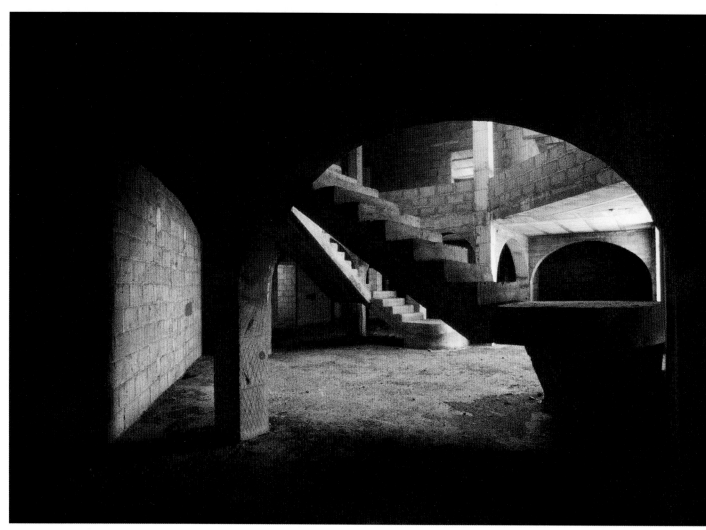

7 Vertical lines, Oblique lines, Curves, Brightness contrast

can be observed during a normal viewing process. The respective true color of any single color remains unchanged as a rule during a momentary viewing consideration.

Apparent Colors

We are used to the idea that a color's qualities exist only in respect to black, white, gray, or to one or more other colors. Every color will increase or decrease in apparent brilliance and even change its apparent hue as a function of its surroundings. Surrounded by black, white, or gray, only the relative light and shade values of the color will change. But a differently colored background will immediately cause the color to undergo a visual change so that real and apparent hues are no longer identical. In contrast to the physical-chemical reality

Diagram B
The influence of colored surroundings on gray surfaces is very subtle. The surroundings influence not only the apparent brightness, but also the apparent hue.

B

8 Horizontal lines, Oblique lines, Circle

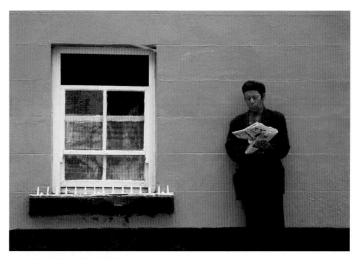

9 Horizontal lines, Vertical lines, Contrast of shapes

10 Horizontal lines, Irregular lines, Brightness contrast

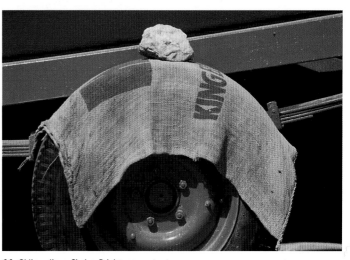

11 Oblique lines, Circles, Brightness contrast

of a color, our color perception is of a psychophysical nature and is called "apparent color". Already in connection with figure-ground contrast and the problems of the visual weight of shapes in an image, we have become familiar with the apparent visual differences in sizes of a white shape on a dark surface and of a dark shape on a white background. A bright shape on a dark surface actively radiates outward from its confines to appear larger than the same- sized dark shape on a light background and its ability to project toward the viewer; in the latter case the light surrounding the dark shape radiates into the area of the dark shape and makes it appear smaller and to recede from the viewer. Similarly, against varying backgrounds, a colored shape will change not only its apparent size, but also its apparent brilliance. Artists and

photographers can use these concepts to influence one's perception of colors and, therefore, the emotional effects of these colors (diagram A, photos 1, 3, 4, 5, 6). The three primary colors exhibit the following different effects against white and black backgrounds: yellow changes from a quiet warmth to a cold aggressiveness; red from a dull obscurity to radiant brilliance; and blue from dark obscurity to a luminous depth. Our eye is almost always deceived by a color's surroundings. As soon as, for example, yellow, red, or blue surfaces are surrounded only by black, white, or a neutral gray, a viewer will clearly perceive that the respective hues are the same. Nevertheless, the viewer's eye, despite our knowledge of the relative qualities of these colors, will become irritated in trying to restore normal brightness contrasts. The hue,

12 Visual shapes, Detail

brilliance, and saturation do not change with these surroundings, and, so, remain reliable as true colors. It is during the viewer's process of considering the image that the ostensible change to "apparent" colors takes place.

Simultaneous Contrast

The change in apparent brightness can be observed most clearly with a neutral bright gray on a black or white background. The one and the same gray looks brighter or darker, but remains, however, a neutral gray. The effect is different if the surroundings are colored. Each of the surrounding colors will push the gray in the direction of its countercolor (complementary color) (diagram B). On the red background, the gray looks greenish; on the green, it tends toward red.

141

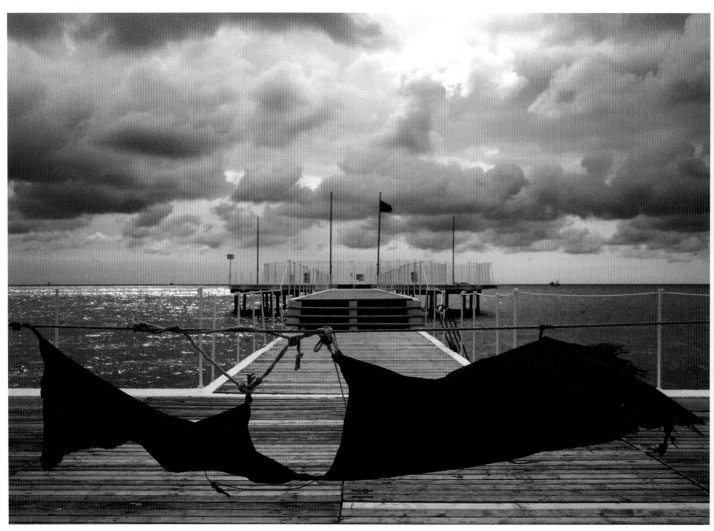

13 Horizontal lines, Oblique lines, Irregular shapes, Cold–warm contrast

These effects become more clearly visible if all the other color examples in the diagram are covered, and one looks at one color surround in isolation at close range. One can generate even more intense visual experiences on one's own by placing gray shapes on a variety of colored backgrounds. The fact that our eye always attempts simultaneously and automatically to generate the complement to a given color if it is not present in an adjacent area is called "simultaneous contrast". This simultaneously generated complementary color originates as a sensation of color in the viewer's eye, does not exist in reality, and also proves by this automatic activity during the visual process our innate need for color harmony. Because the simultaneously generated color does not really exist amongst others, experiencing a clear effect of

generated color depends on the viewer's taking a longer time to consider a color composition. The main color in a picture seems to decrease in strength and intensity, the eye is overstrained, and the feeling for the simultaneously generated complementary

color becomes stronger. The simultaneous effect happens not only between pure colors and gray tones (photos 8, 9, 13, 17), but also between pure colors. With real complementary color pairs, each color already has its absolute opponent – an increase is neither necessary nor

Diagrams C1 and C2
An after-image effect appears after concentrating on the colored figure for approximately 20 seconds and then shifting one's eyes to concentrate on the dot in the center of the empty field.

C1

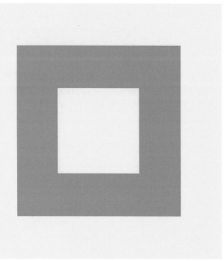

C2

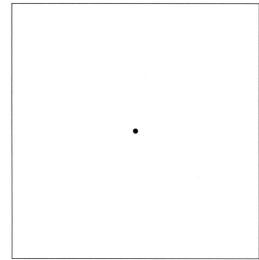

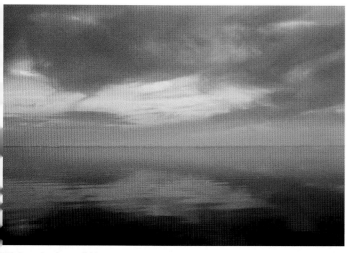

14 Irregular shapes, Cold–warm contrast

15 Dominant points, Vertical lines, Curves

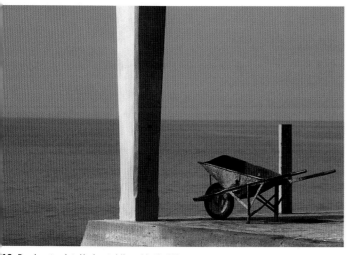

16 Dominant point, Horizontal lines, Vertical lines

17 Visual shapes, Oblique lines, Textural detail

possible. If colors, nevertheless, are not exactly complementary – for example, instead of the complementary red – green pair, there is a red – blue-green, or a red – chartreuse, then both colors try more strongly to generate their respective true complements – the complementary pair green and red-orange or green with red-violet. Such situations of four colors – two real and two imaginary, but as two sets of a real color and an adjacent imaginary color on opposite sides of the color circle – generate a visual vibration, a dynamic excitement that only becomes visible if one takes the time to look for such color resonances photos 10, 11, 12, 18).

The After-image

The so called "after-image effect" offers some proof of the importance to the human seeing

18 Brightness contrast, Cold–warm contrast

experience of apparent colors. The after-image effect is a narrowly defined aspect of simultaneous contrast. With a simultaneous contrast, two or more colors try to influence each other mutually, whereas an after-image is a short-term colored image in the complementary colors to an original. If one looks in a concentrated manner, defocussed and not trying to see detail, with one eye at the figure in diagram C1 for about 20 seconds and then quietly moves the eye to look at the dot at the center of diagram C2, there should appear after a short time an after-image of a similar figure in colors complementary to those in C1. One can also carry out this small experiment with a color transparency followed by a clear or light neutral gray slide, or with small colored papers held in front of a neutral background. A viewer cannot always clearly

perceive the influence of strong pure colors on other strong pure colors; however, the experiment with the after-image effect proves that, in any case, the eye always does react. The constantly present physiological demand to generate the countercolor may be an aspect of the visual portion of our human innate warning system designed to maintain a high level of activation of the systems supporting our color vision. Color compositions in restrained palettes with which complementary color pairs are applied not as pure, saturated colors, but as lightened or diminished in their brightness have a special charm (fig. 2, 7, 14, 15, 16). The mutual simultaneous increase of the restrained colors to an intensive coloredness in the picture is almost physically perceptible.

Using the Tools

Understanding the artistic effects of the design and the different, sometimes very subtle contrasts of color and shape are the basis of an informed assessment of a picture and, in practical applications, knowledgeable picture production. The quality of design can only emphasize a picture's content by presenting it well. Achieving expressiveness in an image requires creativity and conceptual thinking.

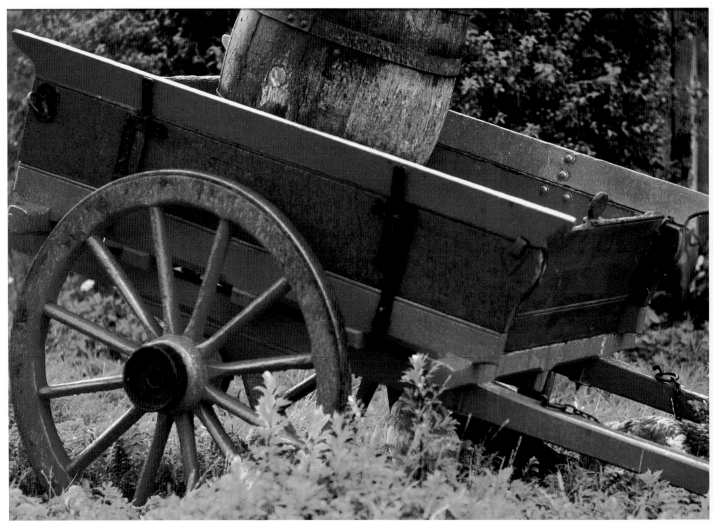

1 Point, Oblique lines, Circles, Brightness contrast

Color Harmony

The term "color harmony" refers to the interaction of two, three, four, or more colors to create a harmonious balance of hues, which, when mixed in the mind's eye, would result in a medium gray tone. The photographer who lacks knowledge of color theory will say that harmonious color arrangements are ones where the different colors have similar characters or tonal values. That is to say, adjacent hues that do not contrast significantly with each other.

Color Harmony

Subjective judgments made without knowledge of color theory will lead different viewers to different judgments regarding color harmony. In addition, such viewers can only judge the effects of colors as being harmonious or not from the points of view of their being "pleasant or unpleasant", "likeable or unlikeable", or some other personally subjective scale. Evaluations of this type are subjective opinions and have no objective content. The concept of color harmony must be separated from a situation of subjective feeling and be brought to an objective legitimacy. Harmony of colors calls for a harmonious balance of hues. It is the symmetry of the visual forces which originate from the different color contrasts and the conditions given in each case of the effects of real color and apparent color.

2 Horizontal lines, Circles, Contrast of hues

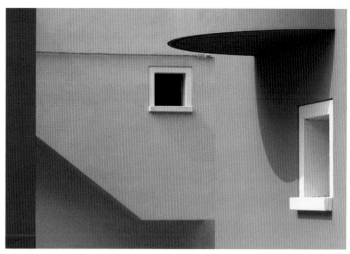

3 Point, Vertical lines, Oblique lines

4 Oblique lines, Contrast of hues, Cold–warm contrast

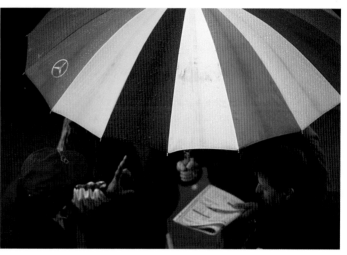

5 Oblique lines, Circle, Brightness contrast

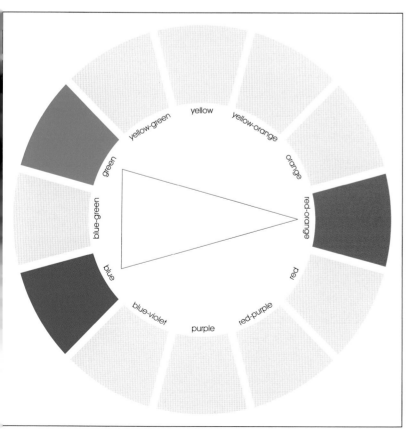

Diagram A
Splitting one of the colors of a complementary pair into its two neighboring colors generates a harmonious color triad.

A

Three-Color Harmonies

With the primary colors, yellow, red and the blue, there originates the strongest and loudest possible color triad (photo 2). This color triad was mentioned already in the chapter on contrast of hue. If one connects these three primary colors within the twelve-point color circle of J. Itten with straight lines, one obtains an equilateral triangle (diagram B). Turning this triangle successively to each of the next colors shows three other possible triads. The three secondary colors are one of these other triads, as are the two possible tertiary triads: one is red-violet, blue-green, and yellow-orange; the other is blue-violet, yellow-green, and red-orange. In addition to these four triads formed using an equilateral triangle, another set of harmonious triads can be

6 Vertical lines, Triangle, Simultaneous contrast

7 Irregular lines, Texture, Cold-warm contrast

8 Horizontal lines, Oblique lines, Quality contrast

formed from each of the complementary color pairs. In each case, one substitutes for one of the complementary colors the colors on either side. Thus, for the color pair red-orange and blue-green, one could choose to separate the blue-green, making the new color triad from red-orange, blue, and green (diagram A, photo 1). Connecting these three colors with lines generates an isosceles triangle with a sharp vertex. Rotating this triangle inside the twelve-point color circle will yield a total of twelve harmonious color triads (diagrams A and B; photos 3, 6, 7, 10, 11). These twelve triads are also called the musical color triads – as a hint to their origin, the six harmonious complementary color pairs. Black, white, and all the gray tones also count as colors in color theory. These are the "hueless" colors, in contrast to the color hues.

Diagram B
Connecting the primary colors, the most powerful three-color harmony, on the color circle with straight lines results in an equilateral triangle. Doing the same with a harmonious triad gives an isosceles triangle with one sharp vertex. By rotating the possible triangles inside the color circle, one can find all the other triple harmonies and triads.

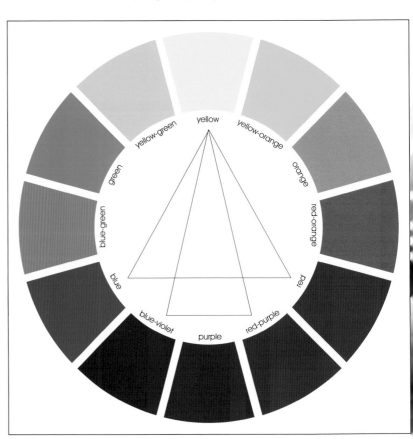

B

9 Vertical lines, Oblique lines, Cold–warm contrast

10 Points, Vertical lines, Brightness contrast

11 Vertical lines, Oblique lines, Cold–warm contrast

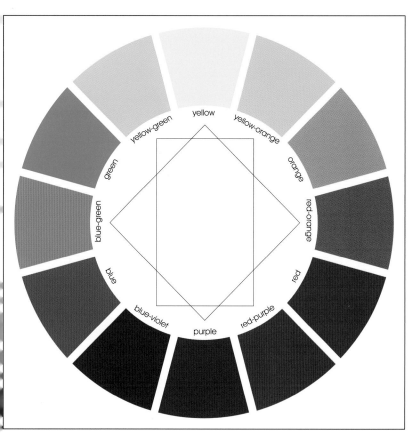

Diagram C
A square inscribed in the color circle points to four colors that comprise a four-color harmony. Drawing a rectangle to connect the two colors bracketing each of a pair of complementary colors arrives at another four-color harmony. Again, rotating the square and rectangle will reveal all the other possible four-color harmonious groups.

Above all, the pure hues strongly crowd into the viewer's sensation of the foreground, while the viewer often will not recognize the hueless colors as "colors". Thus, looking at photo 2, for example, there is the harsh primary color triad, which, with the hueless white, forms a four-color harmony and, strictly speaking, a five-part harmony with the very small areas of black.

c

149

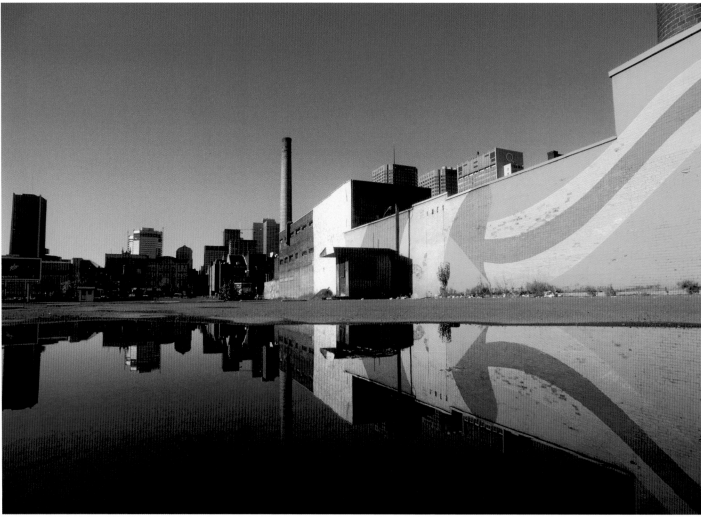

12 Vertical lines, Oblique lines, Brightness contrast

Four-color Harmonies

As are the musical triads, the four-color harmonies are also based on complementary pairs. There are two ways to develop four-color harmonies from the two colors of a complementary pair. One way uses a square inscribed in the twelve-part circle, the two diagonals connecting two sets of complementary pairs separated from each other by 90 degrees: for example, one set would be yellow and violet, with blue-green and red-orange (diagram C). The other way is to inscribe a rectangle so that the corners on the shorter sides touch the neighboring colors on either

Diagrams D-G
From the color triangle one can create color harmonies with different moods by covering the sides or the points of the triangle

D

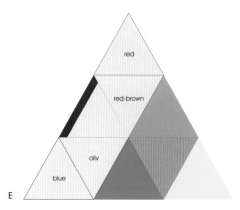

E

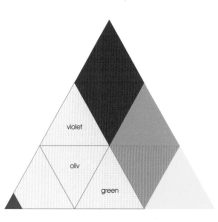

F

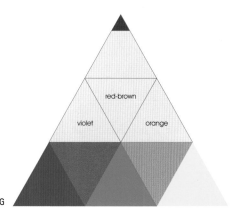

G

150

13 Vertical lines, Contrast of hues

14 Visual lines, Vertical lines, Textural detail

15 Vertical lines, Round shape, Brightness contrast

16 Horizontal lines, Vertical lines, Contrast of shapes

side of a complentary pair, again, as in diagram C. Turning the square and the rectangle generates in each case a total of three sets of four-color harmonies. One should note that all these sets of three and four harmonious colors are pure hues with the highest saturation. If one or more of the colors is lightened, darkened or changed by other colors in its luminosity or saturation, the palette of the three- and four-color harmonies can be considerably extended. However, at the same time other contrasts, such as brightness contrast, quality contrast, or simultaneous contrast, increase their effect and priority in the viewer's perception (photos 4, 5, 8, 9, 12). We can depend to a high degree on our innate feelings in judging and sensing color harmonies, as has already been explained for the complementary contrast and simultaneous contrast.

Harmonies on the Color Triangle

Color harmonies can also be developed easily with the color triangle of G. Field (diagram D). In contrast to the very clear and strong color triads and the four-color harmonies which can be constructed from Itten's color circle, the color harmonies of the triangle correlate with certain moods. Covering the five colors arrayed along a side of the triangle leaves the four colors in the opposite vertex. The three groups are the cheerful group of orange, green, yellow, and ocher (diagram E); the cool, melancholy group of cyan, violet, green, and olive; and the warm group of red, orange, violet, and red-brown. Conversely, covering the four-color groups in the three vertices gives three groups of five colors along each side. The group of red, red-brown, orange, ocher, and yellow

(diagram F) develops a warm feeling with an inclination toward brightness. The group of blue, olive, green, ocher, and yellow has a cool feel that is approximately that of the cool side of the color circle; this group usually turns up in landscapes (diagram G). The last group of red, red-brown, violet, olive, and blue conveys feelings of darkness or seriousness. The additional presence of a very small accent of the complementary color heightens these effects and emphasizes the cold-warm contrast. In the case of the four-color groups, the complement is the middle color on the opposite side; that is, the color secondary to the vertex, which is a primary color (diagram E). The opposite vertex color is the complement in question for the five-color groups arrayed along a side of the triangle (diagrams F, G). Regarding all

the color harmonies of the circle and triangle, there is no need for there to be equal quantities of the individual colors or of the harmonious color groups. To preserve the subjective qualities of these harmonies, though, one should avoid expressive quantity contrasts or brightness contrasts that are too strong (photos 13 – 16).

1 Points, Circular arcs, Triangles, Brightness contrast

Static and Dynamic Composition, Colors with Distinct and Indistinct Edges

Applying technical, creative, and artistic means to a motif can result in a picture or a series of pictures. Depending upon the task, **the client, or one's personal intuition, the approach to creating an image may be determined by a desire to be objective or more** **subjective in the presentation. This decision naturally affects how the artist designs the image.**

Objective Representation and Subjective Interpretation

Any picture is, at a fundamental level, a second-hand slice of reality, a two-dimensional representation of a situation or event, or an imaginative construction filtered through the artist's technique and creative decisions. Within photography, these considerations have led to the concept of the "subjective" photograph, in contrast to an "objective" photograph. But since a photographer has to make any number of subjective decisions before tripping the shutter, there really is no such thing as an objective photograph.
However, photographers often must craft their work carefully to present a subject in an undistorted, objective manner and to avoid subjective

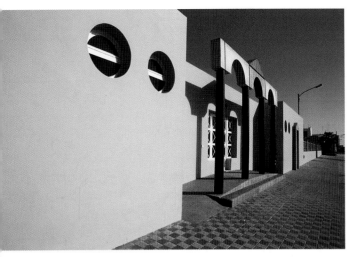

2 Points, Vertical lines, Oblique lines, Detail

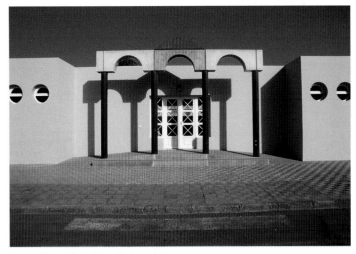

3 Visual lines, Vertical lines, Horizontal lines

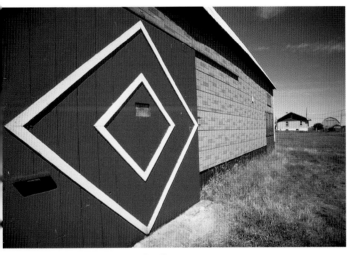

4 Oblique lines, Cold–warm contrast, Detail

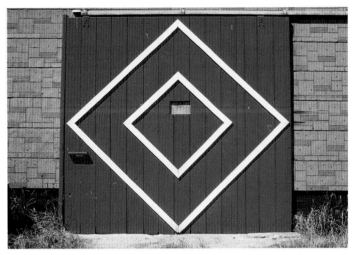

5 Points, Contrast of shapes, Detail

6 Points, Oblique lines, Texture, Bright colors

interpretations. The following items identify some of the technical and artistic decisions that a photographer must make before exposing a frame:

1. The choice of camera: Here the choices range from subminiature formats, to the most common small format, the 35mm (24mm x 36mm), to the medium formats of 6cm x 4.5cm to 6cm x 7cm, to large formats such as 18cm x 24cm and even larger. The choice of format allows the photographer to render materials and surfaces in a range from lacking in fine detail to exquisitely detailed.

2. The choice of lens: Lenses range from extreme wide angle to extreme telephoto focal lengths. Only lenses referred to as "normal lenses, which for each format correspond approximately to the human range of vision, support images of objective or undistorted representation.

3. The choice of film: The choices here are vast, from black-and-white, to color transparency and negative types, in daylight and artificial lighting emulsions, and sensitivities ranging from ISO 25, or less, to over ISO 3,200. Many films can be processed in laboratories or in the home dark room and can be done to normal directions, pushed, pulled, or manipulated with other chemicals and methods. The decision to work in monochrome yields images that deviate the most from representations of our colored environment. A fine-grained color film comes closest to being able to render an objective representation.

4. The choice of settings on digital cameras: Today's digital technologies permit the photographer to manipulate settings on digital cameras, which correspond to the lighting conditions and the color temperature of the subjects. Under normal circumstances, one can use the automatic settings with high confidence. But when the photographer desires a particular result and has suitable experience with the equipment, it can be worthwhile to input custom settings by hand. With high-end, professional-level cameras, one can record images directly onto the digital storage medium in black-and-white or in specifically chosen tones, such as sepia toning. One can also chose settings to treat unfavorable lighting conditions in specific manners or to create in-camera experimental images with movement and blurring.

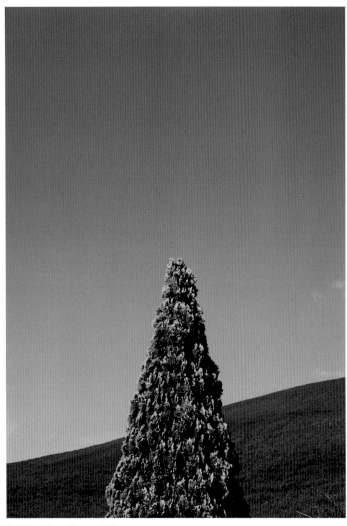

7 Oblique lines, Texture, Cold–warm contrast

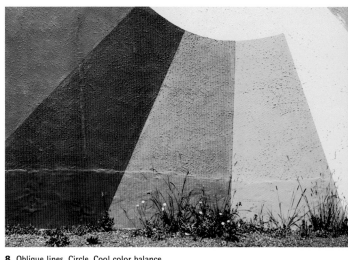

8 Oblique lines, Circle, Cool color balance

9 Horizontal lines, Cold–warm contrast, Four-color scheme

5. The choice of lighting: The lighting palette runs from any hour of sunlight to full moonlight, electronic flash, fire, and any number of other artificial or artistic sources of light, including mixtures of any of these.

6. The choice of time: The times when one might take a photograph can be at any time in 24 hours, or any day of the year, under any weather or lighting conditions, to indicate only some of the possibilities.

7. The choice of point-of-view: Point-of-view can vary from the "normal" one, at eye level with precisely arranged vertical and horizontal lines, to being low to the ground, above the subject for an overhead view, looking straight at or laterally along one or two sides of a subject.

8 The choice of shutter speed and aperture: These control the ability to render crisply or to blur objects moving within the frame, the extent of the depth-of-field, and whether the overall exposure is "correct", overexposed, or underexposed.

Photographing in the style of "objective representation" means attempting to center the viewer's attention on a rendering throughout the image space that is as close as possible to how one would see the same scene from a normal distance – often by using the camera's "normal" lens. However, any aspect of an image can also be approached differently by different photographers, with the result that pictures of any "material" subject can show any possible degree of subjective treatment. Subjective interpretation stands for a personal, emotional interpretation of material situations, where

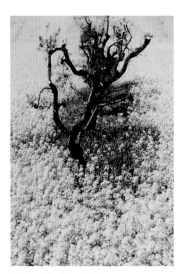

10 Irregular lines, Texture, Luminous colors

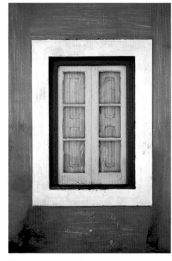

11 Rectangles, Cold–warm contrast

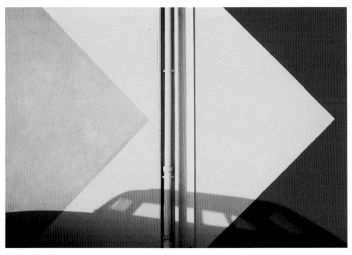

12 Vertical lines, Oblique lines, Triangles, Warm color balance

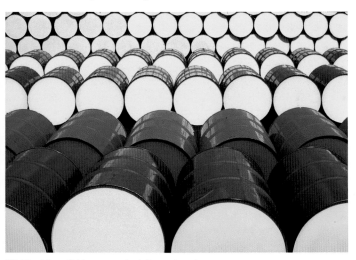

13 Visual lines, Cold-warm contrast, Four-color scheme

14 Vertical lines, Oblique lines, Brightness contrast

the photographer uses technical and creative means in unconventional or experimental ways. Between the poles of objectivity and subjectivity, there is a continuous gradation. Material subjects can be handled in somewhat subjective manners using, for example, wide angle lenses aimed up or down to create converging lines (photos 1, 6, 14). Or photographs handled very subjectively may still show recognizable parts of material objects (photos 7, 8, 12, 17, 20).

Static and Dynamic Composition

Photographers and other visual artists will treat subjects they find or set up in a studio in a multitude of ways to influence the image's effect on the eventual viewer. Controlling any or all aspects of the image, artists can also influence to what degree the image conveys an objective representation or a subjective interpretation of the subject. The equipment and time expended are not always sufficient to achieve one or the other. However, with small format cameras, one can easily make several exposures to achieve different effects because of the equipment's ease of use and the relatively low cost of materials. All the possibilities of using different lenses or changing one's points of view allow the photographer to take static and dynamic pictures of

the same subjects (photo pairs 2/3 and 4/5). A static design as much as possible keeps horizontal and vertical lines parallel to the respective edges of the image frame. The pertinent photographic style becomes particularly evident with architectural subjects (photos 3, 5). With landscapes and natural scenes, though, horizontal and vertical lines are often only details within the whole image. There will usually be a horizon line and, perhaps, vertical trees, masts, fences, or other natural or manmade objects (photo 7). A dynamic, and, therefore, subjectively stressed composition refers primarily to the treatment of vertical lines whereby the photographer tilts the camera upward to emphasize the linear perspective of the verticals by causing them to appear to converge (photos 1, 6). Photos with sloping horizon lines

caused by rotating the camera either accidentally or deliberately have become relatively rare and are still seen mostly in journalistic or documentary work. Unless it is obvious, viewers will not easily understand the reason for inclined horizons and architectural subjects that appear tilted from the vertical. Since wide angle lenses have been in use for so long, we are used to their visual effects in images and accept converging lines in many contexts when these lenses are used competently. When composing with converging lines, it is important for the artist to use them emphatically enough to be unequivocal aspects of the design. A strong, deliberate vertical axis at or near the center of the frame can be a good structural base for dynamic compositions. A central vertical axis can be difficult to find or to use with angled,

15 Texture, Quantity contrast, Warm color balance

lateral views. Oblique lines forming clear connections to the corner areas of an image can be a sophisticated means of stabilizing the image. Naturally one can also use a wide-angle lens precisely to maintain the verticality and horizontality of lines in subjects in an emphatically static manner. However, inattentive handling of the camera can easily cause vertical lines to look slightly tilted in the final image. Slightly skewed lines are immediately obvious to a viewer and are not indicative of a dynamic picture design or a subjective interpretation of the subject, but only of poor camera handling.

Distinct and Indistinct Color Separation

Although a subject may have distinct or blurred edges in an image, it is often the case that either situation can be produced or altered with an appropriate technique. Subjects and color compositions in which colors clearly fill a shape or parts of a shape and differentiate themselves as colors or colored shapes unambiguously from neighboring colors or colored shapes will show a distinct separation of colors. Clear separations of hues, brilliance, and saturation of the colors, as well as relatively large color surfaces rendered using an objective recording method, characterize areas of distinct color separation (photos 1-9, 11-14). Well known techniques, such as placing subjects outside of the depth-of-field of the lens at a particular aperture setting,

moving the camera with slow shutter speeds, long time-exposures with moving subjects, or using soft-focus filters, etc., can dissolve the contours of colored surfaces partially or completely. When the linear contours that clearly separate areas of color disappear, an indistinct, impressionistic sense of color happens. Then too, surfaces made up of many small colored masses will visually "blur" into each other. That is, when it is no longer easy for our eyes to separate visually each of the small surfaces, the colors appear to blend together and form colors differing from those of the component parts (photos 10, 15, 18, 21).
The Pointillistic painters, such as George Seurat, understood this visual phenomenon and exploited it in their work. But also physical elements, such as fog or rain, can weaken or dissolve hard contours. Shade or

16 Vertical lines, Detail, Quality contrast

17 Vertical lines, Detail, Cold-warm contrast

18 Vertical lines, Irregular lines, Detail

19 Points, Oblique lines, Cool color balance

20 Oblique lines, Texture, Cold-warm contrast

21 Textural detail, Quality contrast

patterns of light and shade also obscure shapes and reduce their recognizeability. Wet, foggy, dirty, or structured glass, as well as lattices, fences, shear textiles, and many other articles placed between the camera and subjects, can obscure colors and outlines in expressive manners and create a feeling of subjective interpretation in the image (photos 16-21).

The Content of an Image; Well or Poorly Done?

A viewer's appraisal of a picture's content and message involves rational recognition and emotional reactions. Independently of reactions to a picture's content and message, one can evaluate the objective aspects of the picture's structure, to include its design, use of color, and other aspects of artistry. But now the question remains as to

why the artist or photographer made the picture in the first place, and does it succeed in conveying the artist's intentions. The sense of how well or badly the artist succeeded in creating a "good picture" or a "bad picture" depends only on the picture's content and not on the image quality. Two pictures which treat a topic, one successfully and the other unsuccessfully, can have good or bad design qualities. Thus a picture can have outstanding design qualities, but be unsuccessful as an image, because the content was poorly chosen or poorly used, while an image with mediocre design qualities may successfully convey the desired message in an exact and visually striking manner. Artists can supply titles or texts (captions) with their pictures, of course, that may increase a viewer's understanding of the picture's message and,

thereby, its chances of being regarded as successful. Titles are often only analogies because, not infrequently, they only describe what one sees without any effort anyway (for instance the title "colored barrels" for photo 13). On the other hand, titles can state the place, the country, the subject, or other information about an image that may not be obvious to a viewer. For instance, photos 7 and 10 were taken in Tuscany, 1 and 14 in Canada, and photos 2 and 3 at a kindergarden in Rosario, Fuerteventura.

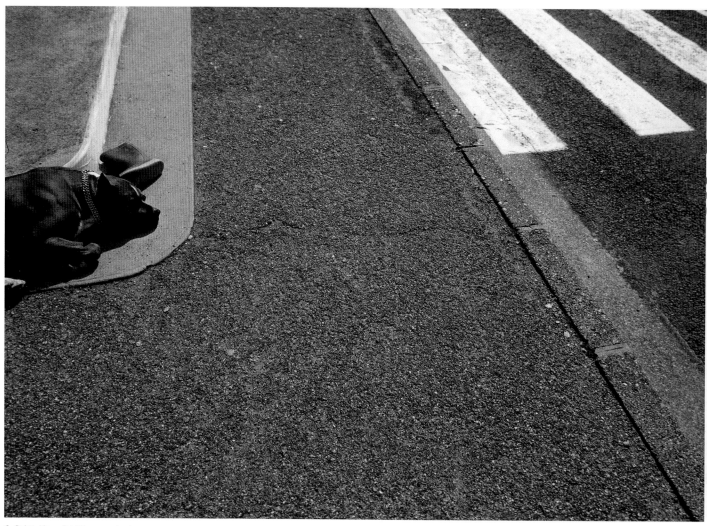

1 Point, Lines, Brightness contrast

The Imaginary Shape: Cutoff Shapes

Content and Design in Pictures

As a rule, a viewer expects the content of a picture to convey information in a clear manner. Viewers judge pictures firstly by their level of interest in the information conveyed by the picture's content and how efficiently the content conveys that information, and only secondarily by the formal qualities of design, color, technique, and presentation. Each viewer will roughly categorize the content of a picture as very interesting, interesting, somewhat interesting, or uninteresting. In addition, pictorial content can be informative, instructive, dramatic, shocking, or amusing. It is noteworthy that a viewer can often recognize the content of a picture that has bad design or poor technical qualities. Supporting the process of

In general a viewer expects a picture's composition to be a complete view of a subject. The subject as "figure" (positive shape) is presented against a background, the "ground" (negative shape), which is limited by the edges of the picture. In most cases the image shows a full view of the subject, and only seldom is the viewer inspired to use imagination to add to the information about the subject in the picture. When the subject is cut off in the image, the viewer's reaction is different. When one can see only part of a subject in the picture, one's imagination automatically comes into play to complete the image of the subject in one's mind, outside of the image frame if necessary.

2 Points, Lines, Cold–warm contrast

3 Points, Brightness contrast

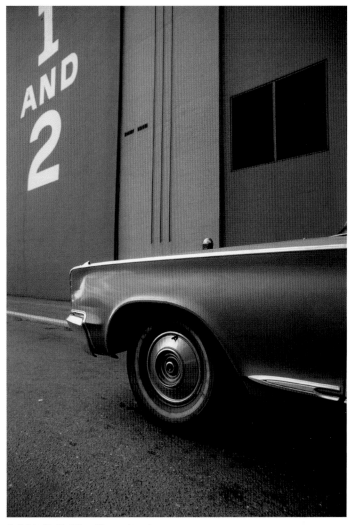

4 Points, Vertical lines, Three–color scheme

recognizing the pictorial content is the primary task of a well-thought-out visual design and color scheme, executed at a high technical standard, and presented in a manner appropriate to the subject. Normally an image's content must be accorded a higher status than its visual design. However, a picture can convey its effect predominantly on the aesthetic level through strong formal and color design. The interested, informed viewer of artistic works may find that the formal contrasts with the balance of points, lines, and shapes, along with the use of color and the effects of the color contrasts, can be sufficient to appreciate an artistic work or may even surpass in importance the content of an image.

5 Horizontal lines, Vertical lines, Triangles

6 Triangles, Contrast of hues

The Whole and the Detail

Any rectangular image plane is limited in extent by the four edges: upper, lower, right and left. In this sense any photograph is a representation of a visual slice or cutout of a larger scene. Even extreme wide angle views are only portions of one's overall sphere of view.
The edges of the image plane determine, in a certain manner of speaking, whether the image depicts the entire subject in an overall photograph or only renders parts of the subject as details. Therefore, an optimum use of the image space determined by the chosen camera's format is always at the forefront of making a photograph. This signifies that the photographer must apply the principles of formal and color design well enough that the viewer will "overlook" the fact of the subject's having been cut off.

7 Lines, Half circle, Cold–warm contrast

A viewer will make a connection between two or more pictures of "full" and "detail" shots only if there is at least a hint of the detail available in the full shots. If this visual proof is absent, for example, with a mixture of outdoor and indoor photographs, some text must accompany the photographs to establish the connections between them. The basis of recognition is knowledge and memory of what one has seen and categorized. Whether someone is gazing randomly within one's sphere of vision or concentrating on a picture, the operative issue in perceiving is that "One can recognize only what one knows." One's ability to perceive exactly and analytically depends on one's general and specialized levels of education and experience. The general education within a certain cultural milieu supports the ability of people with that cultural background to

8 Oblique lines, Brightness contrast, Hued–hueless contrast

9 Point, Oblique lines, Brightness contrast

Diagram A and B
A viewer's mind will automatically complete in the imagination circles that are cut or sliced by other shapes or the edges of an image (diagram A). With triangles and active squares standing on a corner, the portions missing must be relatively small. Only then will one's imagination automatically complete these geometrical shapes with the portions lying outside the image field (diagram B).

A

B

10 Horizontal lines, Vertical lines, Textural detail

11 Brightness contrast, Complementary contrast

12 Point, Lines, Circles, Complementary contrast

recognize familiar subjects often with very little available information. The difference between an image's showing a recognizable portion of a subject and an unattributable detail of the subject is fluid and is defined especially by whether or not there is a full view of a similar subject in the image, or a full view of the same subject in an accompanying image. The photographic discipline of taking "full" shots and "detail" shots of a main subject involves taking a number of photographs that, when presented to the viewer at the same time, allow the viewer to discover each of the details in the overall shots and to understand the cuts in the other pictures. As soon as the photographer isolates formal or color elements from a portion of a subject, he or she foregoes a claim to a realistic depiction with the possibility of an exact perception of the

13 Vertical lines, Circle, Brightness contrast

subject in favor of a free, subjective work. Freely artistic handling of shapes and color while neglecting to include recognizable information about a subject will yield photographs characterizable as depicting a subjective interpretation. Cutting away information about a subject in an image can go so far that the subject is barely or no longer recognizable. The viewer sees then only a more or less abstract shape or a detail from a shape, without being able to accurately categorize the subject. Often, however, only very little recognizable detail is sufficient for an appropriately educated, knowledgable viewer to supplement in one's imagination the shape and color of those portions of a subject lying outside of the image field.

Cutoff Shapes

Cutting shapes at the edges of an image does not generally change information about their color but, depending on the visual treatment, may reduce the quantity of that color in the image. Again, the primary effect of cutting off a subject lies in the aspects of formal design. A subject can be cut on one, two, three, or even all four sides, most commonly by the picture's edges. Shapes with the most intensive formal precision and predictability, such as the circle, the viewer will complement with the least difficulty in the imagination outside of the image plane (photos 8, 12, and 13). However, cutting off squares, rectangles, or triangles formally changes the geometric classification of these shapes. Only if small portions are cut off are these shapes still recognizable (photo 9). Besides the

161

14 Points, Horizontal lines, Three-color scheme

man-made geometrical shapes, there is the infinitely varied world of free, irregular natural shapes. Free shapes generally have no straight edges so that cuts generated by the picture edges form a clear contrast to the rest of the irregular shape. Supplying in one's imagination the missing portions of cut free shapes succeeds only if the shapes are known to the viewer beforehand. Within the image frame, shapes and subjects can also be partially covered or obscured by other components of the image. A cloth lets one see only the feet of the mannequins; a hedge covers part of the rectangular window; and a plastic tarpaulin overlays half of the circular road sign (photos 19, 20, 21).

Cutoff Subjects

The combination of a viewer's recognizing a subject that is cut off in an image and knowing about its function, shape, color, and other attributes allows the viewer's imagination to supply the information missing from the image field. According to the viewer's interest and imagination, this imaginary supplement can be purely objective or be embellished with many details. Whether it is people or animals cut off (photos 1, 10, 11) or whether cars or architecture (photos 2-7, 15, 16), one can always invent stories to go along with the pictures. The picture with details of two umbrellas (photo 14) leaves room for one's imagination, while in photo 17, the smaller image of the more distant umbrella indicates the shape of the closer one cut on three sides. The shadow play of the furniture in photo 18 is a

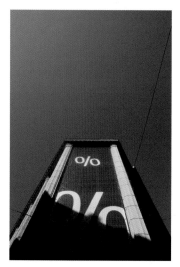

15 Oblique lines, Brightness contrast

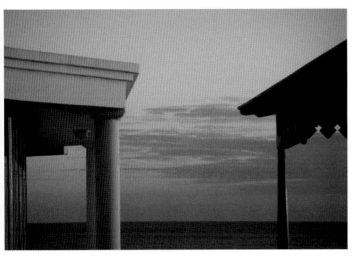

16 Vertical lines, Oblique lines, Cold-warm contrast

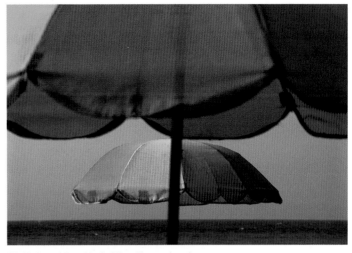

17 Horizontal lines, Vertical lines, Three-color scheme

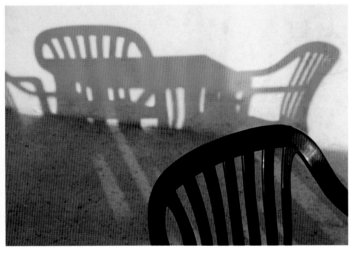

18 Lines, Brightness contrast

19 Vertical lines, Oblique lines, Brightness contrast

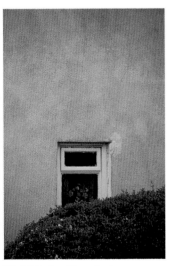

20 Points, Quantity contrast

21 Vertical lines, Brightness contrast

formal default to the viewer's imagination. After one's imagination completes the cut objects in an image, the range of creative possibilities is wide open. Is the dog's walker standing beside the dog, or is the dog alone? Are people sitting or lying underneath the umbrellas? Any absolute answer to such questions plays only a subordinate role in freely artistic pictures. Nevertheless, with subjects of political, social, or commercial interest, the details that are shown or not shown can have immense consequence and importance.

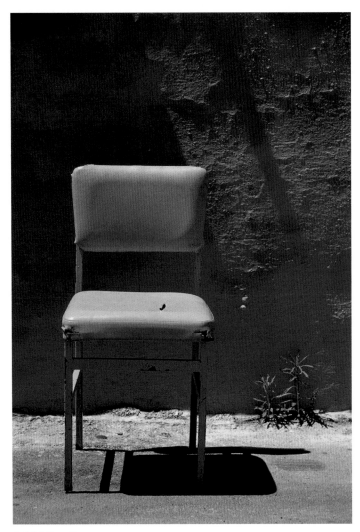

1 Point, Lines, Shapes

2 Vertical lines, Shapes

Seeing Differently: The Vertical Format

The painted picture as a source of information and as an artistic expression has a history of tens of thousands of years. In caves and on the walls of cliffs there were no limitations on the format or size of images. At first it was the desire of artists to be able to carry drawings and painted canvases easily that led to the foundations of modern easel painting. Today's standard formats of paper and canvas were developed after centuries of using other media such as bark, animal skins, clay tablets, parchment, and papyrus.

The Picture Format

The relatively young medium of photography has adopted the rectangle as the primary format from traditional easle painting. Over several centuries, painters have most often used recumbent, horizontal rectangles for scenery or landscapes, and upright, vertical rectangles for figures and portraits; the respective formats are often referred to as "landscape" and "portrait" formats. In the majority of landscape pictures, a horizon line is a prominent, often the dominant, compositional component. The landscape format offers a horizontal line, a horizon, a greater visual stretch and better emphasizes the expansiveness of a landscape. Expanse, or width, is distance, and distance carries an inherent, visual psychological feel of coolness. The horizontal line and the landscape format

3 Point, Rectangles, Brightness contrast

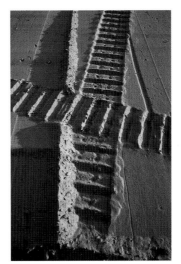

4 Vertical lines, Shapes, Three-color scheme

5 Visual lines, Lines, Shapes

6 Vertical lines, Oblique lines, Complementary contrast

7 Vertical lines, Oblique lines

stand accordingly for a feeling of cool distance. The dominance of the upper and lower edges of a horizontal rectangle gives horizontal lines in a picture composition additional visual support. On the other hand any vertical line in a landscape format stands in strong contrast to the image plane. Long before artists painted landscapes, humans were depicted graphically (symbolically) and pictorially in full length, partial, and, eventually, portrait representations. Standing in front of a living person always means proximity. This experience transfers to a picture of a person through the formal visual stresses of the verticality of sitting or standing people. An upright, or portrait, format contains the inherent upward visual stresses of vertical lines. The portrait format conveys, therefore, an impression of proximity.

Thus, while vertical lines and

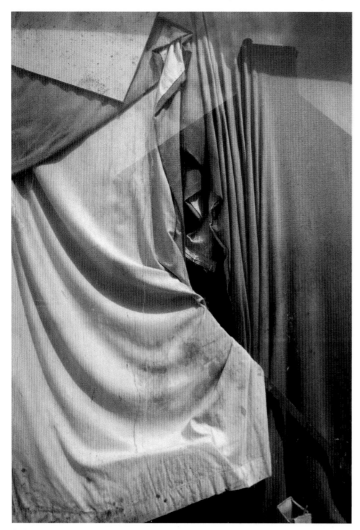

8 Oblique lines, Contrast of lines

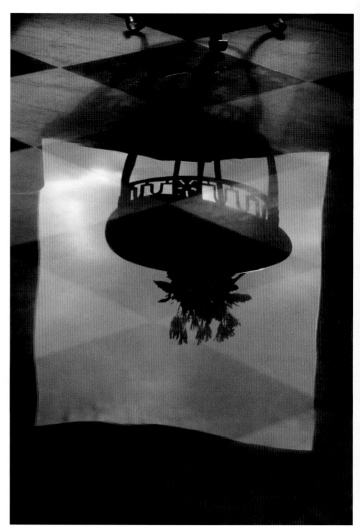

9 Shapes, Brightness contrast, Hueless colors

shapes and the portrait format complement each other's formal design, now any horizontal line or shape creates a formal contrast with the image plane.

The Choice of the Image Plane

As a rule, photographers try to fill the camera's format with the outlines of the main subject. Using point-of-view and other framing techniques, the photographer seeks to fill the image space so that the positive shape, or figure, and the negative space, the remaining surrounding area, are balanced. The image is deemed to be balanced in this connection in that the negative space optimally stresses the outline or contour of the main subject. Large negative shapes and surfaces can develop their own visual qualities and thus compete

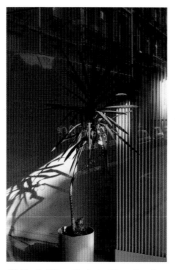

10 Vertical lines, Horizontal lines, Detail

visually with the actual subject. However, experimentally inclined photographers can ignore the sedate use of the format and create daring designs based around the visual competition

A

B

Diagrams A and B
An image space divided into even sections with a grid lacks visual tension and is boring (diagram A). Moving the vertical to the right and raising the horizontals by harmonious divisions of 2:3 produce tensions that are nevertheless well balanced (diagram B)

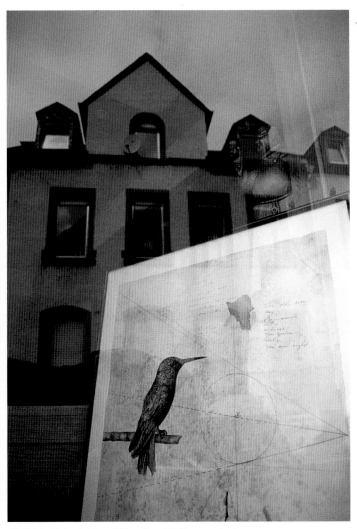

11 Points, Horizontal lines, Oblique lines, Brightness contrast

12 Point, Horizontal lines, Vertical lines, Texture

between the negative space and a subject.

Apart from some exceptions, the greatest percentage of all photographs are taken in the horizontal format. One possible explantion for this is that our eyes lie horizontally next to each other. One can extend this horizontal field of view very easily by moving the eyes and turning the head to the right and left in the manner of a panorama. Because of this visual biology, the horizontal rectangle is, in a manner of speaking, closer to our way of seeing things, apart from the fact that it allows us to maintain also a certain distance from others. The perpendicular, or portrait format, signifies nearness and with it also a necessary concentration on this nearness which allows no digression of one's eyes to the left or right. If one photographs the same subject using the horizontal and vertical formats

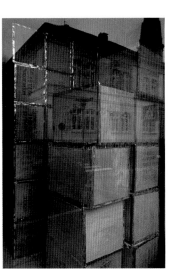

13 Lines, Shapes

14 Point, Contrast of lines, Brightness contrast

with the same lens and point of view, both images should contain identical parts of the subject. These identical parts will be in a square section of each format. In rotating from the portrait format to the landscape format, high and low details in the image will be lost, while details will be added on the left and right. Changing from the landscape to the portrait formats will change details of the subject in the reverse sense. It is continually surprising how much change in the impact and effect of an image can come from this simple change of format. Apart from serious differences in information conveyed to the viewer regarding the content, there can also be significant changes in the formal design, in the color design, in the stresses on individual details, in enlarged or limited visual movements, or even in the style of the image. Naturally

15 Horizontal lines, Vertical lines, Circles

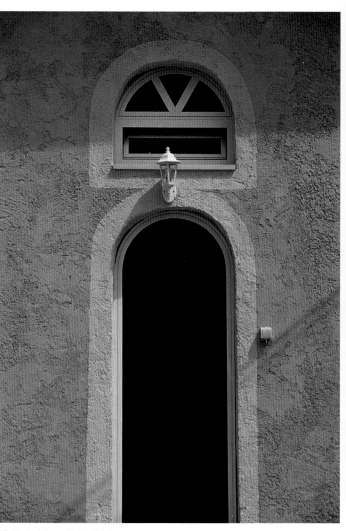

16 Vertical lines, Circles, Brightness contrast

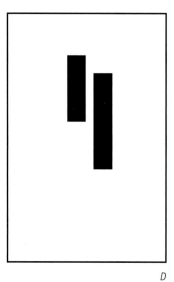

C D

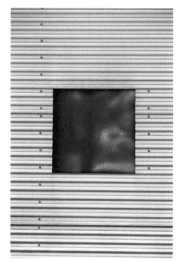

17 Surfaces, Vertical lines, Horizontal lines, Brightness contrast

Diagrams C and D
The bar in the center shows no tendency for visual movement on the image surface. All visual attractions to the corners and edges are even and thus balanced (diagram C). Moved from the center and in competition

with a second, shorter bar, the visual attractions and tensions between the bars themselves and between the bars and the edges and corners are apparent to any sensitive viewer.

there is a set of subjects that can be optimally represented only in one of the two formats. To mention only two examples, the horizontal extent of bridges is probably only renderable in the landscape format, whereas the portrait format is often the better choice to emphasize the height of church steeples. However, photographers are continually inspired to take pictures of exciting subjects in both the horizontal and vertical formats for later consideration of the strengths and differences of their content and formal design qualities.

For optimal comparisons, one should take photographs of the same subject in the portrait format and the landscape format from the same point of view and with the same focal length lens.

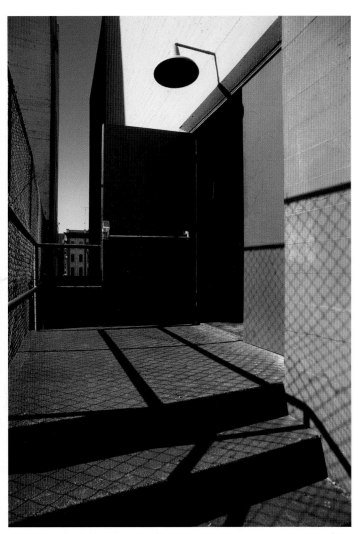

18 Point, Vertical lines, Oblique lines

19 Point, Vertical lines, Oblique lines

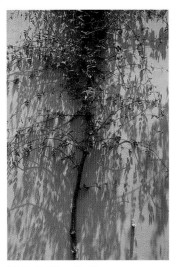

20 Vertical lines, Detail

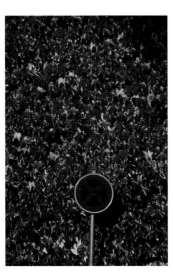

21 Point, Lines, Texture

Formal Balance

In most instances, an artist seeks to achieve a "well balanced"
pictorial composition. This concept refers, above all, to the visual equilibrium of the formal and colored elements with respect to the image plane. A recumbent rectangle, with its wider horizontal aspect, is more visually stable than a vertical rectangle, with its narrower grounded space. Therefore, a viewer's eye is more sensitive to an imbalance in a vertical composition. On any image surface there are more stable and less stable points for the placement of compositional elements. Every detail of a composition has to balance two sets of decisive forces. The first is the set of visual tensions between each compositional element and the center, corners, and edges of the image plane,

somewhat in the manner of a magnetic force field. In which direction the viewer perceives the resultant tendency of all these forces depends on each element's position in the image plane. A design stressing the center of the image or one of the central axes of the frame is the most restful (photos 3, 4, 6, 9, 10, 13, 15, 16, 17, 20, 21). The other set of visual forces within the image frame that must be balanced concerns the visual interactions of the compositional elements with each other. The artist can achieve sensitive designs by manipulating the tensions not only among the points, lines, and shapes, but also the visual weights of the individual colors, and the sizes and hues of colored surfaces (photos 1, 2, 5, 7, 8, 11, 12, 14, 18, 19).

1

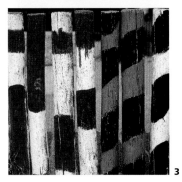

2

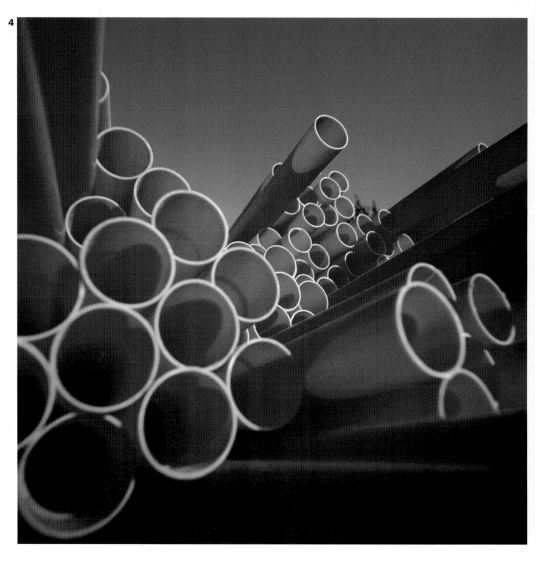

4

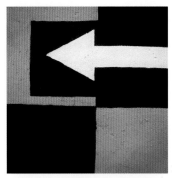

3

The Square Image Format

The effectiveness of a square image relies on its static shape being aligned perfectly horizontally or vertically. The viewer's eye immediately registers even the slightest changes in the orientation of a square frame, although changes in the balance of the design elements within a square image can be just as eye-catching for the viewer as positioning anomalies.

A square consists of four right angles arranged at equal distance from one another. Viewed superficially, a square's regularity makes it appear sedate and perhaps even slightly boring. In its "normal" horizontal position, a square appears static and inflexible, although its edges can still be attractive to a trained eye. The bottom edge is the most obvious of these, followed by the right-hand side. The left-hand and top edges are generally of less interest to the viewer (diagram A). A square that is balanced on one of its corners loses its stable primary nature due to the dynamic sense of movement the position creates. A dynamically positioned square is only really useful as a basic graphic shape in street signs or company logos. However, both static and dynamic squares can be effectively integrated into a

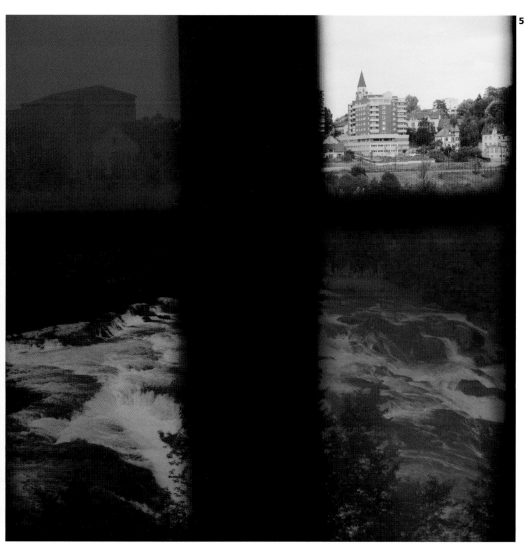

5

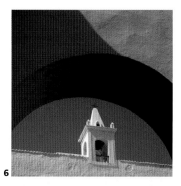

6

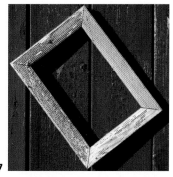

7

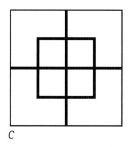

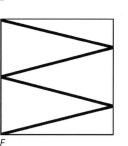

8

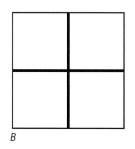

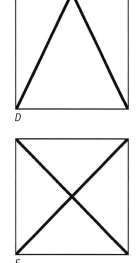

A

B

C

D

E

F

Diagrams A-F
The various sides of a tranquil, symmetrical square provide varying degrees of attractiveness for the viewer (diagram A).
The static nature of a square is emphasized if its surface is divided symmetrically, as shown in diagrams B and C. Dynamic division of the surface area stands in stark contrast to the balanced look of a square's 1:1 aspect ratio. Diagrams D-F show the contrast provided by dividing a square's surface using "active" triangular shapes.

larger composition (see pages 76-79).

During the Romantic and Baroque periods, the square was often used as a basic compositional element. Square landscape photographs convey an impression of indecision, in contrast to rectangular and "stretched" panorama landscapes that emphasize the breadth of the subject and guide the viewer's eye through the image from left to right. The depth of a landscape scene can be emphasized by using a rectangular portrait format and by positioning the horizon in the upper third of the frame to give the foreground space. A square format is simply too narrow to convey breadth and too squat to convey depth.

You can, of course, crop rectangular images to make them square. If you prefer the

12

9

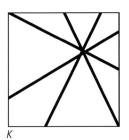

10

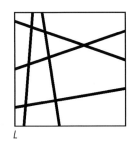

11

Diagrams G-L
A simple grid of horizontal and vertical lines produces basic tension in a square image (diagram G). New relationships and forms are created if an isometric view is superimposed on the vertical and horizontal coordinates (diagram H). A central (or one-point) perspective adds a system of rays to the vertical and horizontal lines that pass through the focal point, creating a complex system of angles (diagram I). Floating lines that don't touch the edges of the frame, non-central perspectives, and slanted lines that divide the frame all produce a feeling of imbalance (diagrams J-L).

G

H

I

J

K

L

13

14

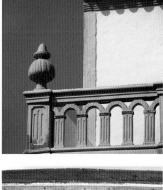

15

16

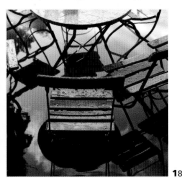

17

18

"optimum usage" approach to shooting in a particular format, you should simply shoot in a rectangular format from the start. Viewed from a purist's point of view, however, every image format should be taken seriously in its own right, and you should aim to avoid cropping images once they have been captured.

Some subjects or image elements require the use of a particular format to emphasize their specific characteristics. For example, the effect of ships' masts, lighthouses, chimneys, and other natural and man-made objects is enhanced if they are depicted in portrait format. The same is true for landscapes and seascapes if they are photographed using a broad rectangular format. While the standard 2:3 rectangular image format allows you a degree of framing flexibility, a square format offers virtually no

potential for increasing tension in a composition. Subjects that emphasize the center of the frame or its central axis (photos 6, 7, 13, 14, 17, and 18) or that divide the frame symmetrically around a horizontal or vertical line (photos 2, 3, and 12) effectively use the balanced nature of the square format. Formal movements from left to right or bottom to top appear harmonious (photos 1, 4, 9, and 11), whereas an implied movement from right to left (photo 2) or dynamically placed colors and shapes (photos 5, 7, 8, and 15) provide tension within the frame.

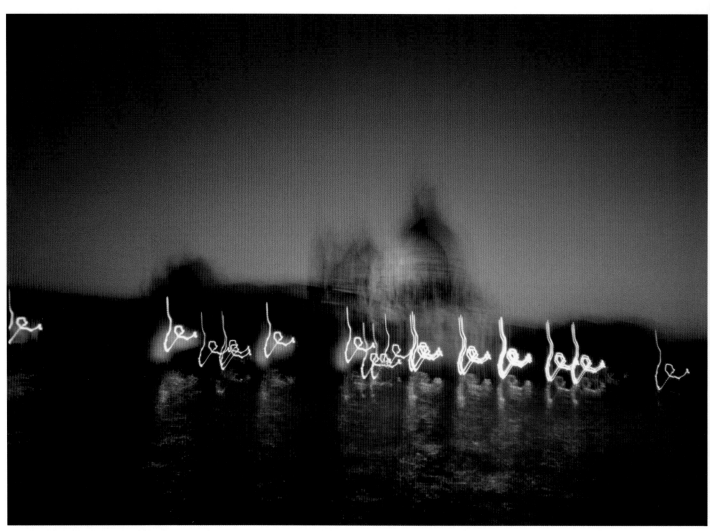

1 Visual lines, Cold–warm contrast, Brightness contrast

Creative Unsharpness

Photography as a visual medium is well known for its ability to render faithfully and in sharp detail every aspect of our visual environment. The first instinct of many viewers is to consider indistinct or blurred photographs to be unsuccessful as images.

The Palette of Contrasts

Artists use the artistic contrasts to convert the visible, material environment into pictures. Most of these contrasts are real, but become more clearly visible when incorporated onto the limited space of a two-dimensional image. Someone trained to see artistically has no problem recognizing these contrasts in a picture. The obvious contrasts, such as bright-dark, young-old, round-angular, rough-smooth, and others, are part of the life experience and awareness of normal adolescent people and need little explanation. However, there are more subtle formal and color contrasts of which one becomes aware normally only after intensive study of the theories of visual design and color design.

2 Visual shapes, Brightness contrast, Bright colors

3 Visual triangles, Brightness contrast

4 Brightness contrast, Three-color scheme

5 Visual lines, Brightness contrast, Warm color balance

6 Irregular shapes, Cold–warm contrast

7 Points, Visual lines

8 Irregular lines, Brightness contrast

Real and Optical Unsharpness

The realm of perceiving and using color involves two aspects: colored areas with clearly delineated boundaries and color masses with blurred edges. In the case of clear boundaries, shapes or surfaces are clearly perceivable and are filled unambiguously with a categorizable color. The limits of such a colored area are defined by the object's shape or by a sharp demarcation with another color mass. When dealing with clearly separated color masses, the color and the shape or surface comprise a unit (see the discussion on page 156). In the case of color masses with indistinct boundaries, colors can mix, shapes and contours dissolve, with the result that the viewer can be deceived in his/her perception. The first type of deceptive situation involves very

9 Vertical lines, Complementary contrast

small shapes or masses of different colors lying close to each other. Our eyes will not be able to distinguish each individual tiny spot, as in, for instance, a spring meadow in flower or a mosaic when seen from a distance. The small colored spots mix themselves in our minds and appear to be new colors (see also pages 156 and 157). Photography has several means by which one can make colors appear to blur. Rain, fog, and snow are natural events that can eliminate sharp outlines. Rain and snow generally require, though, longer exposure times to achieve a soft-focus effect. Photographing through intermediately placed materials such as nets, semitransparent materials, or structured glass, will soften hard contours, as will also using soft-focus filters or breathing on the front element of the lens. In terms of photographic technique, there

10 Point, Vertical lines, Texture

11 Brightness contrast, Complementary contrast

12 Cold-warm contrast, Texture

are two main methods for achieving unsharpness that result in soft contours: the aperture and focus settings on a lens and long time exposures.

Lens Settings

In photography the classical application of sharpness and unsharpness is with respect to the background and the foreground. When the photographer focuses on the foreground subjects and leaves the background out of focus, the foreground is visually separated from the blurred background and receives strong visual emphasis. A long focal length lens used at full aperture, to maintain a shallow depth of field, is particularly handy for achieving this effect (photos 19, 23, 25). One can also blur the foreground without using optical manipulations. Focusing on subjects in the background

13 Brightness contrast, Texture

14 Points, Visual lines, Texture

15 Visual triangles, Lines, Texture

16 Brightness contrast, Texture, Three-color scheme

17 Brightness contrast, Texture

18 Points, Lines, Texture

through gaps in foreground objects that are out of focus can yield quite artistic interpretations. Longer focal length lenses used at wide apertures are also useful for obtaining this effect (photos 24, 26, 27, 28). The third possible experimental effect is for the entire image to be out of focus, where the photographer avoids having any zone of sharpness in the image, as in photo 7.

Long Time Exposures

Also with long time exposures, there are different procedures that yield quite different results. The traditional technique is to mount the camera on a tripod or other stable surface to immobilize the camera. Then, depending on the length of exposure and the speed of the subject elements' movements, the elements are smeared and

19 Vertical lines, Circles

20 Vertical lines, Brightness contrast

21 Visual shapes, Complementary contrast

22 Lines, Brightness contrast

rendered in a diffuse manner; objects that do not move during the exposure are rendered sharply, if they are in focus. The clearly recognizable elements strengthen the impression of movement of the blurred elements (photo 4). If the photographer is on a moving platform, such as a car, boat, or train, a long time exposure will show this movement (photos 1, 8). Additionally, small point sources of light will generate intense, eye-catching lines. However, long time exposures taken with a moving camera lose the contrast between sharpness and unsharpness to a large extent. Panning the camera with a moving subject during a long time exposure is the only way to preserve some measure of selective zones of sharpness in the final image. Experienced sports photographers are masters of the panning techniques, knowing their

23 Point, Lines

24 Point, Shapes, Cool color balance

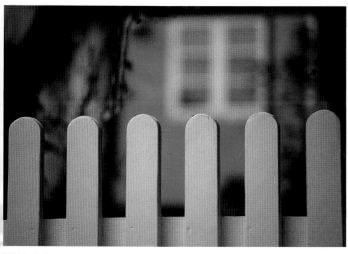

25 Vertical lines, Brightness contrast

26 Contrast of lines, Brightness contrast

27 Point, Vertical lines

28 Lines, Shapes

particular specialities so well that they can anticipate the optimal time to release the shutter at the appropriate speed to capture the desired impression of the action, sharply or with unsharpness. Recording the impression of movement is another way to inject dynamism into one's images. For any living being, human or animal, as well as manmade moving objects, such as cars, trains, carousels, and other things, including impressions of movement in one's pictures can give satisfying results (photo 5).

Varieties of Unsharpness

Moving a camera freely up, down, or in some other way during a long time exposure yields an image with an overall unsharpness with a free, artsy aspect. The resulting appearance of dynamism, though, may not be typical of the subject (photos 2, 3, 6, 20, 21). On the other hand, almost any subject can be rendered in various types and degrees of unsharpness by shooting through textile, plastic, or glass screens or other translucent or transparent surfaces between the camera and the subject. Whether it is frosted or ice-covered windows, lattices, lace, textiles, or one of the multitudinous structured glasses, the pallet of possible overlays is extensive (photos 9 – 18).

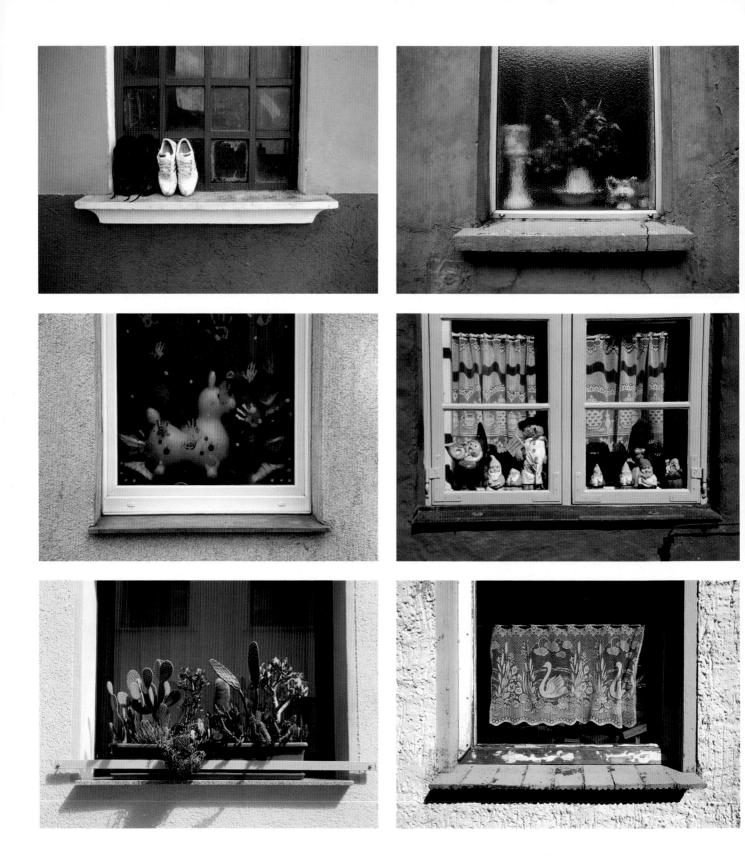

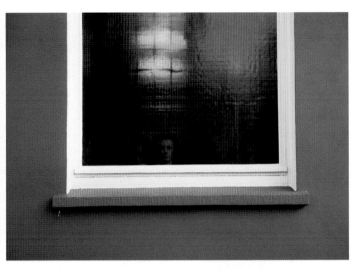

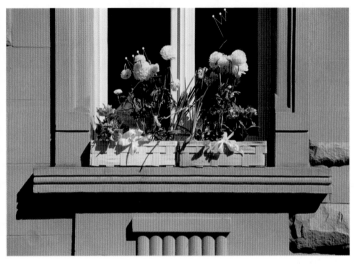

Serial and Sequential Photography

A series or sequence of photos is made up of multiple images that have some kind of common theme.

1 Contrast of shapes, Detail

2 Horizontal lines, Oblique lines, Alternating shapes

3 Points, Shapes, Brightness contrast

4 Oblique lines, Circles, Brightness contrast

Collecting Photographs: The Photographic Series

As soon as a photographer is interested enough in a subject to take several photographs, the foundation for a photographic series exists. A viewer will consider a group of photographs as a series when he/she recognizes a visual unity based upon common aspects of the images' content, formal design, or color design.

Series Taken Over Short and Long Time Frames

Usually one works toward assembling a series without regard for time limits. It is, in a manner of speaking, an additive endeavor undertaken over what may be a considerable period of time. That is, whenever the photographer sees a subject that fits the criteria to belong to an already conceived series, then he/she will add pictures of this new subject to the series. Improving the quality of a series depends, in part, on the number of images from which to choose and, therefore, usually will be a long-term process. Except for professionals' deadlines, it is unlikely that a series must be developed quickly. If one is working on several series at the same time, it is even more likely that they will grow slowly. However, every time one carries the camera, whether just

5 Points, Vertical lines, Oblique lines

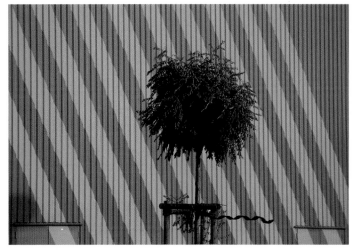

6 Points, Vertical lines, Oblique lines, Textural detail

7 Points, Horizontal lines, Oblique lines

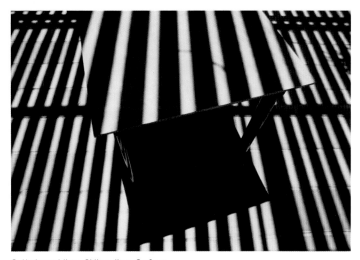

8 Horizontal lines, Oblique lines, Surfaces

9 Point, Vertical lines

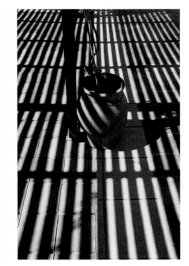

10 Horizontal lines, Oblique lines

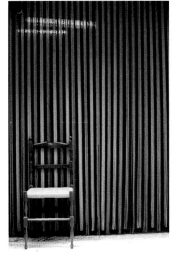

11 Horizontal lines, Vertical lines

The Quality of a Series

The criteria for measuring the quality of an individual image have been described already in detail. With a photographic series, the quality results in large measure from the number of pictures from which one can choose. Therefore, the individual picture within a series may not be subjected to the same standards of image quality as if it were to stand alone. Nevertheless an individual picture should not be included carelessly as a component in a series. The point at which one can start calling a number of pictures a series depends, among other things, on the subject. A topic for a series will often develop out of a range of image subjects, in other words, from the content of a number of images. Of common natural or man-made subjects that are easy to find, for example, trees

out-and-about or a on a dedicated photography tour, in addition to the most often disappointing search for the next masterpiece, one can also have fun adding frames to one's series. There are also subjects, though, which are limited to scenes with specific characteristics or to a particular location. While travelling, one should be alert to discovering such astonishing special features and other curiosities. Making a photographic series based on such unique subjects in natural or urban areas must obviously be completed within the duration of the visit.

12 Vertical lines, Texture

13 Shapes, Texture

14 Visual lines, Oblique lines, Texture

15 Irregular lines, Texture

16 Irregular lines, Texture

17 Vertical lines, Texture

and clouds, or windows, stairs, fences, or other objects, a mature series might be made up of ten to fifteen, or more, carefully selected, interesting images. If the topic of the series is unusual or rare, however, one can certainly build a series with fewer images.

Themes for Series

For the viewer it is important that a series has one or several obvious themes. The one or more themes should be apparent in all the photographs to show that the photographer intended all of them to be viewed as a unified work of art. The main theme of a

series will most likely be of a material or visual subject, but aspects of design and color can be equally intriguing themes for a series. Almost always, one can perceive secondary themes running through the entire series or subthemes that are apparent in a subset of the images. Among several pictures lying side by

side, one can often see small groups forming that might be suitable for developing a series. The small series on "traffic mirrors" (photos 18 – 23) shows formal differences in the round and rectangular shapes, but also the different colors in the edges. With enough material one can imagine a tableau only with

18 Horizontal lines, Circle, Brightness contrast

19 Vertical lines, Circle, Contrast of hues

20 Visual lines, Rectangles

21 Rectangles, Brightness contrast

22 Point, Circle, Rectangles

23 Point, Vertical lines, Circle

round and another tableau only with angular traffic mirrors. The series of pictures of "beach findings" (photos 12-17) originated shortly after a storm tide. Besides these subjects, which are all natural objects, one could do a series on found man-made objects, such as bottles, boxes, gloves, and so on. If a color, combination of colors, or an aspect of design is chosen as the topic for a series, the respective subjects in the photos may be from very different origins. But it is particularly important that the criteria defining a series are unequivocal for the viewer as, for example, the pairing of the colors blue and white in photos 1-4. With the series "lines and stripes" (photos 5-11), there are vertical, horizontal and sloping lines. A possible basis for a subseries would be photos 8 and 10, where the common attribute is that the alternating bright and dark stripes are a shadow pattern from an overhead trellis.

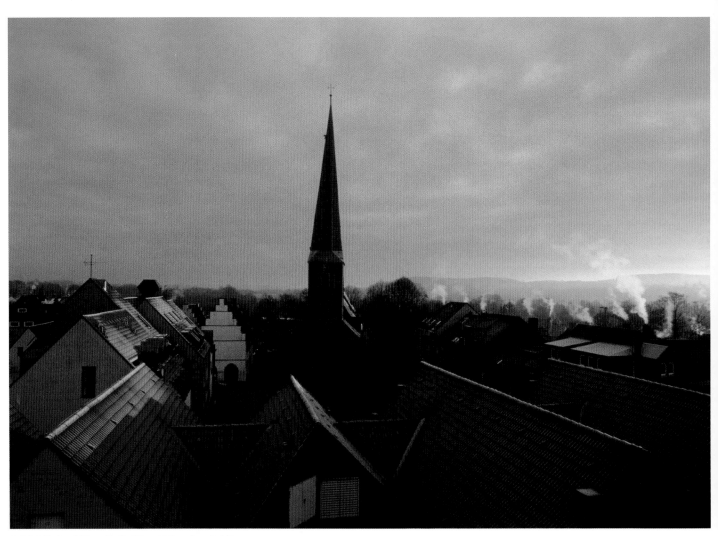

1 Point, Horizontal lines, Vertical lines, Oblique lines, Detail

Representing Time: The Photographic Sequence

The discipline of a photographic sequence is to capture what stays constant and what changes in a motif over time. The viewer is asked to pay attention to what is happening throughout the sequence and what changes from frame to frame. The photographer is an observer documenting the course of events with time sequences of pictures. The successive images must occur under the same conditions, without changing the point of view, the framing, the exposure time, or any other technical parameter; however, the time interval between frames might be allowed to vary within the sequence according to the nature of the changes to be shown. In any case, the changes over time that take place in the image frame are set against a certain invariability in the background.

Time as the Subject

For centuries philosophers have sought to understand the nature of time. Besides philosophers, physicists and artists have also made considerable efforts to understand time. While physicists are concerned with measurability and precision, artists seek to capture the essence of time's effects on a subject using the techniques within their respective arts. Other than video monitoring systems, only television – and then only during a live transmission – can depict the "present". All other visual media give results that can only be regarded as depicting the "past". They can show only pictures of moments, events, and situations which have already happened and belong, therefore, to the past. No matter whether of the distant past or of the recent past, they

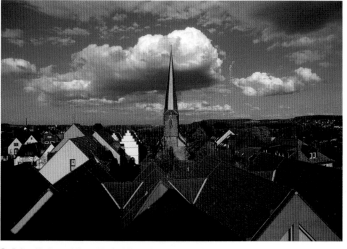

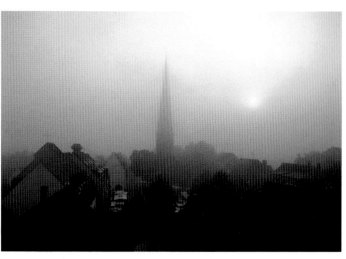

2 Point, Horizontal lines, Vertical lines, Oblique lines, Detail

3 Point, Horizontal lines, Vertical lines, Oblique lines, Detail

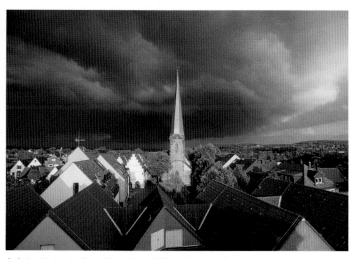

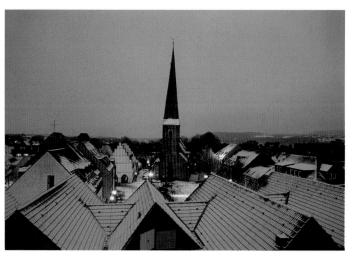

4 Point, Horizontal lines, Vertical lines, Oblique lines, Detail

5 Point, Horizontal lines, Vertical lines, Oblique lines, Detail

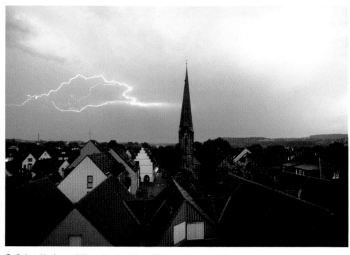

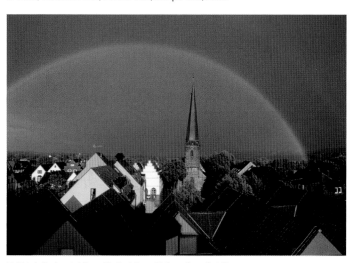

6 Point, Horizontal lines, Vertical lines, Oblique lines, Detail

7 Point, Horizontal lines, Vertical lines, Oblique lines, Detail

are in any case pictures of something that has already happened. These media cannot show anything of the present, and certainly no visual medium can show anything of the future. A course of events, an action, can be documented with pictures taken at brief intervals one after another. These pictorial sequences are the basis of the film, video, and television media and are known as "motion pictures". The rate of passing of time and the length of intervals of time can be experimentally stretched to appear as a slow-motion or shortened to appear as quick-motion action. The key to film-based motion pictures is

187

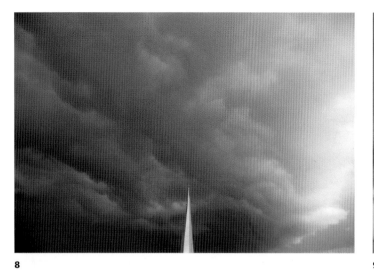

8

9

10

11

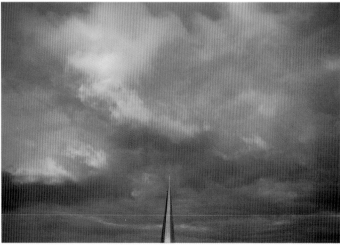

12

13

that each successive frame is presented to the viewer's eye for only a very brief period followed by an even more brief interval between frames; the human perception system cannot register these successive images as separate events, but can only "see" the changes across several frames as movement.

8-19 *Surface-dominating point, Implied vertical line, Oblique lines, Texture, Irregular shapes, Brightness contrast*

14

15

16

17

18

19

A photograph, on the other hand, needs a situation or event in the present moment along with the short time interval of an exposure to capture a picture. Phases of an action can be shown with several photographs of the same subject, separated by shorter or longer time intervals. This artistic technique of the photographic sequence has a long and honored place in the history of the medium. In contrast to film and video, the successive frames of selected moments during the course of an event allow the viewer to contemplate any frame for as long as one desires. In addition, one can move backwards and forward through the sequence as a complete work of art and, in a manner of speaking, experience seeing the past, the present, and the future.

20 Vertical lines, Oblique lines, Brightness contrast

22 Point, Visual lines, Horizontal lines, Vertical lines, Contrast of hues

21 Vertical lines, Oblique lines, Brightness contrast

23 Point, Visual lines, Horizontal lines, Vertical lines, Contrast of hues

Pairs of Photographs

The shortest form of a sequence, and, therefore, the smallest possible means of clearly showing the passage of time in visual terms, is a pair of photographs. The word "clearly" does not refer necessarily to the recognizability of an exact, assignable period of time, but means only that one can see with clarity that an interval of time must have passed between the first and second images. Pairs of pictures, of course, show two events that took place in the past. Nevertheless, at the moments of the two exposures, the first picture shows what happened before the second picture, and the second picure shows, so to speak, the future of what was happening in the first picture. The imaginary interval between the pair of photographs is symbolized by the gap separating prints of the

24 Point, Horizontal lines, Vertical lines, Brightness contrast

25 Point, Horizontal lines, Vertical lines, Brightness contrast

two pictures as they hang either one above the other or next to each other. The above/below arrangement is not as compelling as the side by side arrangement. On other presentation surfaces, such as calendars or exhibition walls, the pictures also can hang next to each other. Sometimes it is clear which photo must be the first and which the second in a paired sequence. Some examples would be images which include a clock, objects moving in a clear direction, a burning candle, or water running out of a container. With such subjects, the first photo must be above or to the left of the second and not the other way around. Otherwise any serious viewer would discover the mistake in the order of the pictures. With most pairs, the only way to prove the order of presentation would be to see the film frame numbers or the digital file time signatures. The

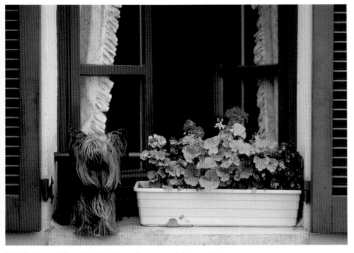

26 Horizontal lines, Vertical lines, Contrast of shapes, Texture

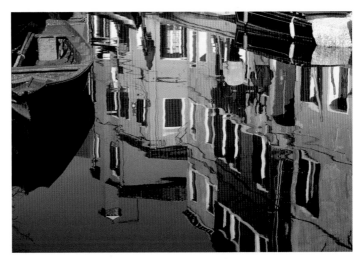

28 Visual lines, Oblique lines, Brightness contrast, Contrast of hues

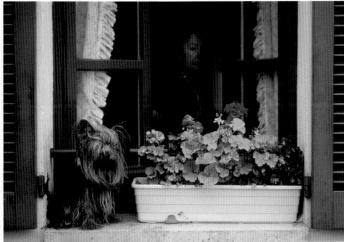

27 Horizontal lines, Vertical lines, Contrast of shapes, Texture

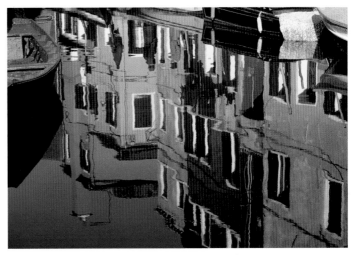

29 Visual lines, Oblique lines, Brightness contrast, Contrast of hues

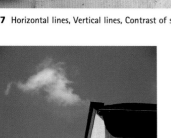

30 Horizontal lines, Oblique lines,
Contrast of shapes, Contrast of hues

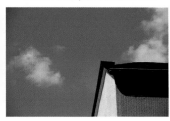

31 Horizontal lines, Oblique lines,
Contrast of shapes, Contrast of hues

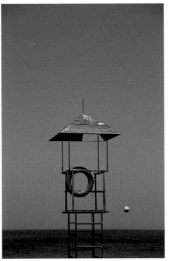

32 Point, Vertical lines, Circles, Triangles

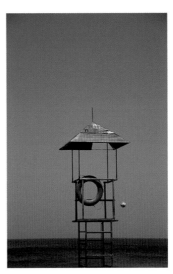

33 Point, Vertical lines, Circles, Triangles

photographer or exhibition manager will make a personal decision to present the images in the correct or inverted order based on artistic criteria. The wind is the cause of such things as curtains or clouds moving (photo pairs 20/21 and 30/31). With human and animal live subjects a change in the attitude of one's head can be of interest (photo pair 26/27). With the photo pairs 22/23, 24/25, and 28/29, it is impossible to discern the actual order from the movement or the appearance/disappearance of a person, animal or object except by knowing the film frame numbers or the digital file time signatures. Another example is the photo pair 32/33, where the volleyball is in different positions, but the players were left out of the frames.

191

34

35

36

37

38

34–38 Visual lines, Horizontal lines, Vertical lines, Oblique lines, Texture, Contrast of hues

39

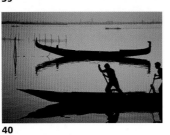

40

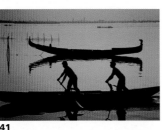

41

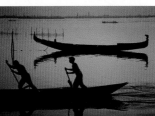

42

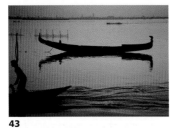

43

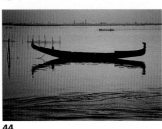

44

39–44 Points, Horizontal lines, Brightness contrast, Warm color balance

Presenting Series and Sequences

Although both series and sequences are built from a variety of images, lay persons often mistake one for the other. Regardless, series and sequences are very different in their concept and origin. One can take certain liberties in presenting a series. Part of the pleasure in working on a series is the possibility of improving the quality of the whole work by continually finding new images and weeding out weaker ones. Sameness of size and format of all the pictures can be part of the thematic criteria for a series, but neither the size nor the situation of the pictures is compellingly prescribed for a presentation. The contents of a series are not altered by changes within the series between horizontal and vertical formats nor by showing prints in a variety of sizes.

Stricter rules apply to the presentation of sequences. Even if the first pictures show the beginning and the last pictures the end of the sequence, all pictures have the same value and must have, therefore, the same size and format in a presentation. Before making the first exposure, one must decide on the portrait format or the horizontal format and maintain that in each case, because a mixture of formats within a sequence is not premissible. There are older and newer theories about how a person perceives a picture. The classical theory teaches that one scans, or "reads", a picture in a manner similar to one's cultural reading pattern. In the western world a viewer scans a picture from the left to the right, back and forth, from the top down. New theories explain visual perception as a more holistic, or comprehensive, capture of a picture. One's eyes are thought to move jerkily over the details in the image plane before deciding at last on a rest point. For analytic scanning of sequences, however, the reading direction of our culture is relevant. The arrangement of

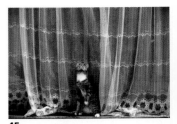

45

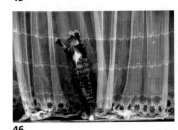

46

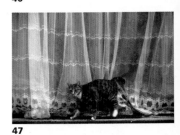

47

48

49

45–49 Point, Visual lines, Texture, Vertical lines, Horizontal lines

the individual pictures in a sequence is a judgment based on the concept and available display space and may be side by side in a row from left to right, in a column from top down (see page 186), or in several rows and columns to be regarded in a manner similar to reading a book (see pages 187 – 189).

50

51

52

53

54

55

The Number of Pictures

A pair of pictures can show only changes only at the beginning and the end of one time interval that, in most cases, is not determinable by a viewer. Three and more pictures are necessary to document a course of action. An appropriate number of pictures taken across what time intervals and what courses of action merit documentation must depend on the artist's conception and the desired end result. One way to train oneself into the discipline of photographing sequences is to start with time intervals of some minutes' duration, move on to subjects where one or more hours would be necessary, and finally to shoot for a whole day. A sequence based on quite short intervals is shown in photos 39-44 of a passing gondola in Venice. This sequence is visually compelling and self-explanatory. The sequences of the cat moving about (photos 45-49), the

50-55 *Visual lines, Irregular lines, Brightness contrast, Contrast of hues*

193

56

57

58

59

60

61

changing reflections on water (photos 50-55), and the wind-blown curtain (photos 56-61) do not allow one a sense of the length of time interval between frames, or even whether the intervals were constant or variable. For anticipated long-term sequences, it must be possible, first of all, for

one to be able to photograph throughout the planned time period. Only some examples of the sequence begun in 1998 are shown from the long term observations of "the sky above roofs" taken from above the roofs and the marketplace (photos 1-7) and the detail of the steeple pointing into the sky

(photos 8-19). The largest assembly up to now of this work in the correct time sequence amounts to sixty-four pictures. One can inject an active element into a time sequence by changing the view between shots. That is, after each exposure, the photographer moves forward, sideways, or in some other

56-61 *Vertical lines, Contrast of shapes, Alternating shapes, Brightness contrast, Complementary contrast*

194

62

63

64

65

66

67

regular manner to change details in the viewfinder. The sequence of colored houses in photos 34–38 was taken by moving to the right parallel to the houses by one width of a house between shots. One can verify the correct order by matching the colored portions of adjacent houses on the left and right sides

of each frame. The sequence of the tables with cutlery (photos 62–67) shows not only changes with time, but also of "position" and "space". Since the tables are not numbered, it is not possible to determine the spatial relationship between any two tables.

62-67 *Numerous points, Horizontal lines, Vertical lines, Brightness contrast, Contrast of hues*

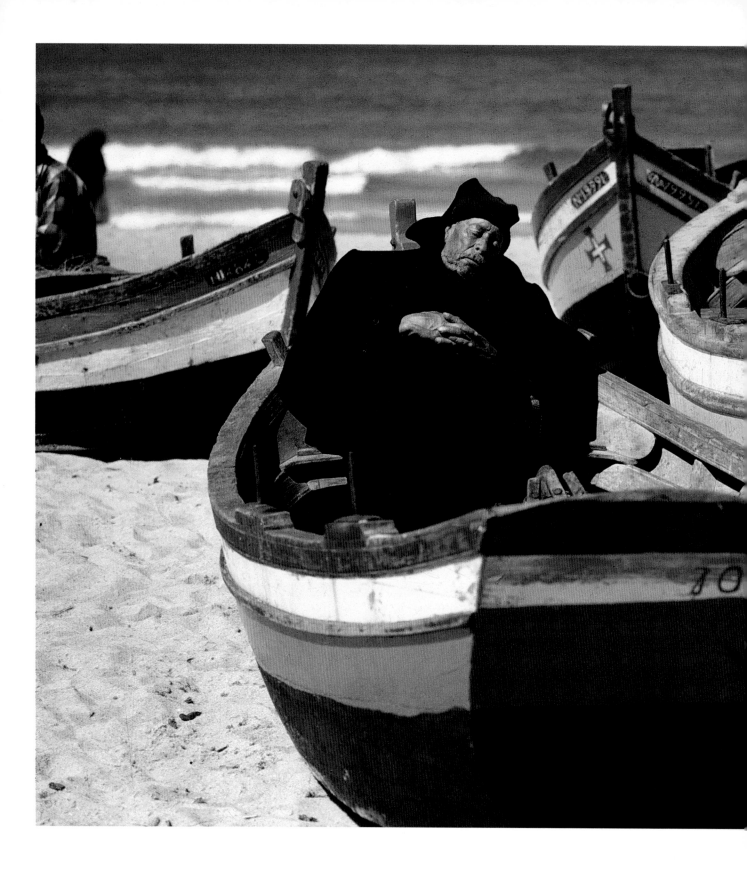

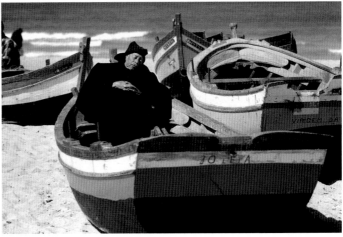

Analyzing Shape and Color

The chapters covering the basic elements of design and color theory illustrate the potential of basic artistic tools and techniques. Once you understand how these function, you can use them to analyze and assess the qualities and content of photos and paintings that you have made by yourself as well as those made by other artists.

The various tonal areas in this black-and-white image just about cover the entire range of contrast between light and dark. The lines are mostly vertical or diagonal; horizontal lines are only implied in a very few places. Additionally, the entire image is full of geometric patterns of one sort or another.

The dominant formal element in the color image is the complementary contrast between the warm yellow and cool blue tones, which even outdoes the overall light-dark contrast. The tiny amounts of green and russet red tones are less obvious at first glance.

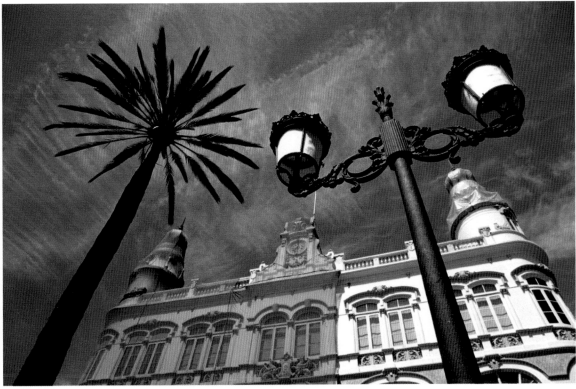

Composition:

Two points, page 100

Diagonal lines, page 60

Line division, page 66

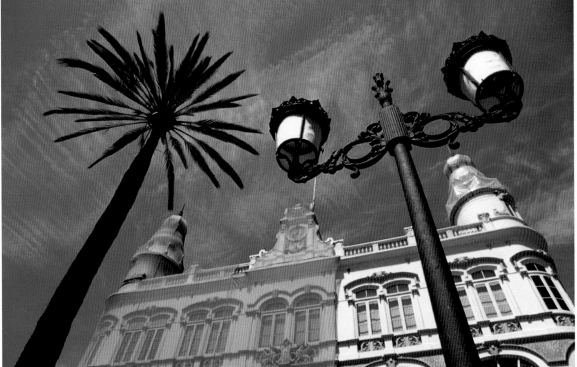

Color Design:

Light-dark contrast

Page 100

Complementary contrast

Page 126

Cold-warm contrast

Page 132

The slanted, wide shooting angle used in this image makes it 100 percent dynamic – in other words, it doesn't contain a single vertical or horizontal line. The two competing points in the street lamp form a compelling diagonal line and the palm fronds bid strongly for our attention. The composition dominates the black-and-white version of the image more than the actual subject does, while the light-dark contrast in the color version competes directly with the color scheme. The yellow of the building and the blue of the sky create not only complementary but also cold-warm contrast. Together with the green of the netting, these colors produce bright, three-color harmony.

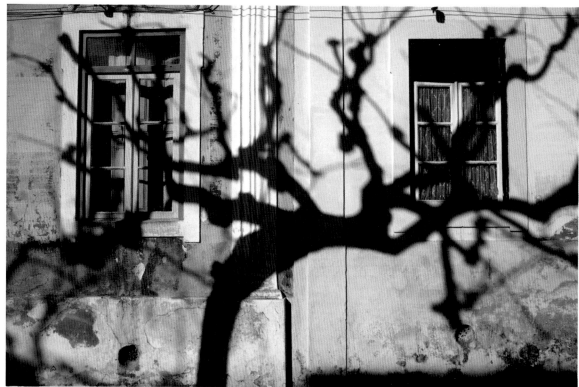

Composition:

Horizontal lines, page 48

Vertical lines, page 54

Irregular lines, page 66

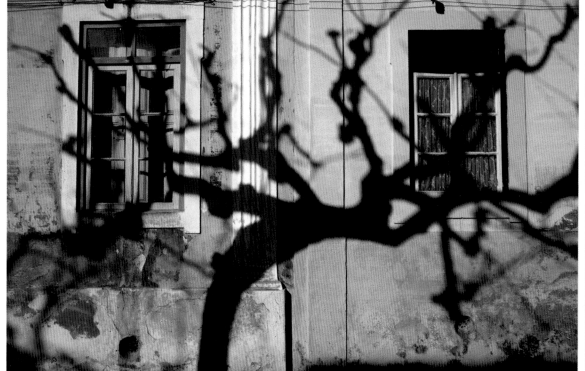

Color Design:

Page 100

Page 126

Page 132

Page 138

The light-dark contrast of the tree's shadow dominates both versions of this image. While the shadow of the trunk forms a broad shape, the shadows of the individual branches form vivid irregular lines. These lines provide strong contrast to the geometric horizontal and vertical lines in the building's façade. In spite of the subdued colors, the color image displays obvious complementary, cold-warm, and simultaneous contrast.

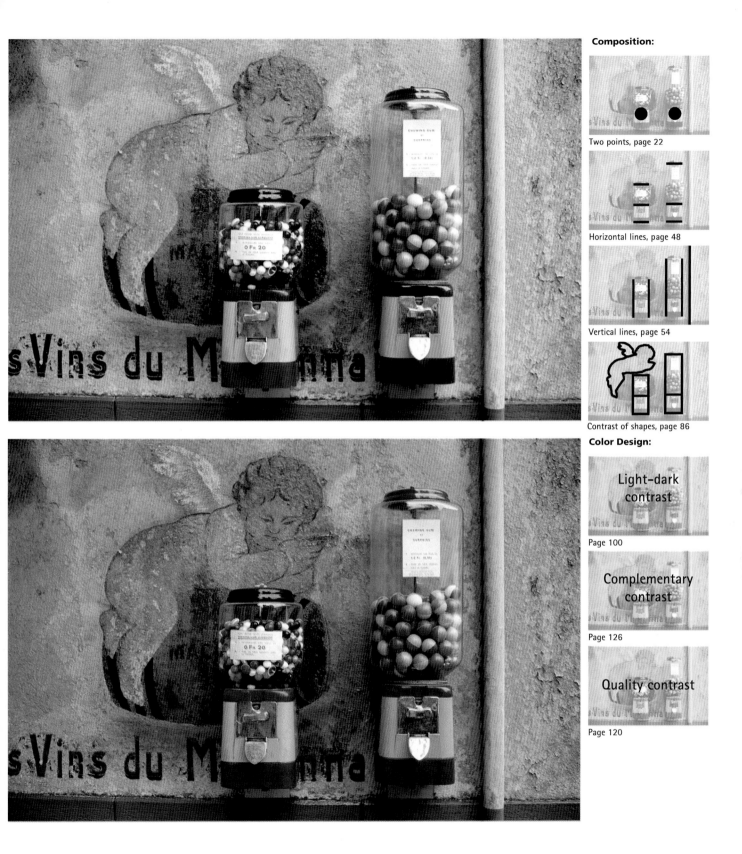

Composition:

Two points, page 22

Horizontal lines, page 48

Vertical lines, page 54

Contrast of shapes, page 86

Color Design:

Light-dark contrast

Page 100

Complementary contrast

Page 126

Quality contrast

Page 120

The dominant shapes in the black-and-white image are the rectangles formed by the short vertical and horizontal lines of the bubble gum machines. Together with the vertical line of the drainpipe, these shapes emphasize the predominantly vertical nature of the subject. The geometrical shapes of the machines provide a strong contrast to the irregular shape of the cherub. The lettering is immediately obvious, whereas the other textures have been reduced to grayscale values and are more difficult to see. The brightly colored lower parts of the machines dominate the color image and provide color quality contrast with the more subdued color of the painted wall, although the bubble gum balls themselves demand attention, too.

201

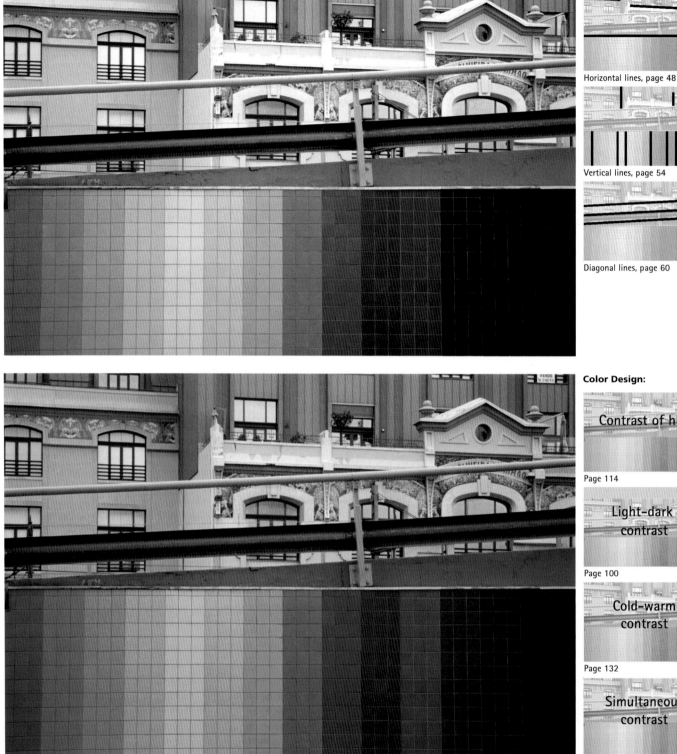

Composition:

Horizontal lines, page 48

Vertical lines, page 54

Diagonal lines, page 60

Color Design:

Contrast of hue

Page 114

Light-dark contrast

Page 100

Cold-warm contrast

Page 132

Simultaneous contrast

Page 138

The contrast between the diagonal lines and the absolute verticals of the tiled wall are the dominant feature in the monochrome image. The strict formal shapes of the tiles also stand in stark contrast to the soft, irregular lines in the façades of the buildings in the upper half of the frame.

The overall tonal effect in the color image is so intense that the composition itself plays only a secondary role. The spectral colors in the tiles perfectly illustrate the tonal contrast and cold-warm contrast aspects of color theory. The buildings are dominated by yellow tones, although if you take a long look at the image, simultaneous contrast reveals that the gray of the guard rail and the roof tiles tends toward violet.

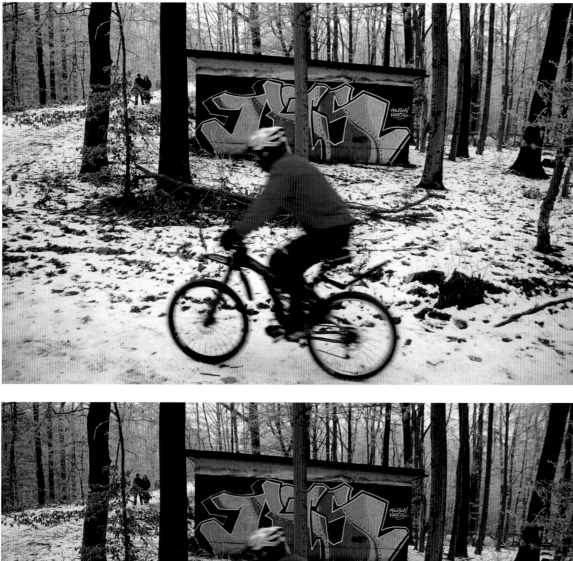

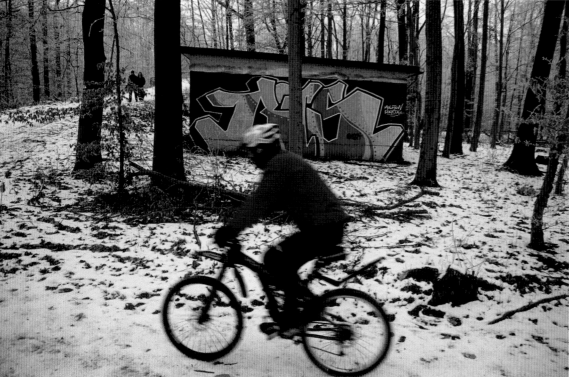

Composition:

Single point, page 16

Vertical lines, page 54

Diagonal lines, page 60

Contrast of shapes, page 86

Color Design:

Contrast of hue

Page 114

Light-dark contrast

Page 100

Cold-warm contrast

Page 132

The recognizability of each individual element plays an important role in the process of perception of an image. The cyclist is the dominant element in both versions of this image. The red pullover, in its central location, simultaneously provides the obvious focal point and the most active color in the color version. Although the graffiti plays only a subsidiary role in the monochrome version, it provides a strong tonal contrast to the cyclist's pullover in the color photo.

Composition:

Single point, page 16

Vertical lines, page 54

Diagonal lines, page 60

Contrast of shapes, page 86

Color Design:

Cold–warm
contrast

Page 132

Simultaneous
contrast

Page 138

The basic shapes, lines, and surfaces in this image are easy to recognize. However, in view of the obvious humorous, large-small contrast, you have to look harder to spot the less conspicuous elements, such as the lines and shapes formed by the points on the wall. The dominant colors are warm, while the red surfaces and yellow lines form a subtle three-way color harmony with the bright green of the vegetation.

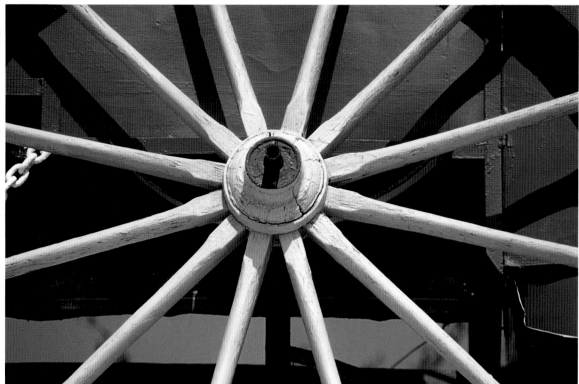

Composition:

Single point, page 16

Horizontal lines, page 48

Diagonal lines, page 60

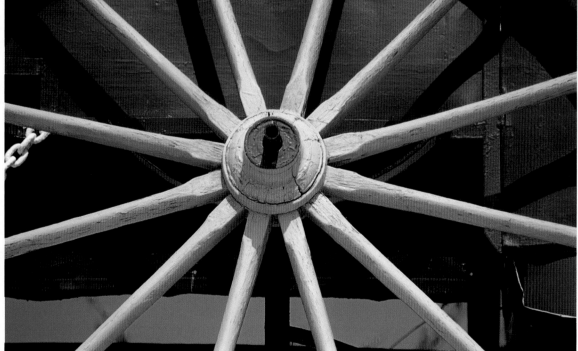

Color Design:

Light-dark contrast
Page 100

Contrast of hue
Page 114

Cold-warm contrast
Page 132

This wagon wheel contains obvious compositional elements. In the monochrome version, the individual spokes form the most obvious light-dark contrast and provide conspicuous diagonal lines. The hub is the clear center of the image and the broken horizontal lines make hardly any impression at all on the viewer.

In the color version, the strong color contrast between the primary red, blue, and yellow colors competes for our attention with light-dark contrast. Yellow dominates, although the blue is strong enough to give the horizontal lines it creates some emphasis.

Photo: Eva Witter

Biography of Harald Mante

Born in 1936 in Berlin.

1950–54	Studied theory of painting
1957–61	Scholarship at the Work Art School in Wiesbaden. Studied painting with Vincent Seber, Heinz Rudi Mueller, Oskar Kolb
1960	First contact with the medium of photography
1961	First of numerous prizes, medals, and honors
1961–67	Lecturer in photography in Wiesbaden and Mainz
1964	Three month photo trip to Ireland
until 1965	Freelance photo designer with travels to Ireland, Portugal, Spain, Italy, East Africa, England, USA, Canada, New Zealand, and other places
since 1965	Numerous one-person exhibits and exhibit participation at home and abroad
1967–71	Taught photography at the Work Art School in Wiesbaden
1969	Textbook *Photo Design*, published in five languages
1971	Textbook *Color Design*, published in four languages. Appointment to the Polytechnic University of Wuppertal
1973	Four week trip to England for talks and workshops on photography at six colleges
1974	Decided to transfer to the Advanced Technical College of Dortmund, Department of Design, subject specialty in photo design, teaching area: free and experimental color photography
1975	Textbook *Color and Form*
1976	Appointment as professor
1978	Guest professor at the University of Sascatchewan in Saskatoon, Canada
1980	Textbook *Seeing Color and Form*
1980–85	Worked on picture books on Tuscany and Umbria, Florence, East Germany, Canada, and Ireland
1986	Textbook *Creative Use of Lenses* (with co-author Josef H. Neumann)
1987	Monograph *Compositions*
1988	Beginning of the black and white work *Image Spaces - Diaphanous Metamorphoses of Locks in Europe* together with Eva Witter (catalog, twelve exhibits), www.simultanfotografie.de
1988	Textbook *Creative Use of Film* (with co-author Josef H. Neumann)
1989	Video documentary on teaching and personal work in the series by Kodak, USA on *Techniques of the Masters*
1994	Photo project "Ireland after 30 Years". Dean of the Department of Design of the Advanced Technical College of Dortmund
1996	Textbook *Creative Approaches to Subjects*
2000	Textbook *The Photo - Composition and Color Design*
2001	Retired from teaching. Work on the photo project on Skies Over Schwerte
since 2003	Guest lecturer on color photography at the European Academy of Arts in Trier. Manage the advanced level photo seminars at the University of Dortmund.
since 2004	Conduct photo seminars for the management personnel of the health resort baths at Zingst, on the Baltic

Harald Mante lives and works in Schwerte

www.harald-mante.de

Index